The Graphic Designer's Guide to Better Business Writing

Barbara Janoff and Ruth Cash-Smith

ALLWORTH PRESS
NEW YORK

11 10 09 08 07 5 4 3 2 1

Published by Allworth Press
An imprint of Allworth Communications, Inc.
10 East 23rd Street, New York, NY 10010

Cover design by Derek Bacchus
Interior design/composition/typography by SR Desktop Services, Ridge, NY

"Global Graphics" is reprinted from *The Business Writer's Companion*, 3e
by Alred, Brusaw & Oliu Copyright © 2002 by Bedford/St. Martin's
Reproduced by permission of Bedford/St Martin's.

ISBN-13: 978-1-58115-472-6
ISBN-10: 1-58115-472-0

Library of Congress Cataloging-in-Publication Data
 Janoff, Barbara.
 The graphic designer's guide to better business writing/Barbara Janoff
and Ruth Cash-Smith.
 p. cm.
 ISBN-13: 978-1-58115-472-6 (pbk.)
 ISBN-10: 1-58115-472-0 (pbk.)
 1. Design services—Marketing—Handbooks, manuals, etc. 2. Graphic arts—
Marketing—Handbooks, manuals, etc. 3. Business writing—Handbooks, manuals,
etc. 4. Business communication—Handbooks, manuals, etc. 5. Career
development—Handbooks, manuals, etc. 6. New business enterprises—
Management—Handbooks, manuals, etc. I. Cash-Smith, Ruth. II. Title.

NK1173.J36 2007
808'.066741—dc22

 2006100743

Dedication

This book is dedicated to
Al Silverstein
and
Tracy Smith
who have enriched our lives
in so many ways with their
patience, support, and good humor.

Acknowledgments

Publishing our first book is indeed a cause for celebration. We owe thanks to the many kind souls who helped us during this twenty-month journey.

First, we are indebted to all of the designers from across the country who generously gave us interviews and contributed their experiences, wisdom, and writing samples to this book. We are especially grateful to designers Shamus Alley of New York City and Buddy Chase at Studio 3 in Ellsworth, Maine, who *always* made time to answer every single question we posed, and whose help was invaluable.

Our deeply felt gratitude extends to Tad Crawford, Nicole Potter-Talling, and Allison Caplin of Allworth Press for their professionalism, courtesy, and patience.

Special thanks go to Kathleen Kelly, our writing partner since 1992, who graciously supported our work on this book at the expense of other collaborations. We deeply appreciate the input from another dear writing buddy, Sherry Christie, for volunteering to read a draft of this manuscript and for providing superior editing and all-around support, plus chauffeuring services.

Our lives have been greatly enriched and nourished—both personally and professionally—by the members of our women's circles and our writing groups, who have kept us on the path and on the page. We also want to acknowledge Tide Mill Farm, Twin Farms, and Wellspring House for providing welcoming safe havens for writers on retreat. And thanks go to Natalie Goldberg who inspired us and brought us together.

For library assistance far above and beyond the call, we are grateful to Carol Briggs and the volunteers at the Roe Jan Library in Hillsdale, New York—the little library that could—for providing us with dozens and dozens of books through the Mid-Hudson Library System.

Likewise, we commend the dedicated faculty of the Gladys Marcus Library at the Fashion Institute of Technology, State University of New York, for researching and making available for us, as well as the students, a vast array of specialized periodicals, online articles, and bibliographies.

Thanks are also due to the Fashion Institute of Technology for granting Barbara a sabbatical to research and complete this book.

Last, but certainly not least, we are indebted to the students in our business communications classes over the past twenty years. We salute your thirst for knowledge, your drive to get ahead, and your knack for keeping us on our toes. Being your teachers has been a gift we treasure.

Table of Contents

Chapter 14: WORKING THROUGH CLIENT CONFLICT

Chapter 15: MAINTAINING CLIENT RELATIONSHIPS

Chapter 16: WORKING WITH FREELANCERS AND OTHER SPECIALISTS

Chapter 17: WORKING AT A DISTANCE

Spotlight On: Christy White/Alpha Marketing: Working Virtually

Chapter 18: WORKING ACROSS CULTURES

PART IV. GROWING YOUR BUSINESS

Spotlight On: Steffanie Lorig/Art with Heart: Design As an Instrument of Change

Chapter 19: PLANNING FOR GROWTH

Quick Reference to WRITING SAMPLES

Graphic Designers ON WRITING WELL

"The belief is—and this is perpetuated by teachers in design school—once you come up with the very best design idea, it will blind people with its brilliance. That's not true. You need clear writing in order to show how it works. Good writing is concise, polite, and graceful. The people who work for me need to write with clarity, and they know I don't like bad spelling, which makes writers seem stupid. Stupid people shouldn't be trusted." —*Michael Bierut*

• • •

"People forget e-mail is business writing. It needs to be clear and straight-forward. It's important to find your voice in business writing of any type. You have to come across as genuine." —*Margo Chase*

• • •

"Reread your e-mails and letters. Take your time. Make use of checklists. Don't assume you've written what you meant to write. Try to reread the message from the point of view of someone who doesn't know what you meant." —*Cathy Teal*

• • •

"Recent grads need to develop an eye for detail. All too often, after they've input the type, they don't look back, when they need to check and recheck their work. I learned this through the school of hard knocks; I was working for a design shop and didn't see that the term "high-interest *yield*" was misspelled "high-interest *yeild*" until it was a ten-foot-high banner in the bank. I almost got fired over that and it was very costly for the design firm. It is important to always check and recheck the work, particularly the spelling of words." —*Steffanie Lorig*

• • •

"Proposal writing is one of the most painful, yet necessary, forms of business writing, and I've discovered that a large number of my peers have no clue how to generate an intelligent proposal." —*Phil Opp*

• • •

"I'm very word conscious. I write lots of business proposals, which need to be very clear and concise. Basically, I take loads and loads of chaotic information and then synthesize it down to one and a half pages." —*Sally McElwain*

• • •

"Thinking about language is crucial to a graphic designer; otherwise you permanently relegate yourself to a lower tier … of clients, of work, and of success." —*Dave Caputo*

PART I. BOOSTING YOUR DESIGN CAREER THROUGH IMPROVED COMMUNICATION SKILLS

Your design talent, training, and experience will only get you so far in your career. Every year, design schools graduate thousands of new graphic designers. Competition for work has never been fiercer, so if you want to succeed, you need to excel as a business writer and speaker as well as a designer. This necessity does not only apply to principals, but to freelancers and staffers as well. It applies to every designer. Even if you partner with a copywriter or work on creative projects with staff writers, you will still need to write and speak for yourself in a clear, concise, and professional manner. There's no way around it. To get ahead as a designer, you must develop excellent business communication skills.

WHY ARE EXCELLENT COMMUNICATION SKILLS CRUCIAL TO YOUR DESIGN CAREER?

Let's assume that if you're reading this book, you've got the training, technique, and some experience as a *visual* communicator under your belt, and that you know you're a good designer. Why isn't that enough?

You're in business; that's why. Whether you're in business for yourself or for somebody else, your work requires proposals, agreements, coordination, and approvals. You'll be called upon to write and answer hundreds of e-mail messages, give dozens of presentations, and conduct all manner of business over the phone.

"Many people can design well," says Michael Bierut, a partner at Pentagram. "Succeeding is about your ability to persuade others to give you their trust, get approvals, and enlist other collaborators—printers, photographers, illustrators, and other writers." Communicating persuasively, giving accurate instructions, developing easy-to-understand explanations, as well as writing clear continuity and follow-up messages are a designer's everyday business tasks.

You'd think that the old pros would be the ones entrusted with these essential communication responsibilities, but you'd be wrong. Sally McElwain of Alexander Design lets you in on what really happens in many firms. "The newest additions to a team are the ones often told to 'send this message out' or 'e-mail them and tell them we're sending this or that.'" This can lead to trouble when the unseasoned designer isn't careful in choosing his words or doesn't check to make sure that the client understands the message. (See "The Communication Cycle" on page 5 for a discussion about feedback.) McElwain recalls one situation where a new designer created a logo for an inexperienced

client, who "didn't understand that when you print on uncoated paper rather than coated paper, the color wouldn't be the same." The new designer used the word "match" in an e-mail, and the client took that to mean the colors would be exactly the same. This miscommunication led to disagreements and disappointment about what should have been a routine matter, and the new designer had to learn the hard way that written and oral communication are as important as visual communication when everyone gets down to business. That's the reason why the want ads for new designers state, "Excellent Communication Skills Required."

Some of you claim in a line on your resumés that you have "excellent communication skills," and no doubt you have developed a skill or two in a college research, writing, or speech class or through your work experience. But the industry leaders we interviewed tell us that while you may think you have overall good written and oral communication skills, most recent graduates and new designers are abysmally lacking in these areas. These industry leaders have noticed that many newly hired designers seem unaware of their communication deficiencies and, what's more, don't know or care about what they're missing. Either way, the leaders in your field are not happy about it. So all other things being equal, those of you who develop your business communication skills will be recognized and valued more than those who don't bother. You'll come out ahead.

WHAT DO WE MEAN BY BUSINESS COMMUNICATION SKILLS?

When we talk about business communication, we're referring to the variety of ways that people send and receive business messages. The more you understand and practice the following communication modes, the more skilled you'll become as a business communicator.

- Writing/reading
- Oral presentations/listening
- Nonverbal signals/observing

You can see that this list is formatted in a way that highlights the sending/receiving dynamic of communications. As a design professional, you'll need to practice both halves of each equation:

- Writing messages for others to read, and *critically* reading material written by others
- Giving presentations and interviews that others listen to/interpret, and *actively* listening to what others have to say
- Behaving in a manner that signals professionalism, and *consciously* observing the gestures and mannerisms of others

Notice that we characterize your role as receiver with these words: *critically, actively, and consciously*. That's where the skill development comes in. You all

know how to read, listen, and watch, but you'll need to become more astute at decoding, prioritizing, and categorizing the information that comes your way in business. That's how you'll minimize your chances of being blindsided by a client or collaborator who gave you early signs of trouble that you didn't pick up in time. That's also how you'll learn from other designers, mentors, clients, and collaborators who have much to share with you, but who lack the time, self-awareness, or eloquence to spell everything out for you.

The rest of this book is dedicated to helping you develop your skills and strategies as a business writer and presenter. However, right now, this section will introduce you to the dynamic, two-way nature of communication. We'll also discuss nonverbal communications and active listening. Then, we'll address reading in terms of research, which is a crucial skill for you to master if you want to advance in your career.

RATING YOUR BUSINESS COMMUNICATION SKILLS

Now that we've given you a basic understanding of the different skills required to succeed in the business of graphic design, review the following communication categories to assess your current strengths and weaknesses. This will help you set priorities and goals for your self-improvement plan.

When *writing* e-mails, letters, and proposals, can you:
- Organize messages persuasively?
- Write logically and concisely?
- Keep your reader's needs in mind at all times?
- Adjust the style and tone of your writing to suit different audiences and situations?
- Know whether a memo, e-mail, letter, or fax is the best vehicle to convey your message?
- Revise for organization, accuracy, and completeness?
- Proofread to correct grammar and punctuation?

When *researching*, are you able to:
- Optimize your Internet searches?
- Determine the authority and bias level of your sources?
- Find information from sources beyond the Internet?
- Pick out and summarize key points from your readings?
- Formulate questionnaires and conduct interviews and surveys?
- Make significant meaning and draw conclusions from your findings?
- Document your findings?

When *presenting*, can you:
- Plan and develop a presentation appropriate for the situation and audience?

- Speak from your notes without reading them?
- Sound natural, and not canned or memorized?
- Gauge your audience's interest and engagement and adjust your speech accordingly?
- Handle unexpected comments or questions without losing your way?
- Close with a flourish?
- Learn from your mistakes afterwards by doing a self-critique?

When *communicating nonverbally*, do you:
- Dress appropriately for each occasion?
- Make frequent eye contact with the client, interviewer, or audience?
- Monitor your hands, posture, and speech so your nervousness is not noticeable?
- Adjust your style and tone to that of the client or interviewer?
- Note the speaker's body language, which may be in opposition to the spoken message?
- Maintain your poise during unexpected questions, silences, or interruptions?
- Take into account when you are communicating with someone from another culture and adjust your communication style accordingly?

When *listening*, can you:
- Put aside your preconceptions and be objective?
- Focus on what the speaker is saying?
- Identify key points?
- Analyze the speaker's message for logic and accuracy?
- Distinguish between fact and opinion?
- Ask questions or comment without losing your train of thought?
- Respond with constructive feedback?

Did you do as well as you expected? What areas do you find that you need to develop further? What surprised you in this assessment? Remember, you can always develop new skills when you set your mind to it. Many people find that the areas they work hardest to develop actually end up stronger than those in which they had innate abilities.

The remainder of this section is sure to increase your knowledge about communication and provide you with some easy-to-follow tips for increasing your effectiveness immediately.

Chapter 1:
TUNING IN TO BUSINESS COMMUNICATIONS

Before we discuss business writing, we want to give you a crash course on other modes of communication. You'll perform better in business if you know a thing or two about nonverbal communication, active listening, and oral communication. We're starting out with a foundational section about the communication cycle, which applies to visual as well as written and oral communication.

THE COMMUNICATION CYCLE

Understanding the overall process of communication will put you ahead of the competition curve, particularly if you comprehend two major points.

- The communication cycle applies to all messages that people send to one another—through writing, speech, images, and nonverbal gestures.
- Communication is a process that loops from the sender to the receiver and, through feedback, returns to the sender. (Sometimes we send messages without conscious intent or awareness of what information we're sending. This is particularly true of nonverbal messages, which we'll get to shortly.)

For now we'll concentrate on examples in business communication to give you a sense of the stages. Briefly, here's how the communication cycle works when it's broken down into seven stages.

Internal

1. You, the sender, have an idea or information to share. At this initial stage, the information is still in your head (like ideas for a sales presentation) or in your files (like background notes for your resumé).

2. You, the sender, work the idea or information into a message that will make sense to the receiver. This is where you figure out how to make your message accessible and appropriate to your audience by:

- Making certain of your main purpose
- Analyzing your audience
- Choosing an appropriate form, tone, and style

3. You, the sender, choose the best time, channel (primarily written or spoken), and medium (e-mail, letter, telephone, face-to-face meeting, etc.) for sending the message.

5

External

4. The receiver gets the message. (If your receiver doesn't read or hear your message, then communication has failed.)

5. The receiver interprets the message. (Successful communication requires active participation on the part of the receiver, who must comprehend your message and respond to it in the way you intended.)

6. The receiver sends feedback to the sender. (Feedback allows you, the sender, to evaluate the success of your communication. If the receiver doesn't understand your message, you will be able to tell from the feedback and go back to Stage two to rework it.)

7. When all of the external goals are achieved, your communication is successful.

NONVERBAL COMMUNICATION

Your actions and appearance tell at least as much about you as your words. This is particularly true when it comes to first impressions—sales calls and job interviews where your dress, grooming, behavior, and body language send strong messages about your professionalism, intelligence, and abilities. Unfair? Probably. Illogical? Maybe, but the experts who measure such things for the rest of us say that anywhere from 55 percent to 93 percent of what we believe about one another comes from nonverbal communication.

The nonverbal message choices you make (whether you're aware of them or not) will open or close doors for you. Potential employers or clients are not likely to tell you about the messages you inadvertently sent that resulted in your not being hired. As one agency owner put it, "It isn't my job to set every applicant straight." Since it is our job to set our readers straight, we're going to alert you to a world of sign making and message sending that you might not know exists. We don't want you to keep repeating the same mistakes.

Clothes and Grooming

Your clothes and grooming are the first messages you send to people about your professional identity, so, if you want to thrive in business, you'll need to give some thought to the image you want to project to others. Keep in mind that your constant communication goal (whether in writing, speaking, or nonverbal messages) is to persuade potential employers, clients, and collaborators to trust you, your judgment, and your abilities. While it may not be like this everywhere, our North American business culture puts a good deal of faith in clothing and accessory presentation. "Perception is reality," notes Steve Adolf, creative director at Zimmerman in Florida. "People judge you by the way you look."

We aren't telling you creative types that you must suit up for *every* interview or meeting as if you were trying to get into a Fortune 500 company (unless you are). We aren't even telling you that you must *always* conform to casual business

garb because we'd lose your attention and trust. But *sometimes* your audience and purpose will dictate that, yes, business attire is the way to go. As with any other kind of communication mode you should:

1. Analyze your purpose and audience
2. Plan your nonverbal message
3. Create your message according to your analysis.

For example, you've applied for a position as a junior designer at XYZ Agency, a large and prestigious firm, where you've been invited for a first interview. Your "purpose" is to succeed at the interview and your "audience" is an interviewer from personnel who needs to choose a few applicants to send to the art department for a second interview. Your attire should send the message that you are a good fit for the position, but your audience (the human resource person) doesn't work in the department to which you're applying. How do you dress for your audience?

When in doubt, present yourself in a neutral manner, which would be casual business attire. Flashing your personal idiosyncratic style advertises your self-absorption, which is an undesirable trait to employers and clients. In other words, they won't want to hire you if you look like you care more about your own needs than theirs. Like typos and inaccuracies on a resumé or proposal, potential employers and clients use clothing and accessory mistakes to cut you from the list.

Yes, yes, we know you're creative and express yourself through your appearance. And we've heard that the designers in the art department at XYZ Agency *all* dress down, up, or over the top, and you want to show that you belong. But you don't belong . . . yet. You're still on the outside trying to get in. Showing a little respect for the process and boundaries goes a long way. Besides, if you've done your homework and researched the agency (see page 111), you might have found that XYZ Agency serves some corporate clients and other clients who require or prefer business attire. Although you are applying for a junior designer position, dressing in casual business clothing sends the nonverbal message that you have the potential for attending meetings and making presentations. That message could be just the one that tips the scale in your favor in a job search.

Pay attention to your grooming too. Steve Adolf advises you to "get a manicure before an interview. I interviewed two applicants with 3.8 GPAs and great portfolios. One had chewed-down fingernails. That showed her nervousness. I hired the other one."

You'll notice that there is no mention of your present personal style here. While some of you may have cultivated a personal image as a student that will generally serve you well in business, some of you will need a makeover (in some cases, an extreme makeover) for the professional world of work. New York City designer Mirko Ilić warns, "When you wear baseball caps to an interview or

aren't neat in your appearance, you lose credibility." Use sound judgment about the image you project. It's also a good idea to ask for feedback from people you trust who are already employed in positions like the ones you are seeking.

Body Language

Personal mannerisms, eye contact, the way you enter a room are all components of body language. Because we are often unaware of the messages we send through body language, modification is a challenging task, but it is one well worth tackling.

Ideally, your body language should reinforce the message you want to convey. In an interview you want to show your interest and eagerness to be hired, but nervousness and fearfulness can subvert your message. Do you tend to cross your arms in front of your chest when you are feeling fearful? A perspective employer or client is likely to interpret your body language as a sign that you are not open to the message that he is sending or that you are reluctant to interact. What he may interpret as your resistance or antisocial behavior could be your feelings of fear that you don't understand what he is saying or that you won't be able to answer his questions adequately. So be aware of your body language: uncross your arms, lean forward to indicate your attention, and focus. While you're at it, sit up tall and keep your body relatively still—no bouncing legs or tapping fingers. You're being read like a text; make an effort to send the best message.

Your eyes also reveal much about your thoughts and feelings. In our North American culture, when your eyes make contact with others' eyes, you are showing that you are paying attention and are trying to follow their thoughts and feelings. In our culture, although not necessarily in others, eye contact shows respect. When you look away or close your eyes, you give the appearance of being bored or distracted. In truth, you may concentrate better with your eyes closed, but you'll have to learn new ways to concentrate, ones that signal to others that you are engaged.

Voice

The way you speak can either support or contradict your words. That is because the speed, volume, pitch, and tone of your voice each carries its own nonverbal message.

If you speak very quickly or very slowly, you run the risk of conveying a sense that you don't care if your listener is following and absorbing your message (particularly if you are not making eye contact). Nervousness or a perfectionist streak may be influencing your speed, but you will be perceived as self-absorbed.

If you speak very softly, your message may not be taken seriously, or else you are liable to be interrupted or ignored. If your voice is very loud, you might come across as arrogant, insensitive, or insecure.

A good way to fine-tune your speaking delivery is to ask a friend to help you rehearse in a mock interview. Tape it and listen for the places where your voice

lowers and raises. Do you mumble at the end of your sentences? Do you drag out your words at the beginning of a thought sequence? Do you raise your voice at the end when you're unsure of your statements? Knowing your patterns is the first step to making adjustments.

The Time Factor

In our North American culture, being on time for appointments and returning phone calls promptly convey underlying messages of respect, courtesy, and a willingness to conduct business. Also, punctuality and promptness are aspects of business etiquette that indicate a concern for schedules and deadlines to come. As the saying goes, "time is money."

On the other hand, when you are late or delay returning calls, you run the risk of being perceived as rude or disrespectful or unwilling to pursue a business relationship. You also might be seen as potentially unreliable. After all, if you can't be on time for a meeting, how can others be sure that you'll deliver your work on time? Depending on other circumstances in your life that affect your ability to be on time, these may or may not be valid interpretations; yet it's necessary to know how your actions might be perceived. Being chosen for a project or a job sometimes comes down to a "gut reaction," where nonverbal signs like punctuality make all of the difference.

Time also may indicate power positioning. You might fantasize that keeping someone waiting for an appointment or taking phone calls and allowing staff interruptions during a meeting sends the message that you're a very important person who is much in demand. Just remember that these nonverbal messages have more of a chance of offending than they do of impressing the receiver. It's better to let your work indicate your importance and desirability. Most successful designers believe in punctuality as a sign of professionalism.

ACTIVE LISTENING

One of the most important business communication skills you should develop is that of active listening, which is a process requiring intention, strategy, and follow up. "I absolutely believe people can learn listening skills," says Cathy Teal, owner of Firebrand Design.

Even if you have natural abilities as a great listener, you can improve your listening skills by reading on, if only to ascertain where in the listening process you need to work a little harder. In other words, you'll be able to notice when your attention most often fails. That's an important step in strengthening your listening skills.

Those of you who have been told that you aren't good listeners can also learn to develop your active listening skills, a little at a time. Simply recognizing that listening is a process that can be broken down into stages will help you to improve through practice.

You need to know two main points to begin thinking constructively about listening as a skill. First, hearing and listening are not the same. Second, listening is a process with a series of stages.

Experts have been complaining about the decline of the modern attention span, and when you consider the complexity of the stages of listening, you can understand why. Effective listening is a process consisting of five successive stages: hearing, perceiving, focusing attention, evaluating, and responding.

1. *Hearing* is a biological activity, so you don't have much control over it. Sound can come at you when you aren't expecting or processing it. For example, when you meet with a client in a central office where other activities are going on, you may *hear* a lot of background noise (voices, the drone of a fax machine) that interferes with your attempts to *listen* to what your client is saying.

2. *Perceiving* is the stage where you start to make sense of what you've just heard. Your perceptions are influenced by your background and life experiences: your beliefs, attitudes, and values, as well as your mental, physical, and emotional states. For example, you might judge what a person is saying on the basis of his accent or voice pitch without fully listening to the ideas and thoughts he's articulating. Or you are so eager to prove your own merit that you forget to listen. "Some people are so anxious to tell people what they know, they never stop to listen to their clients," observes Phil Opp of Animation Annex.

Even though your perceptions are rapid reactions to what you hear, you should practice being open-minded to the speaker's message. Practicing can change your listening patterns. When attempting to listen actively, these two questions should help you keep on track:

- "What does the speaker know that I don't know?"
- "What will I learn or gain by keeping an open mind?"

3. *Focusing* is dependent upon your individual attention span. Your main listening challenges are: a) to increase the duration of your attention span and b) to enhance your ability to concentrate. Animationist Phil Opp recommends maintaining eye contact to help you focus on what the client is saying.

Your challenge is not to get frustrated or panicked when you lose your focus. That's when you really lose your way and waste time chastising yourself. A good thing to remember is that everyone loses focus. It's human nature to lose your concentration and regain it. Our brains avoid information overload and overstimulation by disengaging, regenerating, and turning back on. (Our television culture may have increased the frequency of the interruptions, but that's another story.) When you catch yourself drifting, just jump in and refocus.

The first way you can begin to help yourself focus better is to try to notice your patterns of shutting down. When do you tune out? Do certain ideas or

interactions trigger the interruptions? How long do you remain tuned out? And are you able to refocus? (That is, do you tune back in and pick up the thread of the conversation or speech or do you fall into frustration, boredom, or fantasy, never to return?) Noticing your listening habits can help you make constructive adjustments. Those habits have been with you for many years, and you didn't form them consciously. Tuning out may have served you well as a child and young adult, but it doesn't serve you as a professional.

In addition to noticing when you tune out (this gets easier the more you try it), you can help yourself to focus by following these strategies:

- Tune out background noise
- Identify the speaker's patterns of thought and key points
- Try to anticipate what will be said next
- Interrupt only for clarification

4. *Evaluating* occurs when you apply your critical thinking skills to assess the speaker's remarks. This stage requires your active participation. For example, you meet with a new client who claims to have ample design experience and listen to him describe his needs. As you are listening, you realize that he actually has little or no design background. This is when you begin to figure out what concepts to define for him, how to offer your explanations to help him save face, and what independent research you need to do to make the project a success. In this stage of listening, you:

- Distinguish between fact and opinion, idea and example, evidence and argument
- Analyze ideas for completeness, relevance, and logic
- Assess the implications for your project and business

5. *Responding.* Finally, you are ready to respond to the speaker with more than requests for clarification. It's good to begin by rephrasing or paraphrasing main ideas and logic to make sure you understand and to let your client listen to his/her thoughts played back. Tell your client you want to double check what's been said. Next, you can begin to address some of the pressing issues that occurred to you as you were evaluating your client's needs, opinions, and grasp of the design process. Phrase your response in positive terms (solutions, problem-solving, etc.).

ORAL COMMUNICATIONS

We decided to address active listening before oral communication because we wanted you to be aware of just what you're up against when you consciously attempt to communicate successfully by phone, at meetings and interviews, or during formal presentations. (Remember, communication is only successful if your

audience "gets the message.") With all of the internal and external distractions getting in the way of the stages of listening—perceiving, focusing, evaluating, and responding—it's a wonder that we can get through to anyone with our oral messages.

While we've included detailed information on sales presentations on page 113, on telephone and voice mail strategies on page 198, and on giving presentations and lectures on page 246, here are some all-purpose guidelines for getting your oral messages across to your audience, no matter what the venue.

1. *Be prepared.* Whether you are calling a gatekeeper, participating in a meeting, going on an interview, or presenting your designs, you'll be better received if you prepare your remarks. Choose your words carefully according to your audience analysis. Keep in mind your purpose—usually to persuade or inform in business communications. Then organize your remarks for greatest impact.

2. *Speak up.* Before your audience can perceive, focus on, and evaluate your message, they have to be able to hear you. From the very beginning of your conversation or presentation, make sure that you are speaking loudly and slowly enough to get through to the listener. But strive to sound natural by varying the pitch of your voice and speed of your delivery. You don't want to mumble or speak in a monotone.

3. *Respond to the feedback.* If the person you are calling says he's busy, ask when you can call back. If people in your audience at a sales presentation are checking their watches or cell phones, make your presentation more interactive to draw them back to you.

4. *Close by letting your listener(s) know what you want.* Do you want to set up an appointment, get a job offer, or make a sale? Ask overtly and offer the information necessary for your listener to follow through.

Chapter 2:
APPLYING DESIGN CONCEPTS TO WRITING

When asked how much writing she does at work, Andrea Costa, art director of marketing at *Time Magazine* reeled off the following list:

- E-mail ("of course")
- Proposals to her clients and boss ("You need to know how to phrase them in a succinct way that has marketing pizzazz.")
- Formal letters
 - Cold-call or first-impression letters
 - Thank-you letters
 - Information-gathering letters for meetings ("You need to come up with a graceful way of saying 'I need it now!'")
 - Letters to the client regarding skills and services ("with an upfront focus on the benefits you can give to the client")

All in all, Costa, like most graphic designers, spends a fair amount of her work time writing business messages, and she works hard at writing "short, direct, and polite" messages.

Business writing is a challenge, but a necessary one in the design workplace. Our hope is that the way we've chosen to present the basic writing concepts in the following sections (comparing them to design concepts) will help to demystify the writing process for you.

You already know more about good business writing than you think you do. As a designer, you're familiar with the processes and principles of creating good design. For instance, you understand the need to navigate the terrain between your design aims and your client's.

Here are some more analogies between good design principles and good writing principles.

DESIGN PRINCIPLE

"The first question to be asked about any design problem is who is it for? This is a question that obviously relates to the nature of the audience. Who are the people in the audience? What do they know? What do they desire? The job is empathizing sufficiently with them in order to shape the message to accommodate their nature. . . . Finally, the question emerges: how can I express that message most forcefully and most appropriately?"

Milton Glaser, Art is Work

BUSINESS WRITING PRINCIPLE

Good business writing is based on the writer's careful identification of the reader's needs, wishes, and expectations. Reader analysis must come first in the writing process because it informs the selection and organization of the content as well as the style and tone of the successfully completed message.

DESIGN PRINCIPLE	BUSINESS WRITING PRINCIPLE
"To design means to plan. The process of design is used to bring order from chaos and randomness. Order is good for readers, who can more easily make sense of an ordered message."	Good business writing is the result of a process and developed in stages: planning, drafting, revising, and editing. All of these stages focus on making the message organized, clear, and logical to the reader.

Alex White, The Elements of Graphic Design

DESIGN PRINCIPLE	BUSINESS WRITING PRINCIPLE
"Use only what is needed to create the intended effect, eliminating any elements that might distract attention from the essence of an idea."	Good writing is concise. It tells all it needs to tell and no more.

Paul Zelanski, Design Principles and Problems

Let's take a closer look at each of these principles, particularly in terms of how they apply to business writing.

Principle 1: ANALYZE YOUR AUDIENCE

We are using the analogy of good design/writing principles to help you understand in your own professional terms how to view good writing objectively. The reason we are presenting good writing principles in this way (on your, our readers', terms) relates to important tenets in both visual and written communication:

- Analyze your reader before creating your message
- Use your reader's needs and expectations to guide you when you create, revise, and edit your message

The information you derive from your own reader analysis should drive your choice of information, development of the message, and its tone. Here are the key questions you should ask when analyzing your reader:

1. *Who will be reading this?* (These questions will help you to write in an appropriate tone and vocabulary.)

- A current client, a prospect, a potential employer, a supplier?
- Will more than one person be reading my message? Is there a gate-keeper who may or may not pass on my message to the decision-maker? Or will this go to various potential investors?
- What is our relationship? Will I be writing to someone on my level, above me, or below me on the ladder? Is my reader a colleague or peer

on my approximate level? A principal, partner, or supervisor? Someone whose work I supervise?

- Are we from the same culture? Do we share the same language, expressions, customs, and values?

2. *What does my reader already know/need to know?* (Figure this out to create a message that is easy to follow.)

- How familiar is she with design terms and processes? To what degree do I need to write nontechnical explanations, comparisons, and summaries?
- Is my subject new to him? Will I have to explain past decisions and contractual conditions?
- Will she need an update? Should I write an introductory paragraph or clause that briefs him on recent occurrences?
- Will he need to be reminded of background information? Is she a busy client or distracted supervisor who needs a tactful reminder about information she might not recall?

3. *What are the benefits of approving, complying, or responding quickly?* (Focus on the reader's needs when you phrase your request or proposal.)

- Better profitability?
- Cost savings?
- Enhanced image?

4. *What objections do I expect?* Some messages contain less-than-welcome news. Anticipating your reader's reactions will help you to formulate your message in an empathic manner. (See page 171 for finessing strategies.)

- Resistance to a routine cost increase?
- Exasperation over a delivery delay?
- Irritation upon learning there's a snag in a current project?

5. *What do I want my reader to do after reading my message?* (Don't expect him to guess the necessary response. Spell it out. Be clear, direct, and specific about your expectations.)

- Do I want her to approve my design or send me additional materials or information?
- Do I want him to acknowledge my message, or review it and send it to another individual or department?
- Do I want her to take immediate action or simply take note and file my message?

Principle 2: BRING ORDER FROM CHAOS

Are the designs you submit for approval to a client generally a rough draft or a spur-of-the-moment idea that you sketched quickly and handed over to your client without refining it? It's doubtful. Likely, you thought about who would be looking at it and how you'd like your viewers to react, mused over its proportions and emphasis, worked with both its positive and negative spaces, and then reviewed and revised your results to improve it. In other words, you took your design through a process of planning, drafting, and revision to maximize its impact according to your intent.

Effective business writing works the same way. A simple sales letter, for instance, takes a lot of work to write well. (Remember it's only a successful communication if the reader takes in the information and reacts as you hoped she would.) Designer Mark Cain agrees. "One of the hardest things to develop is a good business letter," he says. "It can take all day to write a good letter; it's a laborious process. Dump thoughts down, get the flow, and then put in the sales copy." It all begins, of course, with a reader analysis. Following that most important first step are six more stages.

1. *Decide what, if anything, you need to research.* (See page 35 for research strategies.)

2. *Choose your most appropriate writing format.*

- E-mail
- Letter
- Memo
- Proposal
- Report

3. *Begin setting down your thoughts and ideas.* We all have different preferences for the beginning stage of writing. Here are four of the most common ways to quick-start your drafts.

- *Mindmapping.* In this method, you start writing words and phrases from the center of the page, outward. Write related ideas, and details, and connect them in clustered groups. The advantages of clustering are its encouragement of nonlinear thinking and its focus on the visual aspects of the writing process (you can see what ideas are related). It's a good thought-processing method for right-brained creative types.
- *Brainstorming.* This is a method where you don't concern yourself with sentence structure, spelling, grammar, tone, or any of the issues that are best left for the revision and editing stage. Just start listing your thoughts in the order they come to mind. Write fragments of sentences or single words or phrases. Don't edit. Don't delete. Don't rearrange. Don't worry. The idea is to record it all. Keep the ideas coming. You may find

yourself repeating an idea, but just go with it. Later you can decide what items to keep. Give yourself about ten minutes for this activity, and then take a break. When you return to your list, review it, and decide what needs deleting or combining. You'll also be able to add new items.

This method of generating ideas works well when you're feeling stuck or blocked. It's also good when you need to write about a disagreeable business issue, such as a misunderstanding or claim denial. There's something about fast writing and keeping your hand (or keyboard fingers) moving that gets rid of your inner-editor. And that can help you loosen up and get on with your business.

- *Outlining.* Classifying and prioritizing your ideas in an outline is another way to begin your writing. You can be traditional by using Roman and Arabic numerals to denote a hierarchy of ideas. Or, if you prefer, make up your own notations to subordinate some ideas to others. Outlining works well for large-scope writing—reports and proposals—where you need to keep track of many different categories and details. (See page 248 for further discussion of outlining.)

- *Sketching out a preliminary rough draft.* Maybe some of you have no patience with the generative writing activities listed above. You want to start right in with what looks like a facsimile of the finished letter, memo, e-mail, or report, and you won't consider any other option. We have no intention of standing in your way or criticizing a method that works for you. But we need to caution you about two pitfalls that come with the rough draft method.

One is a temptation to view a rough draft as a final draft, especially when you've composed it on your computer and it prints out looking so nice and professional. However, refrain from sending that message out into the world without taking the time to revise and edit it. (Revision and editing are two different activities, described later in this chapter.)

The second pitfall is that it's too easy to press the "send" button on your e-mail system immediately after you've drafted a message. Don't compromise your professional image in writing by sending something you can't take back. Instead, draft your message as a separate document. Then, let it rest while you take a break. After you've had some time away from it, review, revise, edit, and *then* send it—either as an attachment or a cut-and-pasted e-mail message.

4. *Draft your message.* Whether you've started with a cluster of ideas, a brainstormed list, an outline, or a preliminary rough draft, you are ready to translate the ideas, terms, and phrases into a working document. Your goal here is to sort your major ideas into an order that makes sense to your reader. In business writing, that means getting directly to the main point in your first sentence or paragraph. Your introduction should address two points: the reason you are writing and your reader's needs and expectations.

Here are some examples of effective introductory sentences.

- I am applying for the position of Art Director that was posted on your Web site on March 12th.
- Attached is my response to your RFP. . . .
- Enclosed are the roughs for. . . .

In sales writing, Mark Cain notes, "You have about a tenth of a second to capture your reader's attention. Sales writing speaks to 'what's in it for me [the reader]' and 'Why should I?' It's a call to action and persuasive. Tease them, but swing it so they feel 'I need to talk to him.' Develop those sentence structures so you're giving the person a reason to respond." Cain offers this example of an effective sales letter introduction:

I've worked with Con Agra and developed their package line so that their sales are up 13 percent. I know that you are in the same industry, looking for those same types of results.

Once you've drafted an attention-grabbing introduction, pay attention to your other main points and to supporting them with relevant details. Use paragraphs to separate the main points. Most business letters and memos are no more than a page long, although some can be longer than that.

5. *Revise your draft.* Revision refers to re-envisioning what you have drafted in relation to your purpose and reader analysis. When you revise, ask yourself if your draft is accomplishing the goals you set out to fulfill when you sat down to write in the first place. Here are six categories to consider when revising your writing: purpose, organization, conciseness, clarity, layout, and tone.

REVISION CHECKLIST
Revise to focus on your purpose and your reader's needs and expectations.
- ☐ Have you told your reader the purpose of your message in the opening sentence?
- ☐ In an e-mail or memo, have you written a subject phrase that will alert your reader to the topic of your message?
- ☐ Have you given your reader follow-up instructions or suggestions?
- ☐ Have you included a timeframe for following up?
- ☐ Have you included your e-mail, phone, and fax numbers for your reader's convenience?
- ☐ Have you made clear the times of your availability?

Revise for organization.
- ☐ Does your message get to the point right away?

- [] Does the information flow logically from the main point?
- [] Have you grouped related ideas?
- [] Have you used headings and bulleted lists (when appropriate, such as in reports, proposals, directions, or instructions)?
- [] Does your conclusion state next steps and contact information?

Revise for conciseness.
- [] Do you repeat phrases or ideas that can be gathered into one effective sentence or paragraph?
- [] Have you overused the same word(s)? (Find synonyms—other words or phrases that mean the same thing. Use the thesaurus on your word processing program or pick up the book version and keep it handy for varying your language.)

Revise for clarity.
- [] Are there places where your concepts are undeveloped or unclear?
- [] Do you need a concrete example or detail to make a statement more specific?
- [] Do your sentences relate a subject and an action?

Revise for layout.
(This should be a snap for designers, but too often we come across correspondence that has the words crammed together on the top of the page or where all margin definition is lost. Frame your words with blank space the way you might frame your images.)
- [] Have you considered the graphic aspects of your letter or report?
- [] Have you organized your information into paragraphs and/or bulleted your main points for easy reading?
- [] Is the type centered on the page?
- [] When creating margins, have you allowed for sufficient cut-off for a fax?

Revise for tone.
- [] Have you written your message in the appropriate voice for your purpose and reader?
- [] Is it written with the right degree of formality?
- [] Have you avoided slang words and clichéd language?
- [] Have you omitted language that indicates sarcasm and anger from complaints and disputes?
- [] Do you maintain a friendly but business-like voice?

6. *Edit your message.* After all revisions are made, proofread your message to correct grammar, spelling, punctuation, and typos. Don't count on your computer spelling or grammar programs to correct every error you make. Proofreading still needs the human touch. If you feel it's necessary, have someone else check your work before it goes out.

Principle 3: CREATE A HIGH-IMPACT EFFECT

You can probably recognize a well-written business document when you see one, even if you can't exactly pinpoint what you like about it. Upon reflection, you might notice that the logic is easy to follow, that you can locate the information you're looking for, and that it contains all the details you need to know without superfluous information. Good business writing gets the message across clearly, completely, and accurately. Furthermore, it effectively informs or persuades the reader, and it's written in a tone that comes across as professional without being stuffy.

The best writing can be described as:

Specific

Let the reader know the particular purpose of your message up front. Here are sample first sentences:

- We received the drawings and need to know the following information before we can proceed.
- I am responding to the job posting for a Junior Designer that was displayed in the Career Placement Office at the Fashion Institute of Technology on April 20, 2007.
- We are enclosing the rough draft of the annual report for your approval.

Accurate

Proofread your message before you send it out. (Yes, this includes e-mails and text messages!) Make sure that all of your numbers and facts have been double-checked. Review for typos and other careless mistakes.

Complete

All of the necessary information is included. An easy way to check your own writing for completeness is to answer the six journalistic questions (who, what, when, where, why, and how). No matter what kind of business message you are writing, you should always include:

- The date that you wrote the message
- Your contact information
- Whether or not you expect an answer

Well-Organized

The reader should be able to follow your logic. Provide clues by backing up main ideas with supporting statements and details. Start a new paragraph when you introduce a new idea. Set off sections of a report or long message with headings. (See pages 118–120 and 127 for specific advice.)

Concise

Write only what is necessary and no more. Business writing is not long-winded. The challenge is to find a balance between completeness and conciseness.

Appropriate

In order to write appropriate messages, you'll need to rely on your reader analysis. (See pages 14–15.) The answers to your analysis will determine your tone, choice of words, and format.

 Spotlight On
ERIC KARJALUOTO/smashLAB: DESIGNERS MUST WRITE

What does our job require?
I believe that my true job description as a graphic designer would begin with this phrase, "Write and respond to e-mail." That's what I do all day. I send notes to designers, clients, and suppliers, and then I task-manage the fallout from these messages. I send persuasive e-mails, abrupt e-mails, congratulatory e-mails, and friendly e-mails. I e-mail direction to our designers, convey ideas to clients, and often sort out my ideas in written form.

Words are a part of our arsenal
I did not make a conscious choice to write as much as I do. It was something I learned to do out of necessity. When you run a firm, there's never a shortage of situations in which you must write. I spend a large part of my day writing briefs, rationales, proposals, general correspondence, or even copy for one of our projects. I will likely never be a writer, but at very least, I am not afraid of using language as my work demands.

Language = Power
In my mind, designers fall into two categories. The first is a craftsperson, one who utilizes the specific tools of his/her practice with precise skill and enjoys a very highly specialized knowledge of craft. The second type of designer is one that sees her/his role as a communicator and will go to any length to convey a message or idea.

Design is not solely visual. Those who believe it is make an unconscious decision to confine themselves solely to craft. This limits these individuals from growing and taking on more complex and broad challenges.

If we want to be taken seriously, we had best approach all forms of language with the same reverence we bring to visual literacy.

Excerpted from a *Creative Latitude* article

Chapter 3:
UNDERSTANDING BUSINESS WRITING BASICS

The most common types of business writing you'll use as a designer are letters, e-mails, and memos. Since your writing is a reflection of your professionalism, you'll need to know the basic formats and understand when each form is appropriate to use.

LETTERS

No matter how they are delivered (e-mail attachment, fax, or snail mail), letters are an important communication medium in the business world. A signed letter is more formal and considered to be more official than a memo or e-mail message. A letter is still the expected mode that is sent to cover important documents and attachments, such as resumés, contracts, specifications, and proposals.

Frankly, many businesses are careless in the ways they send out direct and other mailings that look almost like letters, but are missing key components like a date or signature. For these reasons, you shouldn't use any old letter that comes in the mail as a model for your own business writing. Rely on the good models in this book, instead.

When it comes to formatting your business letters, the easiest one (and the one we prefer) is a full-block. What this means is that all elements of the letter are flush left. Easy to remember, isn't it? (There's also the block, semi-block, and AMS formats, but why make it harder than it has to be when a full-block works perfectly well.)

Your goal should be to create letters that express your attention to detail, proportion, and layout so you'll represent yourself well in the business world. Otherwise, your clients or potential employers may very well react negatively to your careless writing.

Readers expect to find certain information in the same place in each letter. Omissions or misplacement sends an underlying message of chaotic thinking. Don't make your readers search for information in letters that you've written; they may decide it isn't worth their time or trouble.

Save your originality for artistic projects. Your design work can be unconventional, but your business correspondence can't.

Letters are instantly recognized because of their conventional visual parts, which are laid out on the page in a prescribed way. (See page 27 for a sample letter.) The following list breaks down the parts of a letter in the correct sequence from top to bottom.

- Return Address
- Date
- Inside Address
- Salutation
- Message
- Complimentary Close
- Signature
- Reference Initials
- Enclosure(s)
- Copy Notation

Required Parts of a Letter

Below is an elaboration of each of these business letter components.

Return Address. Your return address or letterhead is positioned directly underneath the top margin or directly above the lower margin and includes your name and/or the name of your business, address, phone number, e-mail address, and Web site address.

Date Line. Without exception, letters must be dated in order to document the sequence of a paper trail and to provide crucial information in case a letter is considered a legally binding document.

Write the date two lines below the letterhead in this order: month, day, and year (February 15, 2007), with a comma between the day and the year. International firms prefer to place the day first, followed by the month, and then the year (15 February 2007) without commas. In any case, do not abbreviate the name of the month; spell it out in full ("February" instead of "Feb.").

Inside Address. Two lines below the date line, (the name and address of the recipient of your letter) is written in the same order you will write on the envelope—the name, title (if any), company (if any), street address, city, state, and ZIP code. Specify the country if the letter is going out of the United States. Single-space and do not use any punctuation at the ends of the lines.

Ms. Angela Berg
Chairperson
Cherry Hill Citizens Committee
402 Society Drive
Cherry Hill, NJ 08003

Write the person's name, instead of just "Chairperson" or "Contracting Officer." You might find the name on previous correspondence or e-mail lists. If not, check the Web site, or call the company or association (be sure to ask for the current name, correct spelling, and title).

You can abbreviate courtesy titles (Ms., Mr., Dr.). Don't abbreviate affiliation titles (Partner, Art Director, Operations Manager), civic or political titles (Chairperson, Senator), or academic titles (Professor, Assistant Professor).

Salutation Line. There's a lot to say about this short line, because it can do much to set the tone for your message. First and foremost, if you misspell or mistake the recipient's name, you've lost your credibility, no matter how well the rest of your letter is written.

Set two lines down from the inside address, the greeting begins with the word "Dear" followed by a courtesy title (Ms., Mr., Dr.); the reader's last name; and ending with a colon (Dear Mr. Garcia:). You'll see commas sometimes, but the preferred punctuation is a colon. If you are on a first-name basis with your reader, there's no harm in writing "Dear Al" or "Dear Tracy."

Don't include a full name in the salutation (Dear Katherine Lee:). This gives your letter the awkward appearance of a mechanical mail-merge rather than the formal but personalized look you are seeking to achieve. We've all gotten heaps of mass mailings in our lives and tend to associate them with trash cans and recycling bins—not the response you want.

However, there is an exception to this rule. When writing to people you don't know who have names that might be male or female, omit the courtesy title and use both first and last names. Your reader is likely to understand that you are writing "Dear Lee O'Connor" or "Dear Terry Arness" to avoid giving offense.

You ought to try to find out the name of the person you are addressing through phone inquiries and Internet research. But let's face it; sometimes you will be told just to send it to the committee chairperson or managing editor, or to an even less specific designation, like the Selections Committee or Human Resources. In that case, do as you have been advised. There may be a change in personnel in the offing or other reasons for addressing a title ("Dear Managing Editor") or a group ("Dear Selections Committee"). You shouldn't, however, use "To Whom It May Concern" or "Dear Sir or Madam," which are the equivalent of writing "Dear Anybody." We can think of one exception to this rule, which is when you are writing a letter of recommendation and giving it to the person to use as she pleases. Because you can't know who will receive it, you should keep your salutation nonspecific.

Message. Letters don't have a prescribed length, although most are no more than one page. If what you need to say takes only a few lines, then, by all means, the body of your letter should be a few lines long. (In that case, be sure to center the letter on the page so that it doesn't look top-heavy.) If you have much to say, then your letter may be three or more paragraphs, and possibly be written on two pages. We discuss style and tone later in this chapter, but here are a few strategies to remember while you write.

- Keep your message simple and direct.
- Organize the information so your reader doesn't have to hunt for details.
 - State your purpose for writing in the first sentence. Include an important or persuasive detail in the first paragraph.

- The subsequent paragraphs support your main message with facts and examples.
- The last paragraph contains directions/information for follow-up.
- Double space between each paragraph.
- Revise your writing before you send it.
- Proofread for misspellings, grammatical mistakes, and graphic aspects.

Complimentary Close. Skip two spaces beneath the body of your letter. Only the first word is capitalized. Place a comma at the end of the complimentary close. Traditional examples are: "Best," "Best wishes," "Best regards," "Regards," "Sincerely," "Sincerely yours," "Cordially," "Cordially yours," "Respectfully," and "Respectfully yours."

You have some room for choosing a complimentary close that fits with your style and your relationship with your reader.

Signature. Type your name four spaces beneath the complimentary close. The quadruple space gives you enough room to sign your name (in ink).

If your name is used by both males and females (Pat, Alex) or if you go by initials (B. J. Worth), you may use a courtesy title (Ms. B. J. Worth or Mr. Alex Conroy). This lets your reader know how to address you in return.

Your business or professional title may be placed either on the same line as your name, separated by a comma, or directly below your name without a comma.

Optional Parts of a Letter

Use the following parts for appropriate situations.

Reference Initials. If one person has dictated a letter and another has transcribed it, use reference initials (two spaces beneath signature). The dictator's initials come first in caps, and the transcriber's are written in the lower case (JC/at or JC:at).

Enclosure(s) Line. When you are using a letter to cover one or more other documents, note the name(s) at the bottom of your memo in an enclosure line (Enclosure: Resumé or Enclosure: Contract).

Copy Reference. At the bottom of the page, note the names of the person or people receiving a copy of your letter. You might copy your attorney to make her aware of a claim you are mailing, for instance (cc: Sonia Chavez, Attorney).

Sometimes you will want to send a blind copy, meaning you send a copy to someone but do not wish your reader to know this. In such a case, no notice is made, but you will make that notation on your own copy. (For example, your copy will include bcc: Ray Johnston.)

November 7, 2005

Dennis Mario
Help U Hear Hearing Aid Centers
180 Luring Drive, Suite 200
Palm Springs, California 92262

Dear Mr. Mario:

I bring to HUH? over 20 years of design, production and management experience. From 1986 to 2002 in Los Angeles, I was the sole proprietor of a successful design firm with 8 employees prior to relocating in Palm Springs.

As President and Creative Director of my own design firm, I supervised and managed the design and production of marketing communications, advertising, collateral, and signage projects for our diverse client base. I bring projects in on time, within budget and deliver a quality product. I am qualified and eager to meet the needs of the Help U Hear Hearing Aid Centers.

Thank you for your time and consideration.

Sincerely,

Cathy E. Teal

Cathy E. Teal
Firebrand Design

2103 North Milben Circle, Palm Springs, California 92262 V.760.327-7026 F.760.327.1155 C.323.252.8031
cathy@firebrand-design.com • www.firebrand-design.com

Business letter in full block letter format

E-MAILS

E-mail's efficiency makes it a favored mode for business communication in many situations. "It cuts down on waiting time," one designer puts it. "I'll be working on a project and need a quick question answered before I can proceed. I don't have to wait to catch my client in or messenger my roughs and then wait for a response."

E-mail also enhances convenience, giving you a chance to respond to your mail when you have the time. In addition, it helps make international correspondence quicker and easier, allowing for differences in time and work schedules.

Because e-mail is convenient, quick, and familiar as a means of communication, you will sometimes be tempted to send off a message without giving it enough thought. Don't make this mistake. You still need to follow all the stages of business writing practices before you send e-mail.

While your friends and family members are likely to overlook your spelling or grammar errors and be entertained by your stream-of-consciousness writing, don't expect your business associates to be so forgiving. Like other business correspondence, good business e-mail must be concise, well-organized, accurate, and appropriate.

Here are some issues on which to check yourself when creating e-mails for business:

Review Your E-mail Address

Remember that your e-mail name shows up on your recipient's e-mail summary page in the "From" column. So be sure you have a professional (and easily identifiable) e-mail name as part of your address. Otherwise your message might not be retrieved. Or respected—too many recent college graduates retain the whimsical or—shall we say—silly names they created back in junior high or grade school. A name like *hotpants@catskill.net* or *spiderboy@spudcity.net* or *teddybear@earthcom.net* just won't get you respect in the design business. In fact, it may be viewed as junk mail and discarded unopened. If you can't bear to abandon your old e-mail name, then open a new account with a name that reflects your professional persona, and keep one for business and one for personal e-mail correspondence.

Fill in the Subject Line of Your E-mail

Use a phrase that best describes the topic of your message (for example, "Timetable for the Palmieri Project" or "Request for a Recommendation from Jennifer Chow" or "Agenda for Meeting on June 16th"). If you leave this line blank, your message might go unread. Recipients scan the subject line to decide whether to read a message immediately, save it for later, or, if there is no recognizable subject line, discard it without reading.

Use Appropriate Salutations and Closings

Use the standard letter salutation and a formal closing when your e-mail is going to someone outside of your agency or a person you don't know well.

Dear Mr. Gomez:	Dear Sarah:
Best wishes,	Regards,

For in-house e-mail, you don't really need the salutation or closing because the "To" and "From" are automatically included in an e-mail document. This means that it reads on the screen (and prints out) like a memo. However, many people feel more comfortable starting their message with a first name and ending it with their own name or some informal closing.

Arlene,	Hi Kathy,
Best,	Hope all is well,

Program Your Signature Block

Provide your address and other contact information. This information will automatically appear at the bottom of your e-mail messages.

Vicky Tan, Art Director	Name and Title
Beauty Queen Magazine	Department or Division
ALLPrint	Company Name
P.O. Box 333	
Northampton, MA	Mailing Address
Phone 800-738-7777	Phone Number
Fax 800-738-3463	Fax Number
www.beautyqueenmag.com	Web Address (URL)

Place E-Mail Responses at the Top of the Window

If you are responding to someone else's e-mail, place your answer at the top (beginning) of the window. That way, your reader doesn't have to scroll down to the end of the original message to find your reply.

Be as Brief as Possible

Break the text into paragraphs when possible so that your reader doesn't have to read long blocks of text on the computer screen.

- If your message is much longer than the length of the screen, consider sending it as an attachment along with a brief e-mail message of introduction.
- If your message includes multiple questions or topics, break them down into multiple e-mails (no more than two questions or topics each).

Keep Your Design Simple

Limit your variation of color, font, and line spacing. If your message format is important (and includes headings, bulleted and numbered lists, or tables), consider sending your document as an attachment, but don't assume that it will transmit as sent. First, check that your recipient has adequate hardware and compatible software to view and save the attachment.

Realize Attachments Are Not Foolproof

Avoid sending memory-hungry attachments that bog down your recipient's computer, unless you have checked in advance on its speed and capability.

MEMOS

When you write a message to others within your agency or organization, you are likely to use a memo (short for memorandum) format. Memos are used often and regularly for internal communications, such as progress reports, policy announcements, and project management.

Although memos are traditionally internal documents (used within agencies), we've noticed that among graphic designers, the memo format is used for some external communications as well. For example, the sample memo on page 31 was sent by Don Rigole to a potential client. It underscored a casual approach that meshed with the client's style.

If you are writing to more formal and traditional clients, Fortune 500 or international companies, for instance, you should use a business letter format to match your reader's preferred style and tone.

A memo has fewer parts than a business letter and is often less than a page in length. Note that there is no salutation or complimentary close in a memo. Its design is fairly standard in that it begins with a modified company letterhead or logo, followed by the parts of a memo, which are all flush to the left margin. Also aligned against the left margin are the standard headings: TO, FROM, DATE, and SUBJECT. You sign or initial your memo by your name on the FROM line.

Required Parts of a Memo

Always include the following information in a memo.

The "TO" Line. Type your reader's name and, when appropriate, a title (TO: Randa Gold, Production Editor). Sometimes, you might include several names on this line (TO: Carlos Gonzalez, Jan Tobin, and Melinda Speros). Instead of addressing a list of names, you might simply write to a committee or project team (TO: The Allendale Project Team).

The "FROM" Line. Type your name and, when appropriate, your title. The only way you sign a memo is by handwriting your signature (or initials) next to your name in ink.

620 NORTH 7TH AVENUE
TUCSON ARIZONA 85705
E.MAIL don@regole.com
VISIT www.regole.com
FACSIMILE 520.624.9760

18 March 2005

TO: Jim McVeigh / CANYON RANCH

FR: Don Regole / REGOLE DESIGN

RE: **PROPOSAL FOR GRAPHIC DESIGN SERVICES (5 pages)**
 CANYON RANCH SALES MATERIALS
 BROCHURES FOR TUCSON and LENOX

Thank you for the opportunity to submit this proposal for creative services. After our meeting, and upon further review of your existing materials, we are confident that Regole Design can collaborate with your marketing & sales staff and develop effective marketing materials essential to reaching the goals and objectives of CANYON RANCH.

The following is an overview of our understanding of the project along with a range of associated costs for creative development, production, and delivery.

We would be happy to discuss any aspect of the proposal with you.

520.624.9577

Standard memo format

31

The "DATE" Line. This information gives you and your reader a record of the date you wrote the memo. (Remember—all business writing should be dated.) Business people often use memos to track and document the progress of jobs and projects, so accurate records of the date an action was ordered or reported can be crucial.

The "SUBJECT" Line. Write a phrase (not a full sentence) that tells the reader the topic of your memo. It's important to create a subject phrase that is specific and yet brief. Just as they do with e-mail, business people are accustomed to glancing at the SUBJECT lines of the numerous memos they receive daily to decide which ones to read first, which to save for later, and which to file for possible future reference. Some examples of effective subject lines are: "Schedule for the PRB Annual Report," "Important Change in Employee Medical Coverage," and "Progress Report on the Elite Foods Web Site."

The Message. The same planning, drafting, and editing process that you should use for all of your business writing will work for you in memo writing.

- Plan your message with your reader and purpose in mind.
- Organize your thoughts so that you make your main point in your introduction.
- Try to fit your message onto one page.
- Use headings and bulleted or numbered lists for easy readability.
 - Use numbers when alluding to a sequenced or prioritized list.
 - Use bullets when all or most of the list items carry the same weight.
- Conclude your memo with follow-up requests, instructions, and your contact information. If you memo is not printed on letterhead stationery that includes individual telephone extensions or e-mail addresses, write your contact information to help your reader get back in touch with you.

Optional Parts of a Memo

Include these components, when appropriate.

Enclosure(s) Line. When you are using a memo as a cover for one or more other documents, note the name(s) at the bottom of your memo in an enclosure line (Enclosure: Specifications for Wang Job).

Copy Line. At the bottom of the page, note the names of the people receiving a copy of your memo. These are not the other people to whom your memo is addressed on the "TO" line, but rather people who need to be kept informed that you sent the memo. For instance, you might copy your supervisor to make her aware of your team's progress.

FAXES

The word fax stands for facsimile transmission, which refers to the method of sending a replica or reproduction of an original document or design. You can fax documents such as letters, memos, resumés, proposals, or contracts.

Faxes are preferred over snail-mail when speed is required. Faxes are preferred over e-mail when the document or design you are sending requires signatures that indicate approval and/or ensure authenticity. (If original signatures are needed for contracts, deeds, or other legally binding documents—often requiring the use of blue ink to demonstrate originality—snail-mail or messenger service should be used, possibly in conjunction with faxes.)

Call First if Your Message is Confidential and/or Time Sensitive

Since offices often use one central fax machine, confidentiality should be a major concern whenever you send or receive a fax. If you are sending a confidential document, you don't want it lying around or spilling all over the floor in front of the fax machine for everyone to see. Call your recipient beforehand to be sure she or a trusted designee can be available to retrieve the fax immediately after it is sent. By the same token, if you are expecting a fax, make it clear that you expect the sender to call you first to ensure that you can collect it right away.

Establishing a "call first" procedure (without phone contact, don't send) will help with another potential office snafu. You are using the fax because you don't want to wait for the post office or messenger service to deliver. But if you aren't alerted to the impending fax, someone else might retrieve it and drop it in your mailbox or (perish the thought) inner-office mail, where it will languish for far too long.

Fax Design

The design of your fax will follow those of whatever document (letter, memo, resumé, etc.) or design you intend to transmit. But since you might not know for sure the capabilities or quality of the fax printer your recipient will be using, we do suggest a couple of precautions to take about margin and color selection.

Margins. Use one-inch margins on the top and bottom and both sides to prevent the cutting off or blurring of your document or design edges. We've seen resumé names and contact information lost in transmission. Also at risk are company phone numbers and addresses that are printed at the very bottom of the stationery. Your document or design may look great when you're holding it in your hands before you send it; just be sure it has an inch margin of safety.

Color. Our second point refers to your color choices, as they too depend on the recipient's fax capabilities and quality. Check beforehand to see if your recipient has a color fax printer. If not, make a black and white copy of your color document or design before you fax it in order to see for yourself what it will look like

on the other end. Then make a color adjustment (or a black and white fax version) that shows off your document or design to its best advantage.

Even if your recipient does have a color fax printer, be sure your colors are designed to transmit for legibility. Check for sufficient contrast between your colors and a white background. Most fax machines are loaded with white or off-white paper. Be aware that light colors that look wonderful on your original document might wash out and become illegible on the faxed version.

Chapter 4:
BUILDING UP YOUR RESEARCH SKILLS

Research contributes to the quality and richness of the messages you send: written, oral, and nonverbal. Your research will help you impress clients by demonstrating your familiarity with their industries and businesses. It will make you stand out with potential employers when you interview for a position. It will deepen your understanding of your own profession too. And it will save you time and money in the long run. "The last thing I want to do is to spend a whole lot of time traveling to see someone only to find out this project isn't what I want or need," notes designer Mark Cain.

Developing your research skills is critical to the success of your career, whether you own your agency, freelance, or even if you work for a firm that has a research department. If you want to compete on a high level, you'll need to do some or all of your own research.

And you'll need to do it well. Anyone can type in a word or phrase on a search engine and make do with the results. But if that's the extent of your research, you'll wind up presenting the same information as everyone else at your sales presentation or job interview. That's no way to stand out from the crowd. You want to know how to access superior information that provides the basis for superior presentations, right?

THE STAGES OF RESEARCH
The research process is made up of six stages: 1) planning, 2) source identification, 3) assessment, 4) note taking, 5) record keeping, and 6) making sense of your data.

1. Plan Your Research
Drive your research instead of letting it drive you by doing some initial preparation. Otherwise, you'll find yourself mired in a scenario that goes like this: You look up a topic on the Internet and follow some of the major links until you come up with a collection of data that seems less and less related to your search. As you go further and further into those links, you lose track of what you were looking for in the first place. Maybe, you conclude, you weren't focused enough at the beginning of your search.

Yes, it's true. Research can take you on a long, circuitous journey, where the agendas and opinions of the writers you are reading are likely to distract you from your own quest. One way to stay focused is to begin by doing some brainstorming. Take five minutes or so to jot down the questions you need answered.

Make a list, and refer to it while you are conducting your research, adding to it and modifying it when necessary. By writing your questions instead of trying to store them in your head, you'll free up your mind for critical thinking and interpretation of data. This tip is an invaluable one for keeping yourself on track.

2. Identify Your Potential Sources

Now that you have the questions in hand, you are ready to start thinking about the best places to find your answers. The ease with which you can retrieve information by surfing the Internet makes it tempting to use the Internet exclusively as the source for all of your information. Don't.

Relying only on the Internet means you'll miss out on a diversity of material that can enhance your work and your relationship with clients. On the following pages, we'll suggest many places to find information. Once you know about these possibilities and take advantage of them, you'll be able to conduct research that yields diverse points of view and many levels of information.

Basically, you need to know that there are two kinds of research:

- Primary (information you capture on your own)
- Secondary (information someone else has collected and written up)

Because primary research strategies and skills are more advanced, they are covered at length on pages 166–170. For now, we'll assume you're new to research, and are more likely to go with secondary sources.

Secondary research is the "prepackaged" kind—information that is already written on the Internet and in annual reports, newsletters, and other promotional literature. Articles and essays in trade journals, newspapers, and books belong to this category as well. This information is readily available in the library, at bookstores or in publishers' catalogues, through subscriptions, and on the Web.

3. Vet Your Sources

Get into the habit of assessing the accuracy and credibility of every source you find during your research. For example, be aware of the agendas (purpose and mission) of book authors and journalists. Also keep in mind that a major purpose of annual reports is to assure stockholders that their investments are sound. Even the most well-meaning report writers are likely to put a spin on their data. You will come across as naïve or careless if you mindlessly repeat catchphrases you've read in annual reports or other company promotional materials. Be a critical reader of research literature by not taking everything you find at face value.

4. Take Notes for Your Files

There is no best practice for choosing record-keeping materials. Some people prefer index cards. Others use notebooks or notepaper. Still others enter rough notes into word processing files. The important thing is to develop a consistent

format for entering the information. Design it in such a way that you know where to find the same information on each card, page, or file. Write down:

- *When* you found the information
- *Where* you accessed the information
- Relevant statistics, names, ideas, and terminology
- Quotations plus the person's name, title, and/or affiliation.
 Use direct quotations:
 - If the statement is written in a memorable or unique way
 - If the person you are quoting is famous and/or an authority in the field, one who would lend validity to your subsequent proposal, presentation, or brief

You'll probably be generating your own ideas as you are processing your research, so be sure to record them—whenever they come to you. We've all had great ideas that were lost to forgetfulness because we neglected to write them down. You can keep a running journal or create a separate notebook or file sheets for each project or client. Date your entries. And, while you're at it, make a note about what article, statistic, report, etc., triggered your idea. That way, when you get to the edge of your initial idea, you might be able to expand upon it by returning to the source.

5. Keep a Record of Your Sources

Speaking of sources, don't forget to write down the publication information about your researched information. (This is not the same as what we mentioned above—when and where you accessed the information.) This rule is so important, we gave it its own heading.

First of all, no one expects you to have come up with all the answers on your own. In fact, when you make it clear that you've done your due diligence through research, you come across as more credible and your proposals and presentations gain extra authority. Besides, you need to give credit where credit is due (avoid plagiarism). Someone worked on that article, Web site, or index and deserves recognition for that work. As a creative person yourself, you should be able to buy into that principle.

Second, the writers of those articles, Web sites, or indexes might have imposed their own interpretations or biases on the findings you're citing. Or your client might simply disagree with a claim you just made. It's very hard to defend something you haven't researched or written yourself. Imagine this scenario: you're spouting off statistics to your client when your client says, "That sounds bogus. Where'd you hear that?"

Do you really want to have to respond, "I'm not sure" or "I don't remember"? How much better to respond, "I'll check my files and get back to you."

And do get back to the client with the source information. Who knows? You were probably citing the most current information, which would impress your client.

Therefore, for your own records, you should record:

- The title of the book, Web site, or article (and the journal that published the article)
- The name of the publisher or host
- The date and place of publication (if a Web site has no date, at least you will have the date you accessed it)

6. Make Meaning of Your Data

Now that you have all of your notes and documentation, go back and review your notes, printouts, and photocopies. Compare the information you have found with the questions you initially asked. Remember that "information is not knowledge," as designer Mirko Ilić points out. Turn your information into knowledge by working the data. You can delve deeper by asking yourself:

- Have my original questions been answered?
- What new questions have cropped up in my research?
- What surprising or unexpected information have I found?
- What significant themes and points run through my findings?
- How can I present my findings most effectively?

Now that we've talked about the stages of research, let's discuss the major secondary sources you'll want to access. We're also providing numerous tips to save you time and frustration.

LIBRARIES

Take advantage of your public library, and don't overlook the help you can get from the reference librarians. You'll likely find them sitting behind a desk in an area marked "Reference" that has shelves of resources you can't retrieve without their assistance. They'll also show you how to go through the library's catalogues, indexes, and databases to find what you're looking for.

Libraries also subscribe to specialized collections available online, and the librarians can show you how to access these collections. Even if your local library doesn't have all of the magazines, journals, books, or reports you need, they might be able to request them through inter-library loans from another collection.

Check also on the possibility of gaining access to the libraries of your local colleges. Choose a college that has programs in the industry you're trying to investigate, and you'll find a wealth of material hand-picked for the students. This is an ideal situation for you because you are learning about the industry, too.

If you're a graduate of the college, you should have no problem getting privileges. Even if you aren't a grad, you should be able to gain access for "read-only" purposes, which means you can review and copy materials in the library, but you can't take them out on loan.

BOOKSTORES AND PUBLISHERS

When you decide to specialize in designing for particular industries, you'll want to purchase some of their industry books and journals to keep on hand as references. This is a business expense that will yield high returns. Look for these materials in the following places.

Web-based bookstores have their own user-friendly databases that you can search through. Because they draw from a vast number of catalogues, their holdings consist of many different categories. They are likely to have the most up-to-date holdings as well.

College bookstores have textbooks that present and illustrate the basics of any industry represented through their academic programs. They also carry textbooks for advanced courses. If you drop by after a semester has ended, it's likely you'll be able to purchase a second-hand book at a discounted price. While you're there, check the periodical section for the latest journal issues. If you find a journal that addresses your needs and interests, consider taking out a subscription.

While you're looking through the books, note the names of their publishers and then check the bibliographies in the back of the books for other publishers who are cited repeatedly. You'll probably find one or two publishing houses with several books about the industry you're studying. That's because some publishing houses have specialized catalogues (the way Allworth specializes in books for design professionals). Jot down their Web sites, too, and you can browse through entire catalogues later on to see if they carry books suited to your needs.

THE INTERNET

We know that you've been using the Internet for years. Still, you might find the following discussion helpful.

Useful Web Sites for Market Research

To research clients or potential employers, their businesses, and markets, some of the best sources for online market research and general company information are:

- *www.adage.com*—gives demographics and the latest news on businesses and their industries
- *www.adweek.com*—offers regional news and accounts in review; requires subscription for archived articles (check with your library)
- *www.bigbook.com*—good for locating businesses and their competitors within a geographical area
- *www.hoovers.com*—gives company overviews, histories, and products, as well as industry data, competitors, and news
- *www.marketingpower.com*—the American Marketing Association provides useful practices, articles, marketing terms, and more

Search Engines and RSS

Search engine software takes a key word or phrase that you enter in the search box and reviews numerous sites on the Internet; it then returns to you a list of information that most closely matches your search request. There are many search engines, and it is tempting to use a favorite and stick with it. Nevertheless, you'll increase your chances of getting the best and most specific information if you use several search engines in your research.

Start out by retrieving a general list first, but then try refining your searches. For instance, checking off "news" on the top of the screen will give you a listing of the latest news on your topic with dates and sources.

Following are some useful search engines to help you widen your search beyond Ask, Google, HotBot, Infoseek, Lycos, Netcenter, Safari RSS, Web-Crawler, and Yahoo.

- All-in-one (*www.allonesearch.com*)—accesses numerous search engines for you
- Alta Vista (*www.altavista.com*)—multilingual search and translation capabilities, international searches
- Inform (*www.inform.com*)—a single search term will yield articles on related terms and topics even if the original term is not mentioned in those articles
- Dr. Webster's Big Page of Search Engines (*www.thefreesite.com*)

Search Strategies

Be specific and accurate in your choice of words to avoid information overload and get the best results from your search. Otherwise, you'll be overwhelmed by the size of the list you receive. For example, in response to the initial entry "cosmetic industry," Alta Vista turned up 8,760,000 listings, and Google returned 21,100,000 entries. The returns offered everything from beauty supply sites for consumers to articles for industry insiders—too general for time-strapped researchers to browse through. Here are some guidelines to customize your searches.

- Use key search words and phrases to limit your search. You can use your initial hits to help you limit and refine a more advanced search. For instance, a quick review of the listings for "cosmetics industry" in Google showed different markets within the industry.
- Use synonyms. If your initial search doesn't yield the results you wanted, try using other words that have the same or similar definitions as the words you first entered. Access the thesaurus on your word processing program or look up the initial word in the dictionary to find synonyms.
- Use quotation marks around your key phrases. The search engine will search for the entire phrase if it is enclosed in quotation marks. Otherwise you'll get responses to single words in the phrase.

Evaluating a Web Site for Credibility

How can you tell if the information you find on a Web site is factual? Here are some strategies that will help you judge accordingly.

Consider the Source

Check the ending of the URL to find out about the site's publisher or sponsor and judge accordingly.

- *.com* indicates a commercial or business publication. While you're used to looking at the graphic aspects of a Web site, we suggest reviewing its message and reader focus so you get a sense of its present marketing strategies. Look for what is emphasized, and think about what is left out. Visit the Web sites of competing businesses, too.

- *.edu* means that the site is sponsored by an educational institution. Use these sites to find out about industry history, current research, and terminology. (A note of caution: It isn't difficult for students and college staff to create Web sites through a university sponsor, although the host university may not have vetted these sites for accuracy. You can recognize an individual or personal Web site by the tilde sign ~ in the URL.)

- *.gov* shows a government-sponsored site. These are useful sites for statistics, listings by region, and industry information.

- *.org* indicates that the site is published by an organization or association. Use these sites to enrich your industry-specific language, terms, and concepts, as well as to familiarize yourself with the issues and concerns of industry insiders.

Look for a Date

Beware of Web sites that omit dates. If a Web site does not include the date it was created or revised, you will not be able to determine whether the information is current. (Some Web sites leave out the date for this very reason—to obscure the fact that they don't update their sites.) Since you are using your research to inform yourself and enrich your proposals, presentations, and briefs, be sure that the information you cite is reliable and timely.

Review the Contact Information

The inclusion of contact information means someone has been given the responsibility for maintaining the Web site and shows a good-faith effort.

Check to see if there is a name and e-mail address for feedback and questions. A title and department are even better. True, the contact information might be defunct, but the only way to know that is to try to make contact and see if you get a response.

Review the Quality of the Writing

We know you aren't the grammar police, but be aware that numerous typos or errors in grammar and spelling indicate careless work standards overall. If the Web site writers haven't paid attention to their use of standard English, it's likely they haven't paid scrupulous attention to correctness of information either. Where there's smoke, there could be fire.

Analyze the Content of the Writing

After considering all of the factors listed above, you still need to make a certain judgment about the information offered by a Web site. Here are some questions to ask.

- Who is the designated audience (industry insiders or potential customers/clients)?
- What is the purpose of the site (to entertain, inform, persuade, or sell)?
- Is there an apparent bias to the site? (Are the opinions of the Web site writer apparent? Does the purpose of the site lead to the omission of certain facts and an emphasis on other information?)

PART II. LAUNCHING YOUR CAREER

After you graduate from design school, you're typically faced with two choices of employment: work for someone else or work for yourself. Whichever path you choose, you will be relying heavily on writing and presenting skills if you expect to succeed.

Spotlight On
ANDREA COSTA/TIME MAGAZINE:
ADVICE TO DESIGNERS JUST STARTING OUT

I've worked as an art director for fifteen years and owned my own firm before that. When I started my firm, all of my clients' names began with the letter "A" because I used the phone directory to make my cold calls. Then I started to do research and began selling because I chose the best jobs for myself.

So, one of the first pieces of advice I could give to a designer who is just starting out in the business is this: Hone your research skills when you're looking for a job. That's the only way to get an overview of your options instead of relying on random bits of information. Then you'll wind up with a job you like and clients you prefer. Research time is quality time. To mesh job opportunities with your personal and professional goals, ask yourself:

- What do I want?
- What am I after?
- What am I trying to achieve?
- What will make me happy?
- What are my best qualities?

My second piece of advice is to pay attention to your writing, especially when writing e-mails. When you use shortcuts, you give the reader a prejudice against you that is perhaps untrue. For instance, instant message language makes you seem immature; it's "kid language"—not at all the image you should be projecting. Also check your grammar, sentence structure, and mechanics. When you write in run-ons, in stream of consciousness, it seems like you have disrespect for the reader. Your reader shouldn't have to sort out the message for herself and make sense out of it; that's your job as the writer.

Chapter 5:
LOOK *BEFORE* YOU LEAP

If you're reading this section, you've probably decided the pros of working for someone else (at least starting out), outweigh the cons. Degree in hand, you're ready for the "real" world.

Ideally, you're reading this book *before* graduation so you'll know how to launch your career once school ends. And you still have time to line up internships (also known as on-the-job training or practicum) so you'll be able to include real-world working experience on your resume. Another career tip is to make time to be involved in campus chapters of professional organizations.

Too little time left for taking the above advice? Here's a resumé-builder you can probably manage to sandwich in your schedule. Find two or three places that can utilize your skills for free (nonprofits or volunteer-based operations are usually good choices). What do you get out of it? Great samples for your portfolio, that's what. Real-world experience generally trumps school-related projects (unless, of course, you're a winner in campus-wide competitions). Another back-door way in is to get some work experience, even if it's only over the summer or on a part-time basis, at a printer's. That way you immediately communicate to an employer that you've learned things they never teach you in school.

Whether you are still in school or you've already graduated, let's assume you're *extremely* motivated to do the groundwork necessary to land a job you'll love. But wait. Before you rush off to print hundreds of resumes, it's best to begin with some mulling time—or *creative introspection,* if you prefer a fancier term.

WHAT'S YOUR BOTTOM LINE?
If you begin your job search with some notion of your own bottom line, you save time as well as make a wiser match when it comes to ferreting out the right design position for you. Thinking about your bottom line first makes you less likely to fall prey to desperation moves.

Start with Some Soul-Searching
Ask yourself this simple question: *Where* do I want to live and work? Geography plays a more important role in our lives than we often realize. Will you . . .

- Stay in the city or town where you graduated?
- Move back in with your parents or a relative until a job comes up in that zip code . . . or as far from that area as it's humanly possible to get?

- Move off with your college friends and keep your fingers crossed that once you're relocated, a job will materialize?
- Allow your significant other's or spouse's job to determine where you'll take up residence?
- Ditch life in the slow lane for the allure of the fast lane . . . or vice versa?
- Move to Timbuktu or Kalamazoo as long as *somebody* offers you a steady paycheck and a chance to make your mark?

As a general rule, it's best to sort out the answer to the geography question *before* you launch your job search. Once you've narrowed down a territory (or two) where you'd prefer to live, you're ready to tackle one more bit of self-reflection.

Dreaming Up Your Dream Job

Now that you've determined your geographic sphere, it's equally useful to spend some time reflecting on what your dream job might look like. Here are some questions for you to think about:

- What size firm will suit you better, large or small?
- Other than design, what "additional duties" are you willing to perform?
- When it comes to the company's "culture," what are you looking for? The hottest or fastest-rising firm? One with an awesome client list? Or is a more informal, laid-back style crucial to your happiness?
- Are you willing to work in excess of sixty hours a week? Eighty? Weekends?
- How much on-the-job pressure can you realistically handle?
- Other than salary, what other perks or benefits are definite dealmakers for you?
- How much commute time can you realistically commit to?
- Are you agreeable to working for low pay (or no pay) if the experience and exposure will prove valuable?
- Do you feel burned out or fed up in your current position?
- Are you itching to move up . . . or on?

RESEARCHING THE MARKETPLACE

Before you initiate the actual application process, you need to know what's out there in your field. As a basic starting point, check out *www.bls.gov*, the Web site for the U. S. Department of Labor, Bureau of Labor Statistics. Here are some factoids that may surprise you about the profession you're entering:

Graphic designers held about 228,000 jobs in 2004. About 7 out of 10 were wage and salary designers . . . About 3 out of 10 designers were self-employed. Many did freelance work—full time or part time—in addition to holding a salaried job in design or in another occupation.

Okay, how about the really important thing, M-O-N-E-Y? What light does the Bureau of Labor Statistics have to shed on this important topic? (Their figures are based on the American Institute of Graphic Arts 2005 study.)

Entry-level designers earned a median salary of $32,000 in 2005, while staff-level graphic designers earned $42,500. Senior designers, who may supervise junior staff or have some decision-making authority that reflects their knowledge of graphic design, earned $56,000. Solo designers, who freelanced or worked under contract to another company, reported median earnings of $60,000.

Keep in mind these figures depend greatly on many factors, such as the economy, geographic location, skill level, and, sometimes, just plain old luck. If you're a soon-to-be graduate or a degree holder who is still near campus, a good place to dig deeper and inform yourself about your options is by visiting the college career center. Many offer services that will help you prepare your resume, brush up on your interviewing skills, or search job postings. Often you'll find these services are free or available for a nominal fee.

By the way, if you're interested in moving from one position to another, it never hurts to ask if these same placement services are available to former graduates as well.

Having stuck your toe in the job waters, next you'll probably go online to read job postings. Some common sites for design majors are:

- Monster (*www.monster.com*)
- Craig's List (*www.craigslist.com*)
- AIGA (*www.aiga.com*)
- Graphic Arts Guild (*www.gag.org*)
- Ispot (*www.theispot.com*)
- All Graphic Design (*www.allgraphicdesign.com*)
- Communication Arts (*www.commarts.com*)
- Art Director's Club (*www.adcglobal.org*)

Design periodicals also contain a wealth of information to aid you in tracking down job postings. Make a date on your calendar to regularly review publications you already receive and/or visit the library to read the most recent issues or online versions. Browse through the following:

- *The Graphic Artist's Guild Directory of Illustration*
- *Creative Black Book*
- *American Illustration Showcase*
- *The Society of Illustrators*
- *The Alternative Pick*

A fourth stop on your job search is your local public library, which contains a wealth of information. Libraries often carry newspapers from major cities or can direct you to other resources (such as professional directories, associations, trade journals, or phone books). If your research skills are shaky or nonexistent, spend an hour with a reference librarian, who can help walk you through computerized searches.

Another place for job-hunters is a visit to often-overlooked branches of the regional, state, or federal employment office. Working with the employment specialists at these places entitles you to access specialized databases, plus get other benefits, such as free use of computers, phones, fax machines and copiers. Some will even provide on-site interview rooms or allow you to use designated office space while conducting your job search. Typically, they also have a slew of books and videotapes on resumé preparation, interviewing, and other career-related issues; in some cases, these are digitized so you can have access around the clock.

At the "research" stage of your job search, you're looking to inform yourself about what positions are out there that you might qualify for, what skills and abilities employers are looking for, and what the going rate of pay is. Make note of key words or phrases that crop up in ads, and jot down unfamiliar terms or job titles to look up later. Surf the Web sites of prospective employers, taking note of recent press releases, awards, or client lists.

While you're at the library or career center, you can look up and make copies of other designers' resumés. Studying them can help you to identify words, phrases, or terms that you can legitimately apply when you describe your own qualifications.

NETWORK YOUR WAY IN

Once you've completed your preliminary investigations about the design job market in general, you're ready to narrow your focus to those jobs that you want to go after. If you think that means your next step is to scour the newspaper want ads or search online, we've got a surprise for you: Reading the want ads is *not* an effective means of surfacing job leads! Sad but true, experts estimate that only about 10 percent of jobs are actually posted. Instead, the overwhelming majority of job seekers find positions by following up on a lead provided by a friend, relative, teacher, former employer, or acquaintance.

"The most important first step is to get your networking working," advises Harvey Mackay, author of *Sharkproof: Get The Job You Want and Keep the Job You Love*. "Talk to everyone you know who has any connection with the fields you're interested in. Ask for informational interviews. Offer to take them out for breakfast or lunch."

When it comes to job hunting, the old adage is true: it's not *what* you know but *who* you know. Especially in the design field where word of mouth and referrals rule. Stephen Covey, author of the perennial favorite *The 7 Habits of*

Highly Effective People, says one of the most important keys to your personal and career success is to be aware of who falls in your Circle of Influence. In other words, the people you know.

The more people who know you're looking for work, the more leads you'll receive. The more leads you turn up, the more applications you can put in. The more applications you put in, the more interviews you'll get. The more interviews you get, the more job offers you'll receive.

Your main purposes in contacting those in your Circle of Influence are as follows:

- Let people know you're looking for employment, being as detailed as possible (job title, preferred work location, size of operation).
- Solicit their help in hooking you up with people who work in your field.
- If they draw a blank on the question above, ask them for specific names of people who may know of someone in the field that you can contact.

If you're a recent grad, the easiest place to start is with your professors. Often employers who have positions to fill make their first call to faculty. Enter into your database or write a list of the names of your favorite professors and/or those who have praised your work.

Then go a little more global in your thinking. Whom do you know who already works in the field you hope to enter? Who works in related fields, such as publishing, advertising, etc.? Did you make any contacts with guest speakers in your classes or in professional organizations or conferences you've attended? Any relationships you developed from internships, practicums, or temporary or summer jobs?

Go wider still. What family or friends need to know you're looking for employment? Now add to that list people you personally know who strike you as being at the top of their game, regardless of their profession. Add individuals who seem like they know everyone, regardless of what professional or social circles they move in. These people are potential door-openers for you.

Finally, what groups do or did you belong to, based on sports, religious, political, or volunteer activities or hobbies?

By now you should have anywhere from twenty to fifty listings (hopefully even more). These are the bedrock of your "warm" contact list, those who comprise your own personal Circle of Influence.

At the same time that you're mailing out resumés for advertised positions, you must also simultaneously be working on your Circle of Influence.

At this stage it's time to employ one of Julius Caesar's favorite tactics: Divide and Conquer. In other words, break a large task into smaller, bite-sized tasks. Say you have fifty names on your contact list. Your first step may be to consult your e-mail addresses or day planner to see how many addresses and phone numbers you already have. A logical next step (though not necessarily the only one) would be to gather the contact info you're missing, such as addresses or job

titles. Or perhaps you'd rather organize your list of names according to who will be easiest for you to approach. Or you could chunk the fifty names into five categories and promise yourself that you'll contact ten per day until you've worked through the list.

Working with the names on your Circle of Influence, you'll want to draft a message announcing your recent graduation and/or availability for employment. This can be either a script for a phone call (recommended because it's more immediate) or an e-mail you'll send. Here's an example:

> Hi. This is Margarita Hernandez. I was your intern last summer and I worked on the _____ project. I'm calling because I just graduated from _____ College and I'm looking for permanent full-time work as an assistant graphic designer. I was wondering if you can suggest some people that I can send my resumé to.

People who extend themselves for you like to know their efforts are appreciated. So if you do receive a favorable response (such as an interview or job offer) from one of the leads provided by someone in your Circle of Influence, send a handwritten thank-you note or e-mail or make a phone call to tell the person thank you. If you live in the same city, an invitation to be your guest at lunch is a nice touch.

TEMPING

Although there is no hard and fast rule about how long a job search lasts, recently graduated graphic designers should expect that it will take between three and six months to land a permanent job. If you live in or near a larger city, signing up with a temp service is an option that allows you to gain experience and earn some bucks while still leaving free time for interviewing. Three of the larger temp agencies for creative services are Aquent (*www.aquent.com*), Randstad (*www.randstad.com*), and The Creative Group (*www.creativegroup.com*). If you live in the Northeast, check out BOSS Staffing (*www.bossstaffing.com*). To find temp agencies operating in other specific geographic regions, run an Internet search or comb the yellow pages.

Temp agencies like go-getters, so make frequent phone contact to let them know you're serious about assignments. You may be offered a temp-to-perm or temp-to-hire spot that involves a trial period, usually ninety days. This situation affords both you and the employer an opportunity to see if there's a match.

INTERNING

You never know when a stint as an intern can lead to something permanent, as was the case with Steve Adolf whose internship at Grey Advertising in New York City paved the way to an offer of permanent employment with the firm.

Now the Creative Director at Zimmerman (a division of Omnicom) in Florida, Adolf advises, "When you're just starting out, look at all your options. Move around. Each place you go teaches you something new."

Noted Manhattan designer Mirko Ilić also thinks interning is a viable option. "Get an inside view of how the design world operates by being an intern," he says. "After all, Leonardo da Vinci was an intern. Why shouldn't you be one?" In addition to his staff, Ilić always has at least one intern working in his studio. What qualities does he seek in selecting interns? "I look for attitude . . . is this somebody who is friendly and open-minded. Am I going to want to work with them? Are they eager and hungry?"

PORTFOLIO REVIEWS

The designers we interviewed reported that they receive lots of calls from recent grads asking, "Are you hiring?" Maybe that off-hand type of approach works at a burger joint, but our sources tell us it doesn't cut it in the design profession.

However, it *is* okay to call to inquire if the agency holds portfolio days, sometimes referred to as portfolio reviews. Many firms, like Wages Design in Atlanta, regularly set aside time for illustrators, photographers, and graphic designers to stop in and show their books. "Friday is Portfolio Day," Bob Wages says. "The whole team meets with whoever stops by. This is definitely not a job interview but it is an opportunity for you to get feedback on your portfolio, deliver a leave-behind, and perhaps develop the beginnings of a professional relationship." The payoff for the pro is staying current on design trends while keeping an eye out for hot new talent that can be tapped for future projects. Who knows? If you're lucky, you may leave with a lead or two for job prospects.

INFORMATIONAL INTERVIEWS

In writing this book, we were amazed time and again at the overwhelming generosity and helpfulness of every designer we contacted. They offered us their hard-won wisdom on a variety of subjects, gifted us with great writing samples for this book, and hooked us up with other designers to interview.

It's possible that you, too, can tap into the kindness of strangers as you search for work. With the right attitude and some planning, you may find informational interviews a useful avenue to career information and leads. The "right attitude" means that you should *never* confuse an informational interview appointment with a job interview. Make no attempt whatsoever to sell yourself. Otherwise, you'll be guilty of the old "bait and switch" approach, a transparent tactic sure to turn people off.

During an informational interview, you are there to learn as much as you can about career opportunities in the design field as quickly as possible. Asking good questions yields information you can mine to find a job elsewhere.

Time for a scenario: Let's say your aunt is best friends with a creative director at a top firm, which has recently experienced some cutbacks and layoffs. Clearly not looking to hire you, right? But your aunt's best friend is still willing to give you a half-hour meeting. Consider yourself lucky.

First, determine what it is you want to know. Maybe you want feedback on your portfolio. Maybe you seek specific info about junior designers' job responsibilities. Maybe you want advice on breaking into graphic design. Arrive with your own specific questions. Here are some to get you thinking:

- What led you into design?
- What do you like most about the design business?
- What do you like least?
- What do you wish you'd known when you were just starting out?
- What changes are impacting the field?
- What can you tell me about the market for designers these days?
- What's the best way for a new designer like me to break in?
- Can you think of anyone else who might be helpful that I can talk to?

As the meeting progresses, take notes and jot down any lead or contact information. No matter how eager you are to continue the conversation, don't overstay your scheduled time. Before you depart, offer your thanks, along with a leave-behind. Within a few days, mail a typewritten thank-you letter, expressing your appreciation for the gift of time you were given. And, when you do land your first position, be sure to notify the kind souls who extended themselves on your behalf.

Chapter 6:
PACKAGING YOURSELF FOR EMPLOYERS

In today's image-conscious world, visual appearances count for a lot. As a job seeker, you must be aware of the professional identity you project through your resumé, application letter, portfolio, and other job-seeking materials. Like it or not, how you package yourself for employers can either rule you out or rule you in.

RESUMÉS

You simply cannot afford to approach this all-important step to your career success without investing the time and effort it requires. Trust us, even mediocre resumés take hours and hours of work.

Yes, it may be possible to offload the dreaded task onto your roommate, family member, or professional resumé writer, but that's akin to birthing a baby and handing it off to a passerby to raise.

You're a professional—or will be soon—and this is a professional task you need to know how to carry out. You may never come to *love* writing resumés, but you need to be able to write or update yours the moment you hear about a good job opportunity. Waiting for someone else to do it for you could cost you the job.

A "resumé" is a brief account of your personal, educational, and professional qualifications and experience. In the best of worlds, it showcases your proven track record of being someone who can produce results on a job.

A resumé has one purpose: to get your phone to ring with an invitation for an interview. Many people are confused about this subject, thinking the goal of a resumé is to get you a job. Wrong. A resumé is a marketing tool showcasing your talents, your abilities, and your experience. If your resumé is effective, the desired result will be an invitation for an interview from an employer.

Showcase your visual skills when you design the resumé. Cathy Teal of FireBrand Design in Palm Spring, California, says, "If they can't make it look pretty, I wonder about their skills as a designer. I've seen resumés that are over-designed and not readable or where I can't find pertinent information like a phone number."

Bob Wages of Wages Design in Atlanta agrees. "The resumé better be well designed," he cautions. "If it's on white paper, it better have an elegant design or typography."

What you're shooting for is a design that stands out from the pack, yet doesn't cross the line into being too showy or unconventional. As part of your

entire employment "package," your resumé should have a consistent look that is repeated in your application letter, reference sheet, leave-behind, and portfolio.

Already Got a Resumé?

If you've written a resumé to fulfill a class assignment (for example, in your portfolio development class) or one that you threw together at the last minute to get a summer job, you're already ahead of the game. Not that you'll be mailing this version out. Use this version as a starting place, a draft.

Why not run with what you already have? Nine times out of ten a resumé that worked for a school assignment may very well *not* command attention and respect from designers looking to hire. As business communication professors with eagle eyes, we assure you the following errors are all too common in quickly dashed-off course assignments:

- Misspellings (lands you directly in the Reject pile)
- Missing pertinent data (like your phone number or dates of employment. Puh-lease . . . do you *really* want to work?)
- Inconsistencies in chronology
- Vagueness/lack of specificity

By reviewing the guidelines we provide in this chapter and then applying them to your draft, you'll wind up with a solid professional resumé.

No Resumé?

What if you have never been asked to produce a resumé and you are totally clueless about how to write one? No problem. You're about to learn the basic parts of a resumé and resumé writing rules. With a bit of effort, you'll soon have a resumé you can be proud to circulate.

The Parts of a Resumé

Although opinions differ on what to include on a resumé, employers expect to see certain items. After counseling hundreds and hundreds of job seekers as well as talking with design leaders about this topic, we've developed our own guidelines that we advise you to follow:

Heading

Contact information typically includes name, permanent address, phone, e-mail, Web site, and URL.

 Stop and think: Is your e-mail address a bit too precious? As we mentioned earlier in this book, what's fine for your social life may be way over the top when used for a more conservative business setting. Here's a few that won't work in your professional life: *JudyBlueEyes@aol.com, Hotstuff86@yahoo.com*, or *SmokingJoe@netscape.com*.

Summary of Qualifications (aka Professional Highlights)

This section showcases your unique experience and personal qualities. Think of it as a minicommercial of Coming Attractions, which you'll back up with specific outcomes and results under your work history. You can include this part if you have sufficient experience to appeal to an employer.

Education

Highest degree attained
Other degrees
Minor area of study

Digital Skills (aka Software Proficiencies)

What types of computer applications are you familiar with?
How about your mastery of cutting-edge trends or practices?

Experience

Paid design work
Volunteer or temporary design work
Internships/on-the-job training/practicums
Other work experiences

Stop and think: For every job you've held, jot down three or four primary duties you performed. Whenever possible, *quantify* by using numbers or *capture the results* of your efforts. For example, "Created an AIDS awareness poster that appeared on five hundred buses and trains" or "Researched and recommended new supply vendors, resulting in a savings of 12 percent per year." Were you promoted from within or asked to stay on for a temporary work assignment? Note that too.

Distinctions

Design competitions
Academic honors
Scholarships
Extracurricular activities

Stop and think: Did you design a *pro bono* (unpaid) poster or brochure for a soup kitchen, road race, or voter registration drive? Were you a student member of your school's accreditation team or search committee? Have you lived abroad? Can you speak Urdu or American Sign Language? Are you fluent in a second language . . . or three or four? Now's the time to identify what makes you stand out from the pack.

Professional Affiliations

Are you a member of any organizations in your field?
Have you attended any conferences or workshops?
Did you study or work with a well-known professional?

References

Some people choose to add a line that says "References available upon request." We suggest you eliminate this superfluous line because you will include a separate Reference Sheet (see pages 71–73).

Resumé Writing Rules

- Be brief yet complete. A resumé for a new designer is typically one page long—never more than two.
- Eliminate sentences. There's no place for a complete sentence on your resumé. Instead use brief phrases or lists to describe your accomplishments.
- Use reverse chronological order in every section, which means listing most recent jobs, education, and accomplishments and going backward from there.
- Use Action Verbs. Here are some designer-friendly ones:

Achieved	Customized	Prepared
Analyzed	Designed	Presented
Arranged	Drafted	Produced
Assisted	Edited	Reduced
Attended	Enhanced	Researched
Budgeted	Evaluated	Resolved
Built	Executed	Scheduled
Calculated	Generated	Searched
Collaborated	Handled	Selected
Communicated	Increased	Sold
Compiled	Initiated	Solved
Completed	Instructed	Sourced
Composed	Launched	Tracked
Conducted	Organized	Updated
Converted	Oversaw	Utilized
Coordinated	Performed	Verified
Created	Planned	Wrote

- Pay attention to tense. If you *presently* hold a job, use verbs in *present tense* (example: create, design, collaborate, execute). If the work you did was in the *past,* use verbs in *past tense* (example: created, designed, collaborated, executed).

- Lead with your best shot. If you're light on experience, list Education first, including any academic achievements. However, if you interned, worked summers for a printer, or temped as a freelancer, put that first.
- Exercise bragging rights. Claim whatever successes you can. If you floundered during the first two years of college, but earned a 3.6 grade point average for the final two years, write, "Earned an overall 3.6 GPA for last four semesters." (We recommend including GPAs above 3.5; less than that, omit mention.)
- Repurpose. Earlier, when you researched the job market, you may have gleaned some knock-out phrases or descriptions while checking out other designers' resumés. Can you repurpose them now for your own resumé?
- Never lie. Don't claim jobs, awards, or work projects you've never done. If being ethical isn't reason enough for you, there's this: The design world is a small one, and odds are stacked against you that you'll be outed.

What *Not* to Include on Your Resumé

You also must be aware of what *not* to include on your resumé. Including any of the following brands you as an amateur. Omit these items:
- Salary or benefit expectations
- Social security number
- Restrictions (physical or mental disabilities, lack of transportation, desire for dog-friendly work site)
- Photos
- Pale-colored ink or brightly colored paper
- Cocky tone or false claims ("My artwork will make you rich!")
- Personal information *unless it's job relevant* (certainly not height, weight, etc. Exceptions might be "Avid scuba diver" if you're applying for a position with *Fish Magazine* or "Visited seventeen countries" if your research tells you the company's target market is primarily international.)

Models of Effective Resumés

We've included examples of effective design resumés on pages 58–66 so you can refer to them as models.

Functional Resumés

For those just graduating and entering the graphic design field, we recommend you use the rather straightforward chronological resumé described in the preceding sections. If, however, you have been employed in the design field, a *functional* resumé may work better for you. Sometimes you'll hear functional resumés also referred to as skills-based resumés.

A functional resumé is typically organized around three or four skill sets, each one broken down into several bulleted items. The emphasis is on *what you can do* rather than on job titles you have held. A functional resumé takes more thought to create but the payoff can be a clearer, more detailed picture of your many skills and capabilities.

Taylor Hersh

55 West 26th Street (22A)
New York, NY 10001
212 842 5318
tayl522@aol.com

Career Goal Art Director

Education Fashion Institute of Technology, State University
of New York
Candidate for Bachelor Degree, May 2005
Communications Design Major, current GPA 4.0

Fashion Institute of Technology, State University
of New York
Associate Degree, May 2003
Summa Cum Laude
Communications Design Major, GPA 3.81

St. Joseph by the Sea High School, Staten Island, NY
Regent High School Diploma, June 2001

Honors & Awards Art Director's Club Scholarship Award for 2004
Dean's List, Fashion Institute of Technology
Phi Theta Kappa, Honor Society, Fashion Institute
of Technology
City Merit Scholarship Award, Fashion Institute
of Technology

Additional Education Agency Classes taken during semesters at Fashion
9/03–present Institute of Technology: Euro RSCG MVBMS,
J. Walter Thompson, Ogilvy & Mather,
Saatchi & Saatchi

Fall 1998/Summer 1998 Fashion Institute of Technology: Saturday Live
Classes and Summer Live Classes, New York, NY:
Design classes to build portfolio.

Employment Sheragano Clothing, New York, NY: Retail
6/03–9/03 Salesperson. Cashier. Window Designer.

8/98–1/03 Andrea's Closet Boutique, Staten Island, NY: Retail
Salesperson. Assistant Buyer. Window Designer.
Fashion Show Coordinator.

6/96–7/98 Wonder Years Day Care Center, Staten Island, NY:
Counselor.

Computer Skills QuarkXPress, Adobe Photoshop, Adobe Illustrator

Resumé from a student

JEDSKILLINS

164 Wall Street
Kingston, NY 12401
845.340.1475 **h**
631.258.5056 **c**
jed_skillins@mac.com

EDUCATION

FASHION INSTITUTE OF TECHNOLOGY, STATE UNIVERSITY OF NEW YORK

May 2006 Bachelor of Fine Arts degree, Magna Cum Laude
Graphic Design Major

May 2004 Associate in Applied Science degree, Magna Cum Laude
Communications Design Major

Spring 2003 through Spring 2005 Deans List

DESIGN EXPERIENCE

May 2006 through Present Young & Rubicam
Junior Art Director

INTERNSHIP

May 2005 through Present Wing Chan Design
Assist art director for design layouts of the following:
American Express Bank Portfolio View and Messaging Cross Sell Graphic,
Portfolio View e-flyer, Operations 3-D dashboard, Operations e-dashboard,
Zydowsky Consultants 2005 e-card

FREELANCE DESIGN

February 2006 through Present K11 Project
Cleaned and maintained files
Designed e-vite for movie screenings

June 2005 through July 2005 212 Partners
Designed Logo and Business Card

June 2005 Irina Kagramanova
Designed Logo

January 2005 Fuse Network
Designed promotional Long Board for Spring Break 2005

LEADERSHIP EXPERIENCE

Summer 05 through Spring 06 Resident Assistant
Oversaw a floor of 36 residents
Acted as liaison between residents and staff of the Residential Life Office

Fall 2003 through Spring 2005 Student Government
Vice President of Health Services
Conducted a Blood Drive once a semester and increased amount of donors by 200%
from previous drives

Fall 03 through Spring 05 Resident Assistant Alternate

SKILLS

COMPUTER
Adobe Photoshop, Adobe Illustrator, Adobe InDesign, Macromedia Flash,
Macromedia Dreamweaver, and QuarkXPress

ILLUSTRATION
Hand Lettering, Illustration

Resumé from a recent graduate

··· joseph diStefano ···

394 North Mountain Road • Copake Falls, NY 12517
(518) 577-2017 • jdistef@gmail.com
www.jd19tcf.com

Work Experience

February 2005-Present

Berkshire Publishing Group, *Graphic Design/Production/Web Artist*
• Designed and produced small print items for sale and marketing (Direct mail)
• Created designs for print marketing collateral (Business cards, letterhead, and envelopes)
• Processed and controlled illustrative content (Style guide)
• Acquired photographs, artwork, and drawings for Berkshire publications
• Book Design (Covers, openers, sidebars, and tables)
• Web Design (Layout, Function, Animated Banners, and Overall Design)
• CD/DVD Authoring (Edited, titled, motion graphics)
• Conceptualized/produced/designed *The Berkshire Savant* (Print Magazine/Catalog)
• Produced and devised brochures for several products for Berkshire publications
• Scanned photographs (Retouched, and sized for print and web)

June 2001-2004

Color For Real Estate, *Graphic Artist/Production Artist*
• Designed postcards, real estate brochures, busines cards, etc.
• Scanned photographs, retouching, and sizing
• Executed color correction

January 2000-2001

Mid-Hudson Media, *Graphic Designer/Web Assistant*
• Conceptualized and executed various advertisements
• Created Web graphics, optimizing, cutting images
• Built ads for Mid-Hudson Cable's local access channel
• Worked on multiple televised shows (Camera operator, Set design, etc.)

May 1999-2000

The Independent, *Graphic Artist/Typesetter*
• Designed advertisements for the Independent newspaper
• Performed photograph archiving; Color correction, resizing, scanning

Education

September 2002-2004

New York Institute of Technology
• Bachelor's of Fine Arts in Computer Graphics
• Presidential Honor's List
• Summa Cum Laude

September 1999-2001

SUNY Columbia-Greene Community College
• Associate's of Fine Arts in Computer Graphics
• Dean's List

Skills

Art Skills		Computer Skills	
• Drawing	• Print/Production	• Adobe Photoshop CS 2	• Alias Maya 6.5
• Storyboarding	• Storytelling	• Adobe Illustrator CS 2	• 3ds Max 7.0
• Logo Design	• Web Design	• Adobe InDesign CS 2	• QuarkXPress 6.5
• Animation	• 2D/3D Design	• Adobe After Effects 6.5	• Dreamweaver MX

Awards

May 2005

NYIT Computer Graphics Faculty Award
• Outstanding achievement in Computer Graphics

December 2004

NYIT S.O.U.R.C.E
• Senior animation was chosen for display from a juried competition

Resumé from a recent graduate

J.D. Jordan

440 Tyson Circle | Roswell, Georgia 30076 | t:678.230.9810 | c:678.230.9810
jd@cloudjammer.com

summary

A versatile creative professional with six years experience in web, usability, graphic, and information design and over a decade of experience in print design and production. Has taught creative technologies and techniques at a leading accredited college and has been published nationally in Newsweek. Brings experience bridging design with business services and leading edge back-end technology. Entrepreneurial, team-focused, and responsive to customer needs and priorities.

software experience

Software | Photoshop, Image Ready, Illustrator, Dreamweaver, GoLive, Flash, Fireworks, Quark, InDesign, Pagemaker, Acrobat, Suitcase, Microsoft Office (Word, Excel, PowerPoint), Fetch and PC ftp clients, Internet Software, and AutoCAD

Operating Systems | Windows 95, 98, 2000, NT, XP; Macintosh OS 7x, 8x, 9x, 10x

Computer Languages | HTML, JavaScript, Perl, PHP

career experience

Cloudjammer Studio, LLC | Atlanta, Georgia | 1999 - present
Owner, Creative Director
- One of three principal owners
- Responsible for all design materials: print, identity, and web
- Cooperates with clients to produce extensive, expandable websites
- Maintains client websites
- Web development and testing lead
- Creates proposals and presents concepts and design to clients

University of Georgia | Athens, Georgia | 2005 - present
Teaching Assistant
- Lead discussion sections for groups ranging from 11 to 25 students, ages 18 to 22
- Grade papers and exams, prepare all discussion section materials and lectures
- Meet with and counsel students through office hours and by appointment

Atlanta College of Art | Atlanta, Georgia | 2002 - 2005
Adjunct Faculty
- Responsible for teaching undegraduate courses on electronic arts and web design
- Manages classes ranging in size from two to 14 students, ages 18 to 54
- Prepares all course materials and lectures, selectes relevant texts, and grades all work

Point of Vision Design Group, Inc. | Atlanta, Georgia | 1999 - 2002
Senior Web Specialist
- Responsible for every web project
- Worked with conventional designers to translate their visions to the web
- Operated as a liaison between contract developers and designers
- CGI and Server-Side Include integration

TempArt | Atlanta, Georgia | 1999
Graphic Designer

The Burris Agency | High Point, North Carolina | 1997
Advertising Intern

education

University of Georgia | Athens, Georgia | Master of Arts in History

Hampden-Sydney College | Hampden-Sydney, Virginia | Bachelor of Arts

The University of St. Andrews | St. Andrews, Scotland | Foreign Semester Abroad

languages

French | Proficiency certified by the University of Georgia, 2005

Arabic | Proficiency pursuant

Resumé from a midcareer designer (page 1)

publications **Newsweek** | "My Turn: I'm an Artist, But Not The Starving Kind" | September 19, 2005
Circulation: 4 million, worldwide; 21 million total readership
This editorial essay takes a personal look at both sides of a problem in artistic education: the lack of creative business preparation in art colleges and the impact it has on working professionals.

Creative Loafing Atlanta | "Hope Under My Fingernails" | January 1, 2004
Circulation: 3,180,000
The first-place winner in Creative Loafing Atlanta's third annual fiction contest. The piece was also presented at a reading on January 8, 2004 at the Margaret Mitchell House in Atlanta.

Atlanta College of Art | "Web Standards: A Guide for Web Design and Production" | 2005
Circulation: limited
A professional and student oriented web design text focusing on standards and practices for good design, not on transient technologies. Two professional graphic design firms and the Atlanta College of Art used this text to teach artists and students the basics of conscientious design.

public speaking **4th Inter. Conf. on the Book** | "A Historiographic Analysis of Visual Texts" | October, 2006
Attendance: pending
An analysis of the visual text – the visual representation of historical conditions, trends, phenomena, and hypotheses. This presentation focuses on two classic visualizations – those of William Playfair and Charles Minard – as benchmarks for the comparison of several modern historical visual texts – Richard Bulliet, Élisabeth Carpentier, Jonathan Riley-Smith, and the National Geographic.

Margaret Mitchell House, Atlanta | "Hope Under My Fingernails" | January 8, 2004
Attendance: 80-100
A literary presentation of the winning entry in Creative Loafing Atlanta's third annual fiction contest. Presented in coordination with Hollis Gillespie and Creative Loafing.

Creative Circus, Atlanta | "Web Standards" | 2003 – 2004
Attendance: 20-30
Visiting presenter for web design courses

summary Reading, writing, golf, travel, education, drawing and illustration, history.

Resumé from a midcareer designer (page 2)

When should you opt for a functional resumé?

- If you worked in the design field before or while you were in school
- If you're a seasoned design professional shooting for a job that may exceed your reach (either educationally or experience-wise)
- If you wish to minimize time gaps in your work history (say, time off for child-rearing or a year backpacking in Europe)
- If you have a history of job-hopping
- If you're looking to "re-career" into a somewhat related field (like becoming a media specialist or a copywriter)

Components of a Functional Resumé
- Heading (Name, Address, Contact Info)
- Job Objective (Name of position for which you are applying)
- Highlights of Qualifications (sometimes called Summary of Qualifications)

1234 DILBERT AVENUE SAN FRANCISCO, CA 94117
415-222-6666 • vchitterjee@acedesigns.com

VIJAY CHITTERJEE

OBJECTIVE

Creative Director

SUMMARY

Five years' experience in graphic design and layout
Able to organize and complete multiple complex projects
Creative, energetic, and a quick learner
Excellent hand skills

RELEVANT SKILLS & EXPERIENCE

Graphic Design
Developed identity and collaterals for start-up businesses
Designed and produced promotional materials, including brochures, annual reports, magazines, and print ads
Created logos for nonprofits, retail, and professional services
Subcontracted with talented freelancers and vendors to complete rush projects on time and on budget

Client Contact
Created and delivered presentations to small and large-sized companies
Worked with clients from concepting through production
Advised on creative and technical options
Consulted on clients' marketing strategies

Technical Skills
Pasted up a wide variety of camera-ready art, such as business cards, posters, brochures, and booklets using color and screen tints
Prepared files for printing
Shot digital photos of products
Created mechanicals; proofed blue lines and color keys

EMPLOYMENT HISTORY

2005–Present **Graphic Designer**, Altoid Design, Seattle, WA

2003–2004 **Production Artist**, METRO Magazine, Seattle, WA

2002–2003 **Paste-up Artist**, The Advocate, New Haven, CT

EDUCATION

B.A. in GRAPHIC DESIGN–GPA: 3.6
School of Visual Arts, Seattle Washington

DIGITAL SKILLS

Adept in QuarkXPress, Flash 5.0, Dreamweaver, Adobe Illustrator and Photoshop, HTML, PC and Mac Platforms

Functional resumé

- Key Skills (also referred to as Relevant Skills & Experience). Limit to three or four areas of skill. Each Key Skill is followed by three to five points that succinctly sum up what you did, specifying quantities or results whenever possible
- Work History (sometimes called Relevant Work History)
- Education
- Awards/Distinctions
- Digital Skills (or Software Proficiencies)

The first thing to remember is that your Job Objective drives the rest of your functional resumé. We recommend you invest a few hours in visiting various Web sites or employment listings (see page 47) to familiarize yourself with what skill sets are involved in the positions that interest you. Depending on your area of interest, you'll find some standard categories, such as Graphic Design, Photography, Illustration, Web site Design, Animation, Branding, Account Services, Leadership, or Production Organization.

Flight-Check Your Resumé

- Is all necessary information included?
- Does the order flow easily and logically?
- Have you used Action Verbs to communicate what you've done?
- Did you replace any repeated words or phrases?
- Are your special talents and abilities showcased?
- Does your resumé fit on one page?
- Did you include some arresting design element?
- Do the section headings stand out?
- Have you used easy-to-read fonts (such as Times New Roman or Arial)?
- Is the majority of type size between ten and fourteen points (excluding headings)?
- Have you spell-checked *and* proofread several times?

If you can answer a resounding *Yes* to the above questions, then you're ready to get some feedback. Carefully choose three to five readers who you think are knowledgeable about resumés (for example, former teachers, career counselors, design professionals you already know) and send yours to them. Make it clear that you're hungry for suggestions for improvement (preferably written), and then take their recommendations under advisement. Tweak as necessary. Implement more drastic changes only if your final product will be strengthened.

Print Your Resumé

Whether you selected a standard chronological resumé or opted for the functional one, you've got some more choices to make when it comes to printing.

- Purchase a package of high-grade white, ivory, or pale gray resumé paper and print your resumé yourself, using a quality printer.
- Rely on your new friends at the campus career center or the employment office to do the printing for you.
- Have your resumé printed professionally, budget permitting.

We recommend mailing your resumé in a 9" × 12" mailing envelope. Why? Primarily because unfolded paper makes a better impression than folded paper. Also, once you're written a terrific application letter (see pages 67–70), you'll paper clip—not staple—that cover letter to your resumé. (However, if your resumé runs more than one page, staple your resumé pages together so they won't become separated.)

Thinking of just faxing or e-mailing? Don't. In her online article, "Ten Common Mistakes in Resumés and Cover Letters," designer Petrula Vrontikis writes:

Unless the firm specifically requests a fax or e-mail, never send your resumé that way. It's cold, impersonal, and just generally looks bad. The overall impression you make includes your ability to make the most of these materials. Choose good paper. Be creative. Make the presentation something special . . . E-mail and faxes shift the focus to the content (work experience). If you're just starting out, there may not be that content, so you need to focus on the presentation aspects.

Online Resumés

Since many companies today conduct employment searches online, it's wise to have an electronic resumé. While technology advances and practices can (and do) change overnight, the following suggestions currently prevail.

Keywords. Because some design companies receive literally hundreds of online resumés, the employment recruiter or hiring manager will often read only the first one hundred words to identify potential candidates. Use Keywords to grab their attention. Keywords are stated as nouns, not the Action Verbs you use on a chronological or functional resumé. Instead of writing, "designed fifteen Web sites" or "created award-winning ad," you'd write Keywords like "Web site designer" or "award winner" or "ad designer" (see example on page 66).

Other Features. An online resumé differs from a hard-copy resumé in these other ways as well:

VIJAY CHITTERJEE

1234 Dilbert Avenue San Francisco, CA 94117 (415) 222-6666

E-mail: vchitterjee@acedesigns.com

Creative Director	**Designer**	**Graphic Artist**

EMPLOYMENT HISTORY

Graphic Designer, Altoid Design, Seattle, WA 2005–Present

Proposal writer and presenter to all prospective and current clients
Producer of identity and collaterals for start-up businesses
Logo designer for nonprofit, retail, and professional services clients
Account manager from concept through production; marketing strategies advisor
Supervisor of freelancers hired to complete rush projects on time and on budget

Production Artist, METRO Magazine, Seattle, WA 2003–2004

Layout specialist
Creator of print ads
Proofreader and editor

Paste-up Artist, The Advocate, New Haven, CT 2002–2003

Pasted up a wide variety of camera-ready art, using color and screen tints
Prepared files for printing
Digital photographer of products
Created mechanicals; proofed blue lines and color keys

DIGITAL SKILLS

Adept in QuarkXPress, Flash 5.0, Dreamweaver, Adobe Illustrator and Photoshop, HTML, PC and Mac platforms

EDUCATION

B.A. in GRAPHIC DESIGN–GPA: 3.6
School of Visual Arts, Seattle Washington

AWARDS

Silver ADDY for Su Ling Tso, Photo Mailer, 2005

HOW Self-Promotion Annual, 2004

Online resumé

- Bump up your e-mail address so it appears right after your name (before your home residence).
- To cut and paste your resumé in the textbox of an e-mail, first make sure you simplify formatting to avoid garbling. Use sans serif fonts such as Times New Roman, Arial, or Helvetica. Type size should be ten to fourteen points. Remove all italics, bullets, underlining, and bold fonts.
- Save the document as an ASCII Text Only file [*.txt] file, which also works well internationally. Conduct a trial run by sending it to yourself or a friend first to make sure it comes through in readable form.
- Create a nongeneric file name (*not* resumé.doc). Perhaps something like Janoff_Barbara_GraphicArtist.txt. or Cash-Smith_R._Web Designer.txt.
- With so much spam out there in cyberspace, make sure your subject line won't get deleted because it's too vague or gimmicky. Instead opt for a more straightforward approach like Graphic Designer Application or Commercial Artist for XYZ Corporation.
- Follow up with a hard copy of your resumé and cover letter (which we'll get to very shortly), unfolded and mailed in a flat envelope, which makes scanning easier.

A Word About Your Web Site . . .

First, do you have one? If not, that's fine and as your experience and credentials mount, you will revisit this decision. Resist the urge to just throw something up; a bad Web site can work against you so taking the time to design it right is important.

If you already do have a Web site, is it what you'd term "strictly professional"? This means no cute pictures of you in first grade, no video clip of you snowboarding with friends, no shots of your irresistible wolfhound or calico cat or pet goldfish.

If you developed a Web site to fulfill a course assignment or to showcase samples of your professional expertise, then by all means *do* include your Web site address or URL on your resumé once you have reviewed, revised, and edited it. A Web site can be one more important tool in marketing yourself to potential employers.

APPLICATION LETTERS

Before you begin designing the second all-important marketing tool, your application letter (also known as a cover letter), it's wise to backtrack and review good letter writing basics as discussed on pages 23–26.

Remember we told you that the resumé is an essential marketing tool whose main purpose is to make your phone ring with an interview offer? That's also exactly true about the cover letter, except for one important difference. A cover letter is much more of a personal statement about you. As such, it should be

written in a tone that is both businesslike and yet reflective of your personality. The cover letter is an opportunity for you to answer this question for an employer: *Here's why and how I'm special.*

Because a cover letter is a customized selling of your strengths for one particular job, you won't be sending the same cover letter to every employer. Yes, you may use a template or boilerplate approach to save yourself from pulling your hair out by the roots, but to be truly successful in your mission of making your phone ring off the hook with interview offers, you'll need to design a cover letter that is tweaked for each potential employer.

We're going on the assumption that you'll be applying for an actual job listing or referral so our advice will be geared to that scenario (rather than an Are-you-hiring? situation).

You'll *almost always* send a cover letter with your resumé, either as a hard or an electronic copy, using e-mail or fax. Why? Because a cover letter is the way the business world operates and, as we've already reminded you numerous times, you need to prove you know how to be businesslike. We say *almost always* send a cover letter because in a few specific incidents, employers will specify *no cover letter.* If so, don't.

Research Time Again . . .

Before you begin to design your cover letter, take one giant step backwards to Research Mode. Conducting some preliminary research will be helpful as you go about your task of crafting a customized letter.

If you take the time to find out about the company to which you're applying and use that knowledge *sparingly but appropriately* in your cover letter, you'll stand out from the other hundred applicants as someone who's done your homework. How to achieve this? Here are some suggestions:

- Visit the Web site
- Conduct an online search for recent news
- Obtain a copy of the annual report if the firm is publicly owned
- Ask professionals and/or professors in the field
- Look up the company in specialized directories or trade association materials (See page 39 for a list of Web sites.)

What you're looking for is the scope of services provided, mission and goals, clients, awards and honors, new projects, new markets. Take notes or make photocopies or printouts as you unearth pertinent information.

If the job posting does not identify the specific person to apply to, cruise the company's Web site or call the office directly. The call could go something like this:

Hello, my name is _____ and I'm interested in applying for the _____ position. I'd like to send my credentials to the person in charge of hiring. Can

you please tell me who that is? And is that spelled . . . ? Great. While I have you on the phone, I'd like to verify that person's job title. Thanks very much for your help.

Tuck this information away for later use. Now it's time to switch to Write Mode.

The Parts of an Application Letter

The good news? An application letter (also called a cover letter) is a one-page document. But despite its brevity, it's a very *important* letter so it may take you several tries to achieve the best result. Application letters are limited to three or four paragraphs, each of which has a distinct purpose.

First Paragraph: The Purpose

Why are you writing?
- The name of the position
- Where and when you found out about it
- The most important qualification you have for the position

Middle Paragraph (or two): The Proof

Why you and not any one of the other zillion applicants?
- Cite specific accomplishments relevant to the position description
- Highlight any special experience or qualifications that might not appear on your resumé (projects, courses, workshops, collaborations)
- Showcase your research, sparingly and appropriately
- Avoid regurgitating what's already on your resumé

Last Paragraph: The Close

What do you want?
- Mention what you are sending (resumé, samples, digital portfolio, etc.); also note this on the attachment line
- Indicate your eagerness for an interview, an initial screening by the company recruiter, an opportunity to have your portfolio reviewed, whatever applies
- Repeat your telephone number, specifying the best time to reach you
- Include the dates you'll be visiting the area, if you're from out of town
- Specify when you will follow up with a phone call (and make a note so you absolutely, positively follow through)

Revising the Application Letter

Read your draft aloud. Listen for any awkward transitions, too-casual language, vague or incomplete thoughts. Get out the thesaurus (or use the one on your computer) to replace repeated words, just as you did on your resumé. To sharpen your letter, compare what you've written to the example on page 71.

Just as it's acceptable to review samples of existing work (as you did in formulating your resumé), downright word-for-word copying somebody else's application letter is a bad thing. It's dishonest and could cost you a lot. Just suppose other applicants use the same references you did . . . and send the exact same letter. Imagine how "unique" you'll look then. Secondly, a stock letter somebody else crafted—no matter how well written—cannot convey *your* unique selling propositions (USPs) as well as you can. Finally, if your cover letter doesn't match the "you" that shows up for an interview, you lose major points for trying to pass yourself off as something you're obviously not.

The real test for whether or not your cover letter works is this: Did you make a clear-cut case about what you can do for the employer? If not, make a few more tries until you nail what you really need to say.

Add Visual Interest

Now's a chance to strut your stuff, design-wise. See how your letter stacks up with these qualities as a benchmark:

- Is it visually appealing (the right amount of white space, clear print, easy-to-read typeface)?
- Have you utilized bold type, bullets, or underlining *where appropriate* (remembering that a little of this goes a long way)?
- Did you correctly observe the format of the letter style you chose? (Our recommendation is that you use the full-block, where all text is flush against the left margin.)

Proofread

The same rule applies to cover letters as it does to your resumé—one misspelled word and you wind up in the Reject pile. Spell-check. But because software spell-checkers don't catch every error, read your application letter forward. Then read it backward, starting at the bottom right corner and looking at each word, going right to left, line by line, up to the top. Next read each word on the page aloud . . . slowly. Finally, ask a picky English-teacher person or some anal-retentive type (they prefer the term "detail-oriented") to read it.

Printing Your Application Letter

Consistency counts! Your cover letter should be printed on the same quality and color of paper your resumé is printed on. Whatever means you used to produce your resumé, duplicate the procedure for your application letter.

The overall appearance of your cover letter and resumé should visually communicate that *I know the rules of business and I'm following them because I want this job.*

Taylor Hersh

55 West 26th Street (22A)
New York, NY 10001
212-842-5318
tayl522@aol.com

March 9, 2004

Ms. Pam Reeve
Ogilvy & Mather
309 West 49th Street
New York, NY 10019

Dear Ms. Reeve:

Mr. Ron Bacsa, my internship coordinator at the Fashion Institute of Technology, has informed me that there are positions available for Ogilvy & Mather's Summer Internship Program. As a third year Communications Design major, I have the desire to gain hands-on experience in the industry.

The skills I have gained as a student of the advertising world, as well as my agency class experiences, have given me a strong background in communications and design. I am accustomed to being creative and productive in a fast-paced, demanding environment. I thrive on challenge, and believe that my creativity and teamwork can contribute a lot to your internship program. As an inspiring art director, I believe an opportunity like this, from an agency I respect and admire, will bring me one step closer to becoming a part of the industry I adore so much.

I have submitted my resume, along with a copy of my portfolio for your review. Feel free to contact me anytime at the above phone number or e-mail address. I am looking so forward to learning more about the internship program, and to sharing my work with you.

Sincerely,

Taylor Hersh

Taylor Hersh

Application letter

Last, don't forget to sign your name (legibly, please) *above* the typed signature.

As we mentioned earlier, do not staple your resumé to your cover letter, paper clip it instead. Use a 9" × 12" envelope to mail your application letter, resumé, and samples so that everything arrives looking fresh and wrinkle-free.

REFERENCE SHEETS

Line up references *before* you need them. Select three to five people you will contact for permission to use them as references. Choose carefully, focusing on those who are best able to speak to your qualifications and design abilities. This group may include:

- Professors or teachers
- Past or present employers
- Internship or practicum supervisors
- Satisfied "clients" for whom you have done paid or unpaid work

Never presume to list references without first soliciting their agreement. Why? You'll look careless if a prospective employer calls someone who has trouble remembering you or lets it slip that you didn't ask for permission first. Incidentally, in the future when you're ready to move on to another job, repeat this process so that your referees receive a heads up that you're searching again.

We suggest calling your choices directly rather than writing to them because it's easier for you to pick up on any hesitation or reluctance on the other end. If you encounter such a response, wade on in by asking, "Is this a problem for you?" If the person replies affirmatively (regardless of whatever reason given), under no circumstances attempt to argue with them; instead, settle for a simple "I appreciate your honesty. No problem. Thanks for your time."

Even if your feelings *are* hurt, it's better to know upfront because a tepid or negative recommendation down the line could cost you the job. As professors and former supervisors ourselves, we've occasionally had to deny a reference request from students or past employees. Look at it from our point of view: If we can't honestly say something good about you, wouldn't you rather hear it from us first so you can line up a more positive referee?

Here's another word to the wise. When you're trolling for references, don't be surprised if you encounter a harried professor or former boss who turns the tables on you. "Sure," you'll hear, "write something up and I'll sign it." Gulp.

Daunting as this task sounds, we advise you to go for it! Set your modesty aside. Sit down with a blank piece of paper and put yourself in the prospective employer's shoes . . . what would that person like to hear about you? Bear in mind this is *not* an out-and-out creative writing exercise but we encourage you to rise to the challenge of singing your own praises. Some of the traits you take for granted about yourself (courteous, fanatical about deadlines, diplomatic, energetic) may be just the ones the employer is looking for. And for heaven's sake, *proofread* all those glowing remarks you've written about yourself!

Once you have contacted the people who will give you references, it's a good idea to send each of them an e-mail or letter, thanking them for endorsing you. This is also a great opportunity for you to prep them by jogging their memories about you, reminding them of any of your coursework or school projects (for teachers), promotions or special assignments (for bosses) that you'd like them to mention. Update them on what you've been up to professionally since you were last in contact, and emphasize any specific personal qualities that may be especially attractive to employers (attendance, punctuality, work completed on time, etc.).

Now for setting up your Reference Sheet. Use a style that is consistent with the design of your resumé and application letter. After your heading and contact information, include the following for each of your three to five referees: name, title, firm, address, telephone, and e-mail address.

Only mail this sheet if the job posting specifically requests that you do so; otherwise, take two or three freshly printed copies of your Reference Sheet (not folded) with you to your interview so that as the meeting concludes, you can offer this document. This simple gesture is one more way of saying to an employer, *See I'm special . . . I came prepared so I can make your job a little easier.*

PORTFOLIOS

Somewhere in your education, you've probably had a seminar or a workshop on developing your portfolio. Some schools offer an entire course on the subject, often referred to as Professional Identity. Let's just take a minute for a portfolio refresher . . .

- Invest in a quality case (13" × 15") with fully functioning zippers
- Go with standard 8½" × 11" or 10" × 14" size paper
- Strive for quality, not quantity (ten is the average) in selecting samples
- Select *only* your best work; five outstanding pieces are better than fifteen mediocre ones
- Toss out anything dog-eared or worn-looking
- Lead and close with your absolute best pieces
- Show diversity in traditional print and digital if you legitimately have the expertise to back it up
- Include at least one collaborative project
- Structure the flow of your pieces carefully so they call attention to your creativity
- Showcase your hand skills
- Use labels with very short descriptions, including results
- Flush mount all samples on cover stock, affixing them with removable adhesive
- Protect your work by using acid-free overlays
- Continually refine and update your portfolio

Okay, now that this portfolio refresher is out of the way, let's talk about the need to target your work to your audience. Here's where your research pays off. Let's say you're interviewing with a mid-size firm and you learned from surfing their Web site and doing an online search that they specialize in corporate identity. Knowing that, you'll want to leave the hip-hop album covers and the Goth posters at home, right? If, on the other hand, the firm is known for designing for primarily ethnic audiences, include any of your work with a cultural slant. In other words, carefully target your portfolio to include the work most likely to appeal to your interviewer.

Online Portfolios

With the advent of technology, everything has speeded up, including the job application process. Nowadays, a design firm can post a job online and be inun-

dated with over a hundred resumés and portfolios within a twenty-four-hour period. Plus firms wanting somebody yesterday rarely wait until the cutoff date to begin reviewing applications, so it's to your advantage to apply immediately. If you're a savvy job-hunter, you'll hedge your bets by first applying online and then mailing a print application package.

We've reviewed many articles on this subject and recommend that you read Ellen Shapiro's "The Portfolio That Puts You in Control" on *www.commarts.com*. In it she recommends an e-portfolio sent as an attachment in a PDF file of no more than 2MB. Choose five to ten of your best pieces. Use a consistent layout in your online portfolio and make it an inviting, easy-to-navigate showpiece. Finally, keep in mind what we said earlier about targeting your portfolio—selecting samples based on your intended reader—because that principle applies to online portfolios as well.

The sites listed below are from designers we interviewed for this book. Take a look at their online portfolios:

- *www.drawingspace.com*
- *www.cloudjammer.com*
- *www.positronicdesign.com*
- *www.animationannex.com*
- *www.pentagram.com*
- *www.mirkoilic.com*

If you want to learn how to maximize your online portfolio, read the following articles:

- "Pitching and Winning Assignments Online," by Travis N. Tom at *www.creativeattitude.com*
- "The Selling Portfolio" by Barbara Gordon at *www.commarts.com*

LEAVE-BEHINDS

The purpose of a leave-behind is to serve as a creative reminder of your particular style. Even if you don't get the job but your leave-behind is considered a "keeper," the designer or creative director will hang onto it in case they need a freelancer in the future.

A leave-behind is usually postcard size, 3½" × 5½" or 4" × 7". The leave-behind can also take the form of a CD, business card, brochure, or creative booklet. If you have sufficient work experience, create a specialty sheet of logos or Web sites. Whatever design you come up with, be sure your contact information is on it.

Chapter 7:
SECRETS TO SUCCESSFUL INTERVIEWING

Interviews are yet another opportunity for you to prove that even though you're in a creative field like design, you know how the business world operates. Sick of this refrain? It's true nonetheless! Let your designs show your flair and originality . . . but at interviews opt for the conservative approach.

An "interview" is a formal meeting between you and a prospective employer. That said, the smaller the company, the less formal the meeting may actually turn out to be.

If you receive a phone call for an interview, take the opportunity to solicit some basic information that may serve to calm your nerves. For example, will this be a group interview or one-on-one? Are there any additional materials you should bring? Will the meeting take place in the office or outside of the workplace? How much time is allowed? What if the directions aren't listed on the Web site? Even if you receive a letter instead of a phone call about the interview, it's still a fine idea to call and ask the above questions.

Your primary goal at an interview should be to do nothing or say nothing that will land you in the Reject pile. In other words, be on your very best behavior. And bear in mind that interviews are two-way streets. Setting aside your desperation to land a job that'll pay next month's rent, you should be scrutinizing employers as well to see if *you* want *them*.

Some employers are so overwhelmed with applicants that they conduct a ten-or-fifteen-minute phone screening first, to help them whittle the field down to a short list. Again, your goal is not to land in the Reject pile.

In larger firms, which tend to follow stricter hiring protocols, you may be invited in for an interview despite the fact that the hiring manager has already made up his or her mind as to who the chosen candidate will be. Not that this matter is ever discussed openly—especially with you. But the design world is a small one and afterwards you may hear the true story. Your response? Be grateful for the interview experience anyway and shrug off the rejection. There are other, better-for-you jobs out there . . . and, with persistence, you'll find your right spot.

What can you expect at an interview? In larger operations, you might meet first with a Human Resources person, then the Creative Director, possibly a team of designers. There may be a series of individual meetings, followed by a group interview. You may be taken on a tour or shown a film or given a brief history of the business. Sometimes interviews may even be conducted during meals. Don't be upset if your interview is interrupted so the employer can field an important call or make an urgent decision on a deadline-driven project. It's par for the course.

BEFORE THE INTERVIEW

Now that you have a clearer picture of what goes down at an interview, you can begin preparations to make a terrific impression.

As we pointed out earlier, in today's tight market, applicants must have far more going for them than just good design skills. With such fierce competition for a limited number of jobs, you'll have to polish your shoes as well as your answers to interview questions well in advance of the big day. Trust us, an interview is no place to wing it!

Jeffrey Fox, author of *Don't Send a Resumé* agrees with us. He says, "Most jobs are won or lost in preinterview preparation." We've devised these eight preinterview steps to increase your chances of success.

Research the Firm

Remember our advice to stand out from the pack? Do so by digging around and taking notes before the interview. For example, if you learn that XYZ Corporation is moving into European markets or this firm known for identify work is expanding into Web site development, find ways to work these tidbits into your spiel. More than two or three times is just plain showing off though.

Rehearse Your Interview Responses

What you say and how you say it can often make or break your candidacy so be prepared. We strongly urge you to jot down responses to the interview questions listed below so you won't be caught speechless. Don't memorize your responses, though, because you'll come across as stiff and stilted.

Frequently asked standard questions include:

- Why did you choose design?
- Why did you choose us?
- Who are your favorite designers?
- What three words best describe your design style?
- What three words best describe you as an employee?
- What are your three greatest weaknesses as a designer?
- What's the hardest design challenge you've run up against?
- Describe a difficulty or problem you ran into and what you did.
- Why did you leave so-and-so?
- Why should we hire you for this job?
- What kind of work (or clients) do you dislike?
- How do you feel about production work?

Be aware that some employers, like Cathy Teal of FireBrand Design in Palm Springs, California, will probe to seek more specific information:

When I interview, I want to hear how a person arrived at an idea, how it germinated and became a finished product. I want to know how candi-

dates think and what thought structure they use. I also want to know whether or not they have production skills. Can they flight-check a document for press? If something doesn't print well, it can kill you.

Other employers will throw out some trick questions that can trip you up if you haven't prepared; take for instance "Tell us a bit about yourself," or "What interests you in working here?" Trust us, they really don't want to hear about your parents' horrible divorce or that backpacking trip you took to the Andes. Another potential pothole is "Where do you see yourself in five years?" Don't be fooled into thinking this is the time to share that you expect to open your own shop in a few years, just as soon as you learn the ropes from the person interviewing you.

Practice Interviewing

If you've had little to no experience with interviews or if the notion of going on one makes your palms sweat and your blood pressure soar, you'll want some practice sessions first. You can do this informally with a friend or a working designer or in a more formal setting, such as a videotaped encounter with a career placement officer. While it's definitely ego-deflating to see actual proof of how silly you act on tape or hear how dopey your answers are, it's a truly educational and eye-opening experience. You brave souls who avail yourselves of this opportunity can't help but do better the second time around!

Another tip we offer sounds silly but do it anyway. Practice shaking hands with everybody around you for a few days. Handshakes are a form of nonverbal communication that reveals information about you; go for a firm but not bone-crushing approach. Women, this applies to you as well. No one likes to be on the receiving end of a limp handshake, which indicates weakness.

Develop Your Questions

At a certain point in most interviews, the person doing the interviewing will inquire if you have questions. Responding with a "Nope" will land you in the Reject pile.

The correct answer is always and forevermore "Yes, I do." This is when you whip out your questions you've carefully developed beforehand. Your questions should definitely *not* focus on what the company can do for you, like benefits, salary, vacation, or advancement. Below are some employer-centered examples to get you thinking:

- What are the top three qualities you're looking for in a designer?
- I see from your Web site that you're moving into more product identity work; how might this affect the work I'd be doing?
- How much of my daily work would be spent on _____?
- Is this a newly created position?
- Who would I report to?

- From what you know about me so far, what would be the biggest challenge I'd face?
- I read you've taken on XYZ as a client. Are there plans for the company to move into more designing for the _____ field?

Wardrobe

Decide what you're wearing no later than the night before your interview. As you select your clothes, remind yourself of this mind-boggling fact:

You have only ten to forty-five seconds to make a first impression! Why blow your big chance by a poor wardrobe choice?

Today's workplace dress codes have relaxed somewhat. You're no longer required to wear a two-piece black or navy suit for an interview, but that doesn't mean you can slide. One thing they'll be judging you on is whether or not you'd ever be presentable enough to take along to visit a client.

An interview is not the proper setting for you to display your keen fashion sense; on the contrary, you'll be dressing in a way that implies you know how to fit in, not stand out. Be aware that your choice of clothing can and does nonverbally communicate whether you know how the business world operates or not. Positively no jeans, no bare midriffs, no sneakers, no mini-skirts. While you're at it, remove the facial piercing adornments and cover your tattoos, if possible.

Your clothes should obviously fit you well but certainly not be body-hugging. No low-cut tops for women, no heels so high you wobble, and no bare legs. For men, we recommend bowing to convention by wearing a blazer or a jacket (save the leather for later) but you can leave off the tie so they won't confuse you with a banker. If our sartorial advice is a total turn-off, at the very least go in khakis, a cotton shirt with a collar and a tie.

"I always make it a point to wear a suit to an interview," Michelle Groblewski, Art Director at Supermodels Unlimited in Northampton, Massachusetts, told us when we visited her workplace. "I think it's important to go in full regalia because you're not in yet."

Double-Check Your Carry-Alongs

Because employers are human, they too can misplace items. Be prepared for any snafus. Take along two freshly printed (not folded) copies of your resumé and reference sheet. Carry them in a plain manila file folder or a nice binder. Pack your portfolio, as well as directions to the interview. Tuck your own interview questions into your pocket or purse. Don't forget your cell phone in case you get lost or run late and take along your day planner or BlackBerry in the event they want to schedule a second interview, a common practice in mid-size to large agencies.

Confirm the Appointment

Make a phone call the day before. Ask how many people will be at the interview so you'll have enough sets of materials.

Envision Success

Do you spend inordinate amounts of time terrifying yourself with negative mental pictures? Unfortunately, most of us do; however, experts have concluded that a startling 90 percent of what we worry about never happens. Our time could better be spent picturing success instead of failure.

In order to begin this final step, close your eyes again and take a few deep breaths. Invite your imagination to work overtime. Begin by picturing yourself at the interviewer's office, calm and collected, enjoying the easy rapport you have established. Envision yourself presenting an honest, complete summary of your qualifications. See yourself asking relevant, well-researched questions about the company. Feel the pride and relief as you depart, realizing you have interviewed flawlessly. Then imagine yourself at home; the phone rings and you receive an offer.

Preinterview Checklist

Not only is it wise to prepare mentally for an interview, but also it's a good idea to review this preinterview checklist, which summarizes several points we've already discussed. Running through it all again will help you ensure that you are in peak form for your big day.

When going on an interview, did you . . .

☐ Research the company and develop a list of questions to ask them?

☐ Prepare your answers to anticipated questions?

☐ Internally prepare by doing relaxation and visualizing exercises?

☐ Know how to dress appropriately for the occasion?

☐ Arrive five to ten minutes before the interview?

☐ Give a firm handshake?

☐ Make eye contact with the client or interviewer?

☐ Adjust to the style and tone of the client or interviewer?

☐ Identify and address key points in the discussion?

☐ Detect and respond to the implications of the interviewer's questions?

☐ Respond to unexpected questions and maintain your poise?

☐ Show your portfolio and discuss your process and/or results?

☐ Monitor your nonverbal gestures so you don't appear nervous?

☐ Stay focused on your purpose?

☐ Close strong?

AT THE INTERVIEW

Be sure to set an alarm the night before. Heck, set two. Do whatever it takes to get yourself together. On the morning of the interview get dressed and then check your reflection (front and back) in a full-length mirror to make sure you're presentable.

Don't take your pet and don't take your friend to the interview. Plan to arrive at least fifteen minutes early in case there's an application or form to be filled out. If you encounter an unexpected delay on your way, phone ahead to say you're going to be late. If you're more than fifteen minutes late, don't be surprised if you're asked to reschedule to another day.

As soon as you arrive at your destination, turn off your cell phone. It's considered extremely rude for you to take calls during an interview. However, the same does not hold true for the interviewer. If your interview is interrupted by phone calls or employees, maintain good humor and *never* show impatience.

While you're waiting, don't smoke, eat, or chew gum. Don't fidget. Don't be overly friendly with others who have work to do. Sit quietly and review the contents of your folder, hone your interview responses, or practice relaxation techniques. If you're asked to fill out an application, do it anyway even if it seems totally pointless since most of the same information appears on your resumé and reference sheet.

If the interview takes place at a restaurant, don't order soup (spills) or complicated dishes (shrimp with shells or anything with bones). Don't order the most expensive item on the menu. Don't drink or smoke. At all. Even if the interviewer does. Don't flirt.

If the interview takes place at the office, smile and shake hands with your interviewer. Don't sit down until you're invited to do so. Whatever you do, don't mention your nervousness. Monitor your nonverbal communication (also known as body language) so that you don't sit with your arms folded (indicates defensiveness), giggle or play with your hair, fingernails, or clothing (indicates nerves) or use fillers or slang in your speech (such as *you know, uhmm, like, cool*). It's up to the interviewer to set the tone (formal or informal) and pace of the meeting, so take your cues from his or her lead. Usually there will be a few minutes of chitchat before getting down to business.

Interview Questions

At some point, the interviewer will start by asking to see your book or else move into questioning mode. Let's pretend questions come first. You've already practiced your responses in your preinterview prep, right? If not, backtrack and read that section on page 76 now.

By the way, if, during the questioning phase, your mind goes blank or you get caught unaware, it's okay to respond with the following comments:

- "That's a good question. I'll need a minute before I answer."
- "I'm sorry. Could you please repeat the last part of that question?"

- "I'm not sure I understand what you're asking."
- "I've drawn a blank. Could we get back to that question at the end?"

During the questioning segment, remember to work in two or three pieces of information about the company that you learned during your research.

Portfolio Review

Vow never to let these words come out of your mouth during an interview: "My work speaks for itself so I'll just let you look at my book." That's lame, plus it shows you don't know how to play the game.

Sure, they want to see your book but, just as important, they want to hear you explain the process behind the work. Besides looking at your samples, they want to evaluate your thinking and speaking skills. They are looking for your ability to be articulate, a skill that they know will be required later on at client presentations.

Because you know how the game is played, you'll walk the interviewer through your portfolio, giving the spiel you've rehearsed. Be prepared to talk about your role in the samples you show and, if applicable, the results that each piece produced. As you proceed, expect some feedback. "Great stuff" or "I really like what you did here" is always nice to hear. At times you may undergo some probing, like, "What made you go with that shade of green?" or "How did you come up with that design?"

Some time you may encounter silence; if so, don't jump to the conclusion that it's a bad thing. Some designers just prefer to devote their full attention to your work; others may want to see how you handle pressure. Regardless, keep your confidence intact and don't start yammering away to fill up the silence.

Resist the temptation to apologize for the quantity or quality of your work because for sure you'll come across as a loser. If the unexpected occurs and an experienced designer critiques your work, don't flip out. Really, you are being given a gift, if you can just shove your ego aside long enough to appreciate it.

Salary Discussion

You lose major points if you ask about salary or benefits. Employers consider this a turn-off and doing so may well result in your getting sent to the reject pile. Rest assured, the employer will eventually bring the matter of money up, either at the interview or when an offer is made.

If you did your homework back in "Researching the Marketplace" on pages 46–48, you'll already know the average starting salaries in your field for your particular geographic location. If not, visit the AIGA Web site and check out Salary Guidelines or search on designer-type Web sites for more information about pay.

Always make sure you speak in terms of *salary ranges*. If you're asked, "What starting salary are you expecting?" an appropriate counter response could be, "I'm looking to earn somewhere in the $38,000 to $45,000 range, depending on the benefits package."

Ask Your Questions

At some point, the interviewer will ask if you have questions. This is your opportunity to a) show you're prepared, b) find out more about matters of concern to you, and c) sell to your strengths.

We recommend that you whip out your trusty index card with your questions already written down. (See pages 77–78.) This demonstrates your preparation and organization skills. At least one of your three to five questions should reflect the previous research you've done on the firm or their clients, which demonstrates your research skills.

Offer Your Leave-Behind

As discussed on page 74, it's typical for job-seeking designers to offer some type of promotional material as a leave-behind.

Close Strong

As the interview is concluding—and assuming you're still interested in the position—go for a strong closing, something along the lines of this:

> From what I've learned today, you're looking for somebody with a strong background in design and Web site development, plus a person who can get up to speed right away and be a good team player. I hope I've convinced you that I can make a substantial contribution. I really want this job.

After you've said your piece, don't expect an offer on the spot since very few job offers are extended at the interview. It's okay to inquire when they expect to conduct second interviews and/or make their hiring decision. Offer thanks for the opportunity to interview, shake hands, and head out.

If you are lucky enough to receive an offer but the salary is disappointing, you can attempt to negotiate a higher salary. However, if you have limited or no experience, you can't really expect much in the way of a counteroffer. A fallback approach is to request a shorter salary review period. For example, instead of settling for the standard six month review, try negotiating upfront for a two or three month review period.

AFTER-INTERVIEW COMMUNICATION

Frequency can be an important factor in getting your message across, right? That's why we recommend you take the following actions, which allow you to optimize your chances of reappearing on the employer's radar screen.

Send a Thank-You Letter

One way to stand out from the competition is to send a thank-you-for-the-interview letter. Some experts say to make sure this is done within one week. *Our advice is get this letter in the mail within twenty-four to forty-eight hours.* Why? One,

Taylor Hersh

55 West 26th Street (22A)
New York, NY 10001
212-842-5318
tayl522@aol.com

March 26, 2004

Ms. Pam Reeve
Creative Officer
Ogilvy & Mather
309 West 49th Street
New York, NY 10019

Dear Ms. Reeve:

Thank you again for the chance to interview with you for the copywriting position. I really enjoyed meeting you and the other members of Ogilvy & Mather's creative team. Spending the day with you in the office, watching how things work, was an extremely beneficial experience.

The interview only further convinced me of how compatible my skills and goals are with the objectives of Ogilvy & Mather's creative team. As you pointed out, my portfolio expresses both conceptual and writing abilities needed to create great advertising. I am confident my work for you will create just that.

When going over the interview later that day, I realized that I overlooked mentioning a past experience I had with Ogilvy & Mather. As a junior in college, I was fortunate enough to take a full-semester class at the agency. My class was taught by John LaMacchia, Creative Director, and I used several of the pieces I created in his class in my internship portfolio, for my senior year.

I appreciate your hospitality, and thank you for considering me for the position. I look forward to hearing from you, and remain hopeful that I can become a part of your creative team. After my experiences at Ogilvy & Mather, I am certain that it would be an amazing place to work.

Sincerely yours,

Taylor Hersh

Taylor Hersh

Thank-you letter following an interview

it positions you as a go-getter. Two, it also puts your name before the hiring manager or committee again. Three, it allows you to emphasize how your qualifications specifically meet their needs. If it dawned on you the day after the interview that what you really should have said was . . . well, the thank-you letter is your chance to add that point.

"At my initial interview, I generally create an excuse to have to get back in contact," New York City Web site designer Shamus Alley says. "Sometimes I mention I will send some additional URLs so they can see what I've designed, or sometimes I say I'll crunch some numbers and get back to them with my salary expectations. I always close my letter by thanking them for the time they spent with me."

Maybe you're thinking that a handwritten note or an e-mail will suffice. Forget it.

By sending a business letter you are showing, once again, that you know the ins and outs of the business world. The letter doesn't have to be long—three paragraphs are plenty.

Paragraph One: Jog their memory about why you are writing and thank them for the interview, noting one thing that you particularly enjoyed: the tour, an orientation film or power point presentation, a folder of company literature you were given.

Paragraph Two: Summarize your qualifications, highlight any courses or experience that you forgot to mention previously, and emphasize how you can help them solve the problems they face (without going overboard and sounding arrogant, of course).

Paragraph Three: Reiterate your desire to work there. Indicate your willingness for a second interview, if necessary. If you left your portfolio, repeat when you'll be by to pick it up.

Make a Follow-Up Phone Call

What to do if the deadline they specified for making a decision comes and goes with no news? Put together a little script *before* you pick up the phone. It might go like this:

> Hello, Ms. Bouchard. This is Taylor Hersh. I interviewed with you a week ago for the creative assistant position. I'm still very interested in the job and I'm calling to inquire about the status of your search. Have you made a hiring decision yet?

If no decision has been made, inquire what the timeframe is and repeat your interest. If a decision was made and it wasn't you, at least you know to mark this option off your list. Thank Ms. Bouchard for her time, maybe ask her to consider you for freelance work, and move on.

Reject Rejection

Let's say you *really* wanted that one particular job and you're reluctant to abandon all hope of working for such an outstanding company. There is actually one more step you can take: you can send a follow-up letter. Your basic points to cover are these:

- Why you're writing (sorry I didn't get the job)
- Why you want to work there (compliment two or three things)
- Keep me in mind if the job comes open again or if there's a need for temporary or freelance work (include your business card)

After that, let it go for a minimum of three to six months. If you haven't landed a job by then, perhaps you'll decide to write up a phone script or letter, screw up your confidence, and visit the well one last time. After all, persistence is a laudable trait; being a pest is not.

Chapter 8:
SETTING UP YOUR OWN SHOP

Maybe working full-time for an established firm has never figured into your idea of the future. Instead, after graduation you've chosen freelancing and/or temping as a means of beefing up your portfolio and making the right connections until you've gathered enough experience *and* clients to open up your own studio.

Another scenario is that you've already worked for a few years for a firm or studio, and have built up the requisite confidence (and nest egg!) to launch your own operation. In an ideal world you already have some business courses or seminars under your belt, so you're not totally green when it comes to running a business.

Regardless of *when* you made the decision to fly solo, you can bank on this one truth: Establishing your own design business is very rarely something that falls together overnight. The risk is high, the competition is incredible, and you *don't* want to fail. Therefore, you need to focus your energy on completing some essential tasks that will pave your way to a successful start-up. Once again, we'll be concentrating on the writing skills you need to master.

Start-Up Checklist

Here's our list of essential building blocks you need to have in place before the successful launch of your business:

☐ Designated space

☐ Equipment (hardware and software)

☐ Financial cushion (at least three months' salary cushion; six is better)

☐ Line of credit at the bank

☐ Basic business fundamentals (telephone, fax, answering machine, bookkeeping system, client tracking methods, database management, etc.)

☐ Appropriate paperwork addressed, which varies depending on location (Sole proprietorship, LLC, partnership, incorporation? Employer Identification Number, also called an EIN, used in lieu of your social security number? Licensing? Permits? Zoning?)

FIGURING OUT YOUR POSITIONING

While the desire to succeed is terrific and will carry you a long way, alas, it's no guarantee that you'll wind up where you want to be. To reach your goals, you must invest both hard work *and* careful planning.

Let's begin by getting a handle on your own unique skills and characteristics, the first step in figuring out your positioning. "What the message should boil down to is simply, 'This is who we are, what we value and why you should consider working with us,'" Linda Cooper Bowen writes in *The Graphic Designer's Guide to Creative Marketing*.

First Take

To begin identifying what makes you stand out from other designers, jot down responses to these questions:

- Why am I in design?
- How will I stand out from the others?
- For what do I wish to be known as a designer?
- What image do I want to project?
- What range of services will I provide?
- What type of clients do I want to serve?
- What kind of work do I want to do more of?
- How will I differentiate my business from my competitors?
- What name will I use to operate my business?

Second Take

This next exercise will lead you closer to being able to communicate your message to clients easily, quickly, and completely. First, read aloud your responses to the questions above. Next, try to describe the essence of your design business in one hundred words or less.

Now reduce what you have written to twenty-five words or less. Your goal is to be clear, complete, and brief. It may take several attempts before you're sat-

isfied with your positioning, but we encourage you to keep tinkering until you nail it. For now, let's look at some examples of how other graphic designers have addressed the issue of positioning:

> **Positronic Design** is a full-service marketing and promotion company, which creates excellent, cost-effective print and Internet materials for our clients. We do this by combining our creative and technical skills along with our knowledge of business and marketing to conceive, design, write, illustrate, photograph, and render in final form beautiful print jobs and Web sites.

> **Animation Annex** pushes the combination of video and 3D animation to the next logical level by integrating them together to produce a marketing, engineering, and training tool that takes you inside processes that can't be seen during normal operations, or to a structure that exists only on the drawing board.

> **True North Video Marketing** is a full-service agency specializing in video production and marketing.

> **Advertising Art Studio** is a branding consultancy specializing in consumer product goods packaging.

IDENTIFYING TARGET MARKETS

Before you create a design, you must first determine your audience, right? The same principle applies when it comes to promoting your own design business. Identify your potential clients as specifically as possible *before* you create a promotional mailing campaign to attract them.

Who are these potential clients? Answer these two important questions first: What kind of clients can I reasonably expect to attract, given my experience? Who in my neighborhood (or borough or town or region) could benefit from my services?

The next three exercises will take you even further down the path of identifying your target markets.

Go Digging

When you're starting out, typically your target market consists of small businesses mentioned in newspaper and magazine articles, business-to-business (B2B) directory listings, trade journals, and the yellow pages. Start digging.

Call the Chamber of Commerce about obtaining a list of new businesses that have recently joined the Chamber. Befriend a local librarian. Run a database search. Take note of grand opening notices. Comb through organizational membership lists. Consult regional or local talent directories.

Consult the latest edition of *Artist's and Graphic Designer's Market*, an annual listing of over 2,500 markets for design work, complete with details about contacts, pay, and subject matter. Produced by Writer's Digest Books, the *Market* is also available in an online version.

Create a Prospect List

Copy down all contact information carefully on index cards, one for each listing and divide the cards into A-B-C lists (twenty to forty per group), based on your preference order. Another method is to create database lists with separate categories.

To greatly increase your chances of succeeding with targeted mailings (more on that on page 97), you must reach the person in charge of making decisions. Time for a little sleuthing. Contact the firm and solicit that information from the receptionist. Double check the spelling of the name, no matter how simple it may be. ("That's J-o-h-n M-i-l-l-e-r, right?"). While you have the receptionist on the phone, request the e-mail address of the decision-maker so you won't have to call back later. Enter all information under the heading of Prospects. Double-check all spellings and addresses by comparing the index card to the computer printout. As we pointed out earlier, misspelling a name or getting the address wrong makes a negative first impression, one that you may never have the opportunity to correct.

Think Sideways

Next it's time to review the work you already have in your portfolio. What spin-offs or niche markets come to mind? For example, have you designed menus or Web sites for restaurants or bars? In that case, maybe food suppliers are a logical next step. Or have you photographed or illustrated for garden products or flower shows? What about tapping into related markets like fertilizer manufacturers or florists? Are there other auxiliary markets that occur to you? If so, make note of them now.

WRITING A MARKETING PLAN

Figuring out positioning and identifying target markets are parts of a bigger picture—namely, your marketing plan. According to the majority of design experts we consulted, *marketing is the single most important factor in determining whether you make it as a designer or not.*

Yet sometimes this important message falls on deaf ears, particularly among fledgling design firms. They blow off the advice entirely, approach marketing in fits and starts, or never get around to actually setting aside the money to carry out their plans. Without a written marketing plan, you are far more likely to fall prey to the feast-or-famine cycle that plagues small businesses everywhere. Once you're on that slippery slope headed downhill fast, even your best last-ditch marketing efforts may not be enough to save

you from a nasty crash. Therefore, resolve to make marketing a priority in your business.

All sorts of definitions abound about what the term "marketing" means but we like the one offered by former graphic designer and marketing consultant Linda Cooper Bowen in *The Graphic Designer's Guide to Creative Marketing*: "Basically, *marketing* refers to the process of finding, creating, attracting, and satisfying the client. This process, as I continue to emphasize, is constant and not limited to an annual calendar or quarterly mailings. Every single conscious or spontaneous thing you do to find and keep business is marketing."

Your very first step in attracting clients should be to map out a plan. "Without deadlines and directions, you will flail about and eventually drown," Lee Silber, author of *Self-Promotion for the Creative Person,* warns. "Not having a promotional plan is a sure way to waste time and money. Make marketing a priority and set aside time to do it, even if it's only a few minutes a day." Silber is so committed to this philosophy that he says he won't let himself go to sleep unless he does at least one task every day that furthers his marketing plan.

The rewards that come from putting together even a very simple marketing plan far outweigh the aggravation. A marketing plan offers these benefits:

- Serves as a written road map to keep you on track
- Helps you prioritize your time and energy
- Saves you from wasting a lot of money
- Reminds you that your survival depends on being both a skilled businessperson *and* a terrific designer

Writing a marketing plan also forces you to keep uppermost in your mind a very important fact of life that's easy to forget: While you may be swamped with work today, you must *always* keep an eye out for new clients. Follow the advice of seasoned design professionals and devote from 15 to 20 percent of your time and budget to promotion; another alternative is to set aside one day a week for marketing matters.

The Parts of a Marketing Plan

As you know, the earmark of a good design concept involves two elements working in tandem—original thinking and strategic planning. These same two skills you've already developed as a designer are equally applicable when it comes to writing your first marketing plan.

Marketing plans don't all look the same. They come in a variety of styles and lengths. Your first one should be a serviceable document that is easy to follow, logical and organized in a sequential game plan for marketing your business. Even a one-page plan is a whole lot better than no plan at all.

Most marketing plans have three common elements, as Cameron Foote points out in *The Creative Guide to Running a Graphic Design Business:*

1) they detail the marketing mix, the what, when, and where of the various activities; 2) they indicate what resources are required and what the cost of them will be; and 3) they project what results can be expected and when.

Drafting Your Plan...

1. *Activities.* In the first section of your plan, generate (by brainstorming, mind mapping, or creating lists as discussed on pages 16–17) the action steps most likely to attract clients. Depending on whom you identified as your target markets, you may need to send different messages to different audiences using different media. To illustrate this point, imagine you're setting up your own shop. Let's say you have prior design experience in branding for food manufacturers, you enjoy producing corporate newsletters, and you'll work with start-ups on logos, signage, etc. Your activities could include creating a Web site for yourself, sending out news releases announcing the launch of your business, placing an ad in the yellow pages and/or local newspaper, writing a prospecting letter to selected audiences, hosting an open house at your studio, and making eight corporate sales visits a month.

Now think about your target markets. What activities will best reach each individual market? And which choice of medium will you employ to accomplish your purpose? Once you have generated a broad list of possible marketing activities for each market segment, narrow your list down to what's a) essential, b) doable, and c) affordable.

2. *Timelines.* When you're satisfied with a shortened version of activities, next develop timelines. Since you're just launching your marketing efforts, we recommend you map out a year in advance. Later, as your freelancing business lifts off, you can revisit this document and revise it as you see fit.

For now, we suggest one of two approaches. Divide the year into three columns, labeled one to three months, three to six months, and six to twelve months and slot in the activities. Another way to get your ideas down on paper is to sketch twelve boxes (one for each month) and plug in the activities.

3. *Budget.* Assign an estimated price for each activity.

4. *Projected Results.* Finally, you need to set some reasonable outcomes that you can expect to realize from each activity, which we call projected results. For example, let's say you send out a direct mail piece to five hundred people at a cost of five thousand dollars. You project results of fifty calls and five new clients, each of whom brings you ten thousand dollars-plus worth of work. Now go back to your list of activities and specify projected results for each of them.

A final word of caution: Once you're satisfied with your written marketing plan, post it where it will haunt you. Review it frequently to make sure you're on target. Amend it if and when changes need to be incorporated. The bottom line is *use* it.

Establish a Marketing Budget

In doing the above exercises you probably discovered your creativity and your enthusiasm far exceeds your limited budget. Just how little can you actually get by on for your initial marketing budget? That may depend to a large extent on your good old creative thinking and/or your ability to barter services.

We pass along some standard formulas that start-up or mid-size design firms use as a guide in determining marketing funds:

- Set aside 5 percent of gross revenue per month
- Earmark two thousand to five thousand dollars per year
- Dedicate 10–25 percent for marketing and promotion

WRITING A BUSINESS PLAN

Another powerful aid that helps you succeed is a written business plan; conversely, the lack of a plan is a precursor to failure. While the choice is up to you, we urge you to put together at least a rudimentary plan because it is a catalyst for clarifying your thinking. Besides, if you're intending to borrow funds to finance your start-up, a business plan is mandatory. Why? Because no sane person will invest money unless you can prove on paper that you're a sound financial risk.

Get Help

If the mere thought of tackling a business plan gives you a migraine, rest assured there are many free resources available online to help you. Here are just a few helpful sites that offer tips for preparing business plans and/or provide some easy-to-follow samples:

- Small Business Administration *www.sba.gov*
- National Small Business Development Center *www.sbdcnet.usta.edu*
- Service Crops of Retired Executives *www.score.org*
- Business Resource Center *www.morebusiness.com*
- Local small business assistance initiatives listed in the yellow pages

If you want advice specific to design firms, download Cameron Foote's article, "Business Planning: The Exasperating Made Simple," available for purchase at *www.creativebusiness.com*. This article includes a sample informal business plan for freelancers as well as a formal business plan for multiperson shops. Another source you'll find very useful is Cooper Bowen's *The Graphic Designer's Guide to Creative Marketing*.

Business Plan Components

First, different so-called "experts" utilize different terms for the parts of a business plan so don't be confused when you run across this phenomenon in your

reading. Second, in an effort to make this section as simple and useful as possible, we've reduced the parts to those that will provide you with the bare essentials of a business plan and yet won't take months to write:

- Description of business *(mission statement, services offered, clients)*
- Marketing Section *(market analysis, competition, and market strategies)*
- Financial Data *(start-up costs, monthly cash flow and overhead, sales projections, pricing, break-even points, potential funding sources)*
- Management Section *(applicable only if employees or freelancers are utilized)*

An optional feature included in some business plans is a Critical Risks Section or Contingency Plans. This shows you've given consideration to things beyond your control that might occur but for which you have, nonetheless, developed alternative plans.

Chapter 9:
BUILDING YOUR INITIAL BUZZ

Opening your own studio means the pressure is on to bring in clients. Here are some strategies to accomplish that goal.

PROFESSIONAL IDENTITY PACKAGE
Since you've already figured out your positioning, it's time to design a professional identity package for your business. This includes logo, tagline, business cards, brochures, letterhead, and related material like envelopes or notepads, mailing labels, and extra adhesive logos that can handily customize plain folders, a low-cost alternative to more expensive printed or embossed folders. Use the same color and typography on your Web site and signage as you used on your print materials. The one hard-and-fast rule here is that consistency rules; make your "look" uniform.

Here are some things to avoid:

- Miniscule type that excludes some of your potential near-sighted clients
- Pale-colored ink
- Overly complicated typography or too many fonts in one document
- Reversed-out type too small or not high-contrast enough to read

The Web site and e-mail you use for your personal life is probably not appropriate for your professional persona. Play it safe and make necessary adjustments before your entrée into the business world. The same is true for phone lines. Business people like you should establish a dedicated line (keep receipts; it's a tax-deductible expense). Even the message on your answering machine can contribute to (or detract from) your professional image. (See page 199 for more details.)

MAILING LISTS
Before you mail out that totally cool and incredibly creative announcement about the launch of your design studio—the one that will hopefully result in clients clamoring for your services—you have to create a mailing list to send it to, right?

Unfortunately, creating and maintaining a mailing list falls under the category of grunt work. While it may be a tedious and boring chore, you still need to do it because your marketing campaign stands a much better chance of success if you work with an accurate mailing list. What about purchasing commercial lists

of people who buy creative services? If you're in start-up mode, that option is probably a budget-breaker for right now. Following these six time-and-labor-saving steps will reduce your mailing list workload:

1. *Determine what mailing list software you'll be using.* Excel, Access, and Filemaker/Pro are popular choices. So are marketing software packages like Act! and Telemagic. Play around with whatever program you choose until you've figured out the basics.

2. *Set up some system of categorizing.* For example, your list may look something like this:

- *Clients*
 - Past clients
 - Current clients
 - Dream clients
 - Prospects
- *Vendors and Suppliers*
 - ones you have worked with
 - ones you aspire to work with
- *Creatives*
- *"Friends" of your business* (teachers, relatives, friends, cyberpals)

3. *Create an expanded hit list.* Remember that section a few pages back, the one called "Identifying Target Markets" beginning on page 89? Take out those lists you made (or backtrack and go create them now).

Next sift through listings in your Rolodex, your BlackBerry or, your e-mail Address Book. What about business cards you've collected and all those little slips of papers or beer coasters with scribbled numbers or Web sites?

Add names of people for whom you've worked, for pay or as an intern. How about professional groups or organizations that you belong to? Do you already have their membership lists? If not, call to see if they'll give you one or sell you one for a small fee. Ditto for conferences you've attended. Does the school you graduated from publish an alumni list, particularly one broken down by majors? If so, request mailing labels or lists.

What about fellow creatives—especially ones further along on the freelancing path—who may be willing to share names or provide you with their mailing lists?

4. *Enter the listings into your database.* Make the entry as complete as possible, including names, titles, addresses, e-mail addresses, Web sites, phones, etc.

5. *Flight-check your mailing list.* By that we mean print out the entire database and then scrupulously proofread it. Errors on a mailing list can cost you money and it can even cost you clients. Remember, if you can't spell our names correctly, we sure don't want to do business with you!

6. *Update frequently.* Once your mailing list is good to go, realize that your work is not over. This mailing list is one of your most valuable business assets;

update it carefully and frequently so you won't make foolish mistakes, like sending a former client a notice of a new customer promotion. Also when an e-mail bounces back, make a phone call and obtain the correct e-mail, then enter the new info in your database.

Once or twice a year overhaul your list—or better yet, have an intern or clerical do it during slow periods. Call each contact, say you are upgrading your mailing list, and verify the information you have on file is correct. This way you'll stay informed about job hoppers and/or promotions.

PROMOTIONAL MAILINGS

By "promotional mailings," we mean the letters, brochures, flyers, postcards, presentation folders, and other collateral materials that freelancers and small design firms use to market their own services, as well as those of their clients.

In *The Business Side of Creativity*, author Cameron Foote advocates that small and mid-sized firms choose direct mailers as their promotional medium of choice. "When done well and mailed to the right people, direct mailers create more immediate impacts than any other type of promotion," he explains.

Four Pointers about Promotional Mailings

1. *Long-term Investment.* The first thing you need to realize about promotional or direct mail is that it may take time (and repeated mailings) to get a response from your prospective clients. Marketing specialist Maria Piscopo sums it up this way, "Repetition leads to recognition, which leads to response."

You will do well to remember that a promotional mailing is neither a shotgun approach nor a one-time shot; rather it is an important part in your concerted, ongoing efforts to reach your target market.

2. *Frequency.* When you're creating a promotional campaign, frequency beats impact. This may be a bitter pill for many impact-loving designers to swallow. However, when you're operating on a shoestring and cost is a determining factor, make the wise decision to spend your dollars on frequency.

How frequent? Freelance illustrator and graphic artist Michael Fleishman advises, "I myself believe a mailing every forty-five to sixty days is an extremely effective program."

3. *Response.* Develop a realistic expectation about the response rate. Direct mail is considered effective if it garners a 2 to 5 percent response rate. What can you do about such a poor return, you wail? Keep plugging away is our answer. The sooner you get that first promo piece in the mail, the sooner prospective clients may contact you.

4. *Audience.* Last, remember that promotional mailings are useful not only in attracting new customers but also in keeping you on the radar screen of past and present clients. Periodic promotional mailings remind your clients that you're still around and eager to work with them again.

The Predesign Work

1. *Get your creative juices flowing with a little research.* Before you begin designing your first promotional mailing, check out what other creatives have done by browsing through the Self-Promotion categories in any of the many annuals and creative directories, such as *Communication Arts, HOW*, or *Print*. Also if there are local competitions in your area, scope out those winners.

2. *Gather information about bulk mailing.* Call or visit the United States Postal service Web site at *www.usps.com*. Familiarizing yourself with bulk mailing regulations (for mailings in excess of two hundred pieces) may save you both time and money.

3. *Review "Boosting Your Design Career Through Improved Communication Skills" beginning on page 1.* Then compose a promotional message that observes the ABCs of effective direct mail:

- **A**rrest attention
- **B**e easy to read and understand
- **C**ontain a single focused message
- **D**irect your reader to take a specific action
- **E**mphasize a client-centered point of view

4. *Make your message all about your reader, not all about you.* Your text absolutely, positively must convince prospective clients that you understand their needs and you are the one best suited to helping them meet those needs. If your copy merely extols the features you offer and plugs your creativity, chances are very good that your message will get ignored.

5. *Approach your writing with the certainty that it will take numerous revisions to nail your message.* Once you think you've achieved the maximum impact, circulate your promo mailing to select audiences for feedback. Revise, revise, revise. The last step is to proofread several times until your message is letter-perfect.

6. *Know you don't have to go it alone.* Suddenly developed a bad case of jitters about writing top-notch copy *for yourself*? You can bring in a talented copywriter. Offer to barter services, your designs for his or her words.

7. *Finally, before you rough out some concepts, think about multipurpose usage.* For instance, can your promotional pieces be used as leave-behinds after an initial client meeting or passed out to new people you meet? What about as self-mailers or as an insert in a presentation packet (more on that in a minute)? Maybe you can hang direct mail pieces on neighborhood or community bulletin boards or hand them out as calling cards when you exhibit or attend trade shows.

The Initial Promo Piece

Your initial promo piece has two primary purposes: get the word out that you're open for business and create a desire in your reader's mind to contact you.

If your initial promo piece succeeds, then you'll receive an invitation to meet. Hopefully, that meeting leads to actual assignments or invitations to bid on proposals.

"You want to intrigue a prospective client with a promo piece that demonstrates the high caliber of your work, so you'll want it to be one of the best-designed and well-crafted things you've ever done," advises illustrator Mike Fleishman.

You also want to create a design that will impress your audience—not just other designers. In *The Business Side of Creativity*, Cameron Foote cautions, "Much of the material creative individuals and firms produce for themselves focuses too much on trendiness and techniques and too little on showing their ability to understand and solve complex communication problems."

Design-wise, your initial promo piece can be any size or shape, limited only by your imagination and your budget. It can take the form of a brochure, a card, a specialty sheet, a flyer, or the centerpiece in a presentation folder. You can go bold with black and white or splurge on four color. Print your initial promo in-house or hire a printer. Send it as a self-mailer or in a number ten envelope with a cover letter. (More about that is coming up shortly under "Targeted Mailings" on page 108.)

Brochures

A brochure provides a succinct overview of your abilities as well as printed samples of your work. While design is important, of course, brochures rely heavily on copy to get your message across. It's okay to start with a simplified version (sometimes referred to as a "Slim Jim" because it's a two or three fold small enough to fit in a number ten envelope), which can be tweaked as your portfolio and client list swells. The more sophisticated and full-blown version, a capabilities brochure, is often a designer's standard promotional piece useful at all stages of his or her career.

Brochures typically include the following:

- Capabilities (the services you provide)
- Artistic vision or philosophy
- Inducement (prompts customers to contact you for something they need or want)
- Listing of clients and/or testimonials
- Selected samples of your work
- Your bio
- Memberships
- Contact info

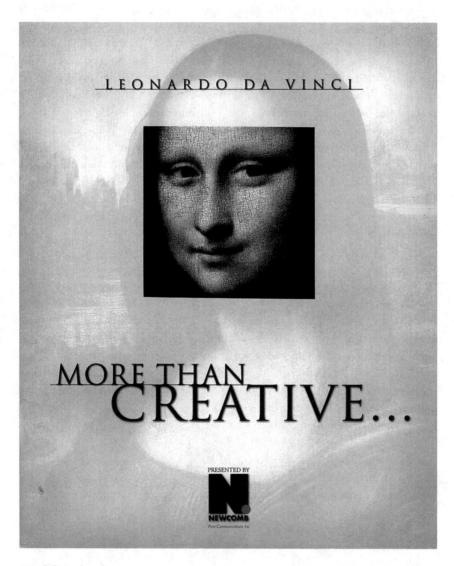

Capabilities brochure

What impression will your project have on your audience? This is a very important question, one that Newcomb considers strategically whenever we begin work for a client. Is the purpose to build your business' name recognition or image? Is it designed to garner a strong response? Is it going to help your company build profits, reputation, or both? What emotion should it evoke in your audience. . . . Admiration? Friendliness? Desire for your product or service? We help you find the answers, and then we make sure the printed communication makes the right impression to accomplish your objectives.

LADY WITH ERMINE

Capabilities brochure

Wages Design, Inc.
887 West Marietta St.
Studio S-111
Atlanta, GA 30318
www.wagesdesign.com
t. 404.876.0874
f. 404.876.0578

WAGES DESIGN, INC.

THE PLACE: Strategic design consultancy housed in former plow factory turned arts center. It's not heavy farm equipment but 21st century brands we're forging.

THE GOAL: Help clients achieve an integrated presence across all relevant media. From core identity development to full-strength, broad-spectrum branding, we create design that incites positive change. Moving our client-partners and their brands toward accelerated growth.

THE PEOPLE: A staff of highly talented people who speak five languages collectively. Not including their fluency in print, interactive, environmental design and the inspired strategy that drives it. Creative director and founder Bob Wages brings 20 years' experience to the task.

THE PRACTICE: One of the best identity firms in the country continues to embrace print and new media with unbridled virtuosity. Corporate and product naming. Packaging and print promotions. Advertising and annual reports. Exhibit design and dynamic interactive. Including database-driven web sites. We project your voice and vision with power.

THE CLIENTS: Antec, Assurant, Berkeley Process Control, Bowcutter, Canada Life, Cox Communications, Datalex, Delta Air Lines, DuPont, Georgia-Pacific, Georgia State University, Kids II, Rex Corporation, and UPS.

THE RESULT: From broadband networks to child development toys, we build foundation identities and powerful, integrated presence programs for business-to-business and consumer brands, start-ups and multinationals. And we have fun doing it.

Capabilities brochure

Extending *distribution channels*

1. Datalex, a technology company specializing in the travel industry required brand roll-out to include collateral, web, trade show, and annual report.

2. Identity development for Bowcutter Technologies, a technology company. Roll-out of identity to web site, collateral, and an interactive sales presentation.

Online capabilities brochure from Wages Design

Mini-portfolios

Mini-portfolios can be a great attention-getter for prospective clients. Even the most harried among us can squeeze out a few moments for a quick peek. *The Works: A Creative Archive* from Regole Design in Tucson is reproduced below. Measuring 4" × 6", this fan book is a colorful bonanza of samples inside black embossed covers that earns high marks for a creative piece that both shows *and* tells.

Another approach involves sending the mini-portfolio cover and one or two inserts followed by monthly or semimonthly installments. While the serial aspect is a clever way to maintain frequent contact, the downside is that harried readers probably won't invest the time to locate the cover and stick in the inserts.

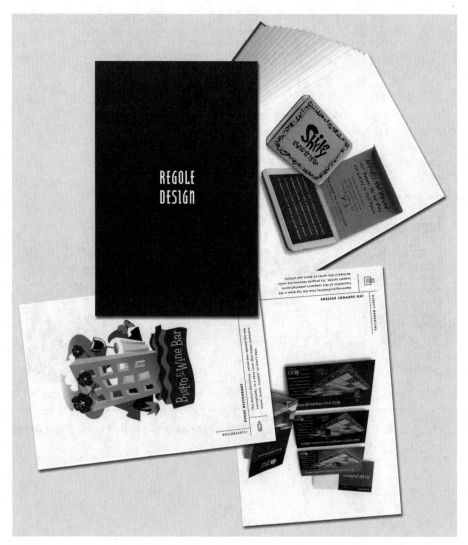

Mini-portfolio

Postcards

Like the capability brochure, postcards also pack a punch and deliver results. Here's a captivating one from Positronic Design in Holyoke, Massachusetts.

Newcomb Marketing Solutions in Michigan City, Indiana, sent this announcement about their name change.

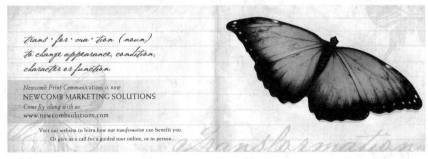

Other Promotional Mailing Options

Specialty sheets are typically 8" × 11" promotional pieces that focus on one thing. For example, a specialty sheet is useful to showcase a variety of logos or thumbnails of Web sites you've designed. Another use of specialty sheets is to reach a specific audience, such as restaurateurs, feed store suppliers, or perfume manufacturers.

1998 - International Logos & Trademarks IV
1998 - Letterhead and Logo Design 5
1998 - New Logo & Trademark Design (Japan)
1998 - More Logos & Letterheads

1998 - New Logo &
Trademark Design (Japan)
2000 - LOGO 2001
2000 - Summit Creative Award, Silver

1998 - New Logo & Trademark Design (Japan)
2000 - Bullet-Proof Logos
2004 - Logo Design for Small Business 2

1998 - New Logo &
Trademark Design (Japan)
2000 - LOGO 2001
2001 - Letterhead and Logo Design 7
2002 - Graphically Speaking
2003 - LogoLounge, Volume 1
2005 - New Logo: One (Singapore)

1999 - American Graphic Design Award
2000 - LOGO 2001
2000 - New Logo & Trademark Design 2 (Japan)

1998 - New Logo &
Trademark Design (Japan)
2000 - LOGO 2001
2003 - LogoLounge, Volume 1

1998 - New Logo & Trademark Design (Japan)
2004 - Logo Design for Small Business 2

2 BOYS IN A BED ON A
COLD WINTER'S NIGHT
1998 - New Logo &
Trademark Design (Japan)
2000 - LOGO 2001

1998 - New Logo & Trademark Design (Japan)
2000 - Bullet-Proof Logos
2000 - LOGO 2001

International award-winning corporate, retail, restaurant and nonprofit graphic identity

1998 - New Logo &
Trademark Design (Japan)
1998 - Great T-shirt Graphics 3
2000- LOGO 2001

1998 - New Logo &
Trademark Design (Japan)
2000 - LOGO 2001
2005 - New Logo: One (Singapore)

KIMBERLY WEBSTER
1998 - PRINT's Regional Design Annual
2000 - LOGO 2001
2000 - New Logo & Trademark Design 2 (Japan)

1999 - American Corporate Identity 15
2000 - LOGO 2001
2000 - New Logo & Trademark Design 2 (Japan)

1998 - New Logo &
Trademark Design (Japan)
2000 - LOGO 2001

1998 - New Logo &
Trademark Design (Japan)

DI NE TUTCH
MANAGEMENT CONSULTANT
1998 - New Logo & Trademark Design (Japan)
2000 - Bullet-Proof Logos
2000 - LOGO 2001

DIVERSITY NETWORK
2000 - American Corporate Identity 16
2000 - LOGO 2001

Post Office Box 17155
Portland, OR 97217-0155

Phone: 503/ 283-8673
Facsimile: 503/ 283-8995

jeff@jfisherlogomotives.com
www.jfisherlogomotives.com

Specialty sheet

Samples require the clients' approval to use. They may consider the material proprietary, in which case the client won't want competitors to get hold of it. If your client gives you the nod to proceed, tack a hundred or so copies onto the print run. In exchange, you can pick up the tab for the overrun or lower your price accordingly. Either way, you wind up with some nice high-quality samples at a much lower cost.

710 N PLANKINTON AVE, MILWAUKEE, WI 53203-2454 · PHONE: 414-276-6306 · FAX: 414-276-7925 EMAIL: ADARTS@ADARTS.COM · WEB: WWW.ADARTS.COM

Client: Con Agra
New Package Design
Design, Illustration & Name Generation

Sample page

Presentation folders are yet another choice. This is a versatile marketing tool, easily customized so a prospective client has all your relevant materials in one place. You can insert brochures, specialty sheets, business cards, CDs, relevant samples of your work, and other materials as a leave-behind for a prospective client. You get double mileage out of presentation folders if you also use them to submit proposals. Check the RFP specs first to be sure there are no restrictions about covers.

Targeted Mailings

A targeted mailing is a personalized letter, which is accompanied by a capabilities brochure, flyer, specialty sheet, or some other promotional piece. The personalized message has three purposes:

- Notify clients of your services, stressing your expertise in their arena
- Convince them of the benefits they will gain by enlisting you to help them solve their problems
- Make it easy or desirable to respond

Without duplicating the message already contained in your brochure, this one-page letter will be three or four paragraphs long, perhaps with an incentive to get the reader to respond within a specific time frame.

Incentives work only to the degree that you offer something your potential client needs or wants. Here are some standard incentives:

- Free calendar or poster
- Special publications that educate the reader, such as guides, checklists, or tip sheets
- Free assessment or consultation (the more specific, the better; for example, will you focus on logos, ads, or the total identity package?)
- Introductory discounted rate on specific services
- Complimentary newsletter (electronic or printed)
- Invitation to a special demonstration or tour of your studio

To maximize your letter's chances of being read, follow these seven steps to make the targeted letter look more inviting:

- Use business letterhead
- Create an irresistible lead that speaks to reader's situation
- Emphasize and quantify results you've achieved
- Keep your message short, using bullets or special headings to enhance readability
- Address the letter to a particular individual, not just a generic "Dear Creative Director"
- Personally sign each letter with blue or black ink

- Don't use metered mail; instead choose a cool stamp—but one that is suitable for business

Here is an example of the body of an effective targeted mailing from Regole Design in Tucson, Arizona:

Regole Design still has its wheels in motion.

We've been designing exciting advertising campaigns for our clients for more than 10 years now and we continue to implement fresh, creative strategies that make an impact and produce desired results.

Yes, our client list continues to grow, but we are always focused on the key reasons that have led to our success—outstanding creative and exceptional client service.

THE WORKS is a small sampling of our portfolio archive for national and local clients in the areas of print and collateral materials. Once you have reviewed the portfolio, I hope you will consider Regole Design for any future projects that XYZ Corporation may develop.

We would be happy to meet with you to discuss these opportunities at your convenience. Have a festive holiday season!

An alternative to letters is an e-mail targeted mailing. First, go online to review the current criteria for junk mail filters so you can create a spam-proof message. Next, compose an e-mail following the same seven-step formula above.

You can also provide readers with a link to your Web site or attach a brief portfolio with five to seven samples, ones especially chosen to relate best to the person you are contacting. In doubt about what type of file to use? Make it as easy to access as possible. "When in doubt, dumb it down," advises designer Buddy Chase of Studio 3.

Thinking about sending the same message electronically and on paper? In a word, don't. That's overkill for an initial contact.

Follow-Up Promotional Mailings

A key to your success is to "Plan your work and work your plan," right? So then pull out your calendar and lay out your plans a year in advance. Jot down reminders about when you will review your marketing plan or launch a direct mail campaign. On average, strive to send direct mail at least every quarter to your current and prospective clients. Otherwise, they'll be hearing from your competitors and not you!

While your calendar is handy, schedule other due dates so you have sufficient time for design, production time, printing and mailing follow-up promotions. Of course you'll want to keep detailed database records about when and to whom your promotional mailings go out.

Chapter 10:

COURTING CLIENTS

Clients are the lifeblood of your business. Without them, you will simply not survive. Therefore, attracting potential clients and converting them into satisfied customers rank as your highest priorities.

INITIAL MEETING WITH THE CLIENT

Imagine the following scenarios:

- Your initial direct mail piece has resulted in a phone call from a prospective client.
- A former teacher of yours has provided you with an introduction to someone who may need your services.
- As you're making cold calls, you hook a live one on the line.

In all three cases, the ball's in your court. Your next step is to set up a meeting. Some people like to refer to this as a "consultation," which implies the two-way nature of the meeting. Just to be clear, this initial client meeting is definitely not a platform for you to launch a hard sell. Instead, it's an informational meeting to determine if there's a potential match between your talent, experience, and interests and the client's needs. At this stage, you're getting acquainted to see if you have a future together. In other words, a first date.

At the time you set up the meeting, it's wise to agree upfront on a timeframe. Thirty to sixty minutes should be sufficient for initial meetings. The actual "show" portion of your portfolio should not exceed fifteen minutes, even though you could happily spend several hours rhapsodizing about the creative challenges you've met.

What happens after you've got a date set up? Research, of course. Winging it, no matter how skilled you are at improvisation, won't work. If you haven't done your homework first, you may fizzle rather than dazzle. Run an Internet search on the business or client. Visit the Web site. Contact somebody in the same field for some background on the business.

Learning whatever you can *before* you arrive helps position you as a professional. This way, you can target your portfolio to include samples of your work most likely to impress the person with whom you are meeting. To make sure your portfolio is in the best possible shape, backtrack now to read "Portfolio" on page 73.

At the Meeting

Don't assume your book will "speak for itself," especially to someone who may know zip about design. It's quite probable that the prospective client will be judging you solely on how convincing you are in presenting yourself. To make the most positive impression, practice beforehand, preferably with a live audience, so that your patter flows smoothly. Don't succumb to designer-speak; instead practice explaining design processes in simple, everyday language. (See page 163 for strategies.)

Dress appropriately to the situation (more formal for corporate clients, casual-Friday for noncorporate). Make sure you have all materials on hand before you leave the office, including a small notebook. Arrive on time—or even early. Begin with a handshake and an exchange of business cards, followed by some chitchat before getting down to basics. Do a little grounding or orienting for your audience:

> As I mentioned when I first called you, Professor Jenkins suggested you and I get together because your former designer moved to Cleveland.

To get the conversation off on the right track, float a trial balloon like this one:

> I understand your dry cleaning business is expanding to three new sites this year, plus you're considering branching off into laundromats . . . do I have that right?

This approach gives the prospective client a heads-up that you've done your homework and invites corrections to your initial premise so that you can swerve accordingly.

Now is an opportune time to mention any similar clients or campaigns you've worked on. Begin to show your portfolio, emphasizing each time the problem, the creative process that you went through, and the results, if known. Your goal is to convince the client that you are an experienced problem-solver.

As the prospective client examines your book, resist the impulse to keep talking all the time. It's better to allow for some silence so as not to distract attention from your work. You may or may not be asked questions. If not, it never hurts to periodically ask if the client has any. Keep an eye on time and stay true to your fifteen-minute allotment for the look-see segment of your visit.

After you've made your way through the portfolio, the next part of your visit requires even more confidence and finesse on your part—asking for what you want. "Now that you've seen some samples of my work, I'm wondering if you have any projects coming up that I can help you with?" or "When we spoke, you mentioned you were interested in a new logo. Shall we talk more about that now?"

If you sense a green light, listen intently to the information that's forthcoming, jotting down notes in your notebook or on a client intake form. When

you're sure you've got the whole picture, ask "What will be our next step?" Maybe it's another meeting, an invitation to submit a proposal or do a presentation to the whole team or the brass.

What if you're asked to deliver something you don't know how to do? "Bottom line, never tell a client that you can't do something," cautions Cathy Teal of FireBrand Design. "Never. Get out of the meeting, find someone who knows what you don't, and get it done."

If the signal you're getting is a yellow or red light ("I won't know until . . ." or "At this stage, we don't need anything"), respond with, "When would be a good time for me to check back with you?" Jot that down in your notebook. If the response is along the lines of "Don't call me, I'll call you," your reply is, "That's fine. In that case, I'll keep you on our mailing list in case something materializes in the future."

If you've brought a leave-behind, this is the time to present it. It's also a good time to ask for leads. "By the way, Pat, can you think of anybody else who might need my services?" If you get an affirmative response, take careful notes. Since networking is a key factor in drumming up new business, ask, "May I have your permission to use your name when I call Jordan Humphries?"

Thank the prospective client for the initial meeting, shake hands, and head back to the office to enter notes about this meeting in your database. Regardless of the outcome of the meeting, within a few days send a thank-you letter, enclosing any additional material or estimates you agreed to provide.

PROPOSALS

A Request for Proposal is usually referred to as an RFP; this invitation to bid is akin to a job posting for designers. The work can be a project or, better yet, a campaign. The RFP may appear in newspaper classified sections, on electronic bulletin boards, or circulated to a preselected audience. If you're really fortunate, you may be the only recipient invited to submit a proposal. Otherwise, the winning candidate is most often chosen based on a combination of the written proposal and the personal interview or presentation.

The Short Version

A prospective client from a small business is more inclined to take an informal approach when inviting you to submit a proposal along the lines of "put something down on paper and get back to me." If you know the client, you'll have a sense of the degree of formality that is expected in crafting your proposal. However, do keep in mind that this proposal may be "sent upstairs" so others unknown to you may read it as well.

On the other hand, some clients—more comfortable dealing with people than paper—may prefer to discuss the details of working with you face to face. Even so, it never hurts to follow up these encounters with a written record that captures the gist of the meeting (see sample proposal on pages 114–117).

9561 Brentwood Way, Suite A
Westminster, CO 80021

Voice (303) 467-3929
Fax: (303) 467-3962

Animation sequences for Valleylab

Scope:

To facilitate the training, education and marketing out reach of Valley Labs and the medical community, a 3D computer animation in conjunction with actual surgery theater video footage depicting a Complex Vaginal Hysterectomy are to be created and combined using the latest video equipment and 3D computer software.

Further, accentuating the versatility of the Ligasure™ surgical instrument in this surgical procedure and how it makes this procedure a viable alternative to conventional hysterectomy procedures.

Estimate:

1. Pre animation development: Creation of all of the models to be used in four segments of the animation. This includes the construction of a female body with the internal organs necessary to explain the processes in each segment. Some of these elements have been completed for the proposal stage of the project. Some elements still need refinement before they are used in the final animation and others need to be built with information provided by the customer.

 Modeling: 36 hours @ 115.00 per hour $4,140.00

2. Positioning Animation. Positioning of patient on operating table. Show how legs go in stirrups and show the removal of table sections.

 This animation will use a female figure converted into 3DS file for use in Character Studio. Estimated run time: 20 seconds.
 Estimated creation time:

 Modeling/Timeline: 24 hours @ 115.00 per hr $2,760.00
 Final render: 2 days @ 200.00 $ 400.00

3. Speculum Animation. Showing how existing speculums differ from the newly developed speculum. First to show how existing speculums push the cervix deeper in the body and how the newly developed speculum does not. Two 2D animations may be sufficient to create this segment.

Short proposal. Four pages excerpted from a five-page document. (page 1)

This animation will use 2D-compositing software with an altered 2D-cutaway artwork where different organs are moveable to show how the different speculums cause the body to react. Estimated run time: 20 seconds. (Includes two 10 seconds segments.)

Estimated creation time:
Modeling 2D art:	16 hours @ 115.00 per hour	$1,840.00
Final render:	1 day @200.00	$ 200.00

4. Hemostasis using Ligasure™ during removal of a normal uterus. Estimated run time: 30 seconds.

This animation will again use a female figure and 3D skeletal model converted to 3DS file for use in character studio. Internal organs will be created and manipulated in 3D Studio MAX.
Estimated creation time:
Modeling/Timeline:	32 hours @ 115.00 per hr	$3,680.00
Final render:	2 days @ 200.00	$ 400.00

4 and 4b. Morcellation of diseased uterus and closure of vagina. Two segments, estimated run time 20 seconds x2.

This animation will use models created for the animation above, but will be more animator intensive. As per customer request, the tumor-infested uterus is to be sectioned into removable portions.
Estimated creation time:
Modeling/Timeline:	40 hours @ 115.00 per hr	$4,600.00
Final render:	4 days @ 200.00	$ 800.00

Total Estimate for Animation

Modeling/Timeline:	112 hours @ 115.00 per hr	$17,020.00
Final Rending:	9 days @ 200.00 per day	$ 1,800.00
Total estimate:		$18,820.00

All models will be available for reuse in future animations. Each segment will be recorded to a DVCam tape for insertion into the final video edit unless otherwise directed.

Additional Services

CD-ROM .mpeg copies can be compressed and made from the final segments upon request. Setup cost is less if compressed files are made while the original files is still on the computer.

CD-ROM .mpeg compression and copies while files are still on the hard drive:

Compression:	$ 115.00
Each CD-ROM blank:	$ 1.50

CD-ROM .mpeg compression and reloading files:

Reload and compression:	$ 230.00
Each CD-ROM blank:	$ 1.50

Definitions:

Modeling: The construction of a three dimensional model in a virtual 3D computer world where the model has height depth and breadth. Once constructed this model must be adjusted and assigned control features so that the animator can manipulate the model. This manipulation can as simple as controlling a movement in the specified duration of time or as complex as a morph where the model changes from one shape to another. This service is charged at $115.00 per hour.

Time Line: The choreographing of all of the movements of the three dimensional models in the 3D realm. This part of the production happens after all elements are in place. It is also charged at $115.00 per hour.

Proof render: This is a low resolution (usually 320x240 pixels) rendering of the animation for approval prior to full resolution output. It lacks the detail of a full resolution render in that there are no shadows and the image is pixilated, it depicts camera and model movement in the time line at real time and gives enough detail to detect mistakes in the model and the timeline.

Short proposal (page 3)

116

The first proof render is at no charge. Each additional proof render is at the flat rate $150.00 per day. Changes that were not in the original scope of work (subtractions, color changes, additional models, etc.) are charged at $115.00 per hour.

<u>Final render:</u> This is the final resolution that will be used in the video (720x480). Ray traced lighting and shadows, plus textures and reflection values are depicted in this render and require intense processor usage, therefore it is the more time consuming and requires that all of the networked computers be used. This service is charged at a flat rate of $200.00 per day. Final rendering is done only after the proof render is approved. Changes to the model or the time line that are not in the original scope of work during the Final render stage of the animation is charged at $115.00 per hour over the original estimate. Re-rendering at full resolution requires a 1-hour set up charge at $115.00 over the time for model and time line changes. It is recommended that an additional Proof render be performed and approved before the Final re-render is initiated.

Thank you for the opportunity to present my proposal for this animation. I look forward to working with you. If you have any questions, please feel free to call me anytime for clarification.

Sincerely,

Philip J. Opp
President — (the) Animation Annex

Short proposal (page 4)

Phil Opp of Animation Annex adds, "Clients like to see their own words come back to them, so use them in the proposal. My proposals are usually single-spaced, four to thirty-six pages. Often I include thumbnails or storyboard snaps to prove I can handle the images. People are visual animals, so proposals need to take that into account."

Short proposals are generally organized around these section headings:

- Statement of Problem (background)
- Scope of Services (what you agree to do)
- Action Plan (when you will do what; a timeline)
- Projected Budget (what it will cost)

Perhaps you'll include an appendix, which can contain a relevant client listing, a copy of your resumé, honors/awards, and references.

The Long Version

Large firms or corporations tend to be more formal in their bidding process. This is especially true of companies that deal with state, federal, or international contracts. A rule of thumb is the bigger the contract award, the more formal the application.

Cathy Teal of FireBrand Design in Palm Springs, California, offers some advice for dealing with governmental RFQs (requests for qualifications) and RFPs (requests for proposal). "If you're not a good test taker, don't bother. You must be able to answer only what they ask for and follow their directions exactly. If they tell you to put dividers in there, put dividers in there. If it's twenty seconds late, forget it. You missed the deadline. There are no make-ups in life."

The Parts of a Long Proposal. An extensive proposal (ten to one hundred pages) is organized similarly to a long formal report. Although headings vary from proposal to proposal, these are the parts that are covered.

- *Title Page*—identifies the company or organization for whom you are preparing the proposal, your contact information, and the date the proposal was submitted.
- *Table of Contents*—a map that helps your readers locate information easily.
- *Executive Summary*—a persuasive and pointed synopsis that is two or three pages maximum. This part requires top-notch writing because some readers use this section as a screening device to decide if they want to bother reading the rest of the proposal.
- *Statement of Problem*—defines the client's problem or situation you are going to address. Describe how things will improve if you come on board.
- *Purpose/Scope of Services*—explains what you will and will not do. It also outlines the tangible products or deliverables you will contribute to the project.

- *Goals and Objectives*—know your terms *before* you address them. *Goals* fall into a broad, rather abstract category. They're generalized intentions; for example, "increase awareness and name recognition among potential clients." *Objectives*, on the other hand, are more narrow and focused. They're precise, concrete targets that you're shooting for. An example is "to conduct a direct mail campaign that results in two hundred inquiries and five new clients." *Strategies* are the ways in which you will accomplish objectives.
- *Team Composition and Credentials*—answer the question, why you? Why your team? What's your background and area of expertise that will most appeal to this particular client?
- *Studio's Relevant Experience*—emphasizes similar projects you have worked on for other clients, preferably those in a closely related field. Use thumbnails or some other means of illustrating the problems you solved.
- *Schedule*—focuses on the specifics of your work plan and timeframe.
- *Budget*—how much is it going to cost for you to get the job done? Some designers break costs down into stages or phases so that the amounts for each category appear smaller that just one big total. Include any outsourced services that will be required.
- *Evaluation/Outcomes/Measurements*—outlines procedures you and your client will utilize to determine if you produced the results you promised.
- *Works Cited/References*—includes a list of the source materials you consulted in your research, proof positive to the client that you've done your homework and research.
- *Appendix*—contains supplemental material that may be related to the report but is to long or complex to include in the body of the text.

10 Guidelines to Creating Your Own Winning Proposals

1. Begin by reading the complete RFP several times to make sure you clearly understand the scope of the work and the qualities the client seeks in a designer. You must be able to prove on paper that you're the best-qualified candidate to receive the contract.

2. Allow plenty of time. Responses to RFPs can take days, weeks, or months to prepare. The experience is often grueling, particularly if you're a one-person operation juggling other deadline-driven projects at the same time.

3. Contact colleagues to obtain a copy of one of their previous RFP responses or consult reference books so you can visualize what the final product looks like.

4. Create every RFP response anew. Avoid generic "boilerplate" responses, although some of your sections (such as your credentials) can be "repurposed," a nice term that means used over and over with minor tweaking.

5. Write in readable business language—your reader will appreciate it.

6. Follow directions to the *n*th degree. Submit *exactly* the sections specified in *exactly* the order specified.

7. Rely on your design sense to make the proposal package look both professional and inviting (white space, bulleted items, headings, clear fonts, page numbers). Design an impressive cover—unless expressly forbidden in the specs.

8. Spell-check. Then proofread. Frontward, backward, and aloud.

9. Observe deadlines; they are not the least bit arbitrary. RFPs are just like design competitions: If your brilliant entry arrives a day or a week—even an hour—late, all your hard work is down the drain.

10. Compose a well-written letter of transmittal to accompany your proposal.

Sample of a Long Proposal. If you're new to writing a long proposal, you'll find it very helpful to read this one from Cloudjammer Studio (see sample on pages 121–126).

Recommended Plan to Write a Proposal. *Devour the RFP.* Tear into it, highlighting sections, jotting notes, sketching out rough ideas. It's imperative that you fully understand what you're getting into if you do decide to proceed with a proposal.

Commit . . . or not. Determine if this is a job a) that you really, truly want to land and b) that it's one you have the resources to handle. If it's not, go no further. If it is, bring the team in to brainstorm ideas and get your creativity flowing.

Devise a Plan of Attack. Sketch out milestones and deadlines. Divvy up the work, especially the research. Schedule future meeting dates. Store all information in files or folders that everyone on the team has access to.

Sift through the research. Discuss your findings. Identify missing pieces of information that you will need. Begin to brainstorm strategies for solving the client's problem. Now is the time to set deadlines and assign responsibility for the completion of each proposal part.

Begin by writing the easiest section, the Title Page. Once you get this no-brainer out of the way, you've officially begun!

Tackle Team Composition and Credentials next. Pull out your resumés and review your studio's promotional material. Rework what you've got and, before you know it, you've moved into word-generating mode.

Proceed to Studio's Relevant Experience. Go through client files and pull out your successes. List some of your clients, indicate types of work you delivered, and the range of project costs. If you are using new technologies or shared equipment that gives you a competitive edge, include that.

Fine tune the Statement of Problem. Spend time on defining the problem as clearly as possible since doing so increases your chances of coming up with brilliant solutions. Make sure the team buys into the definition so problems don't pop up later.

Determine the Goals and Objectives. Focus on your client's needs. Use phrasing or terminology that the client will relate to.

cloudjammer

Prepared for: [prospective client name]
 [address line 1]
 [address line 2]

Prepared by: [estimator name]
 Cloudjammer Studio
 440 Tyson Circle
 Roswell, Georgia 30076

Date prepared: [month] [day], [year]

A proposal to [description of project/s]

Proposal contents

Long proposal. Six pages excerpted from a nine-page document. (page 1)

121

Estimate of Costs

Project title
 Item (description) $000.00

Subcontracted Services
 Item (description) $000.00

Production Expenses
 Item (description) $000.00

General Expenses
 Item (description) $000.00

Estimated Total **$000.00**

Additional services and monthly website maintenance
If work is required on the website beyond the scope of this proposal, or after the terms of this proposal are completed, Cloudjammer Studio can be engaged as needed on an hourly basis (billing in 0.25 hour increments) at the following rate.

Cloudjammer's hourly rate $100.00

Long proposal (page 2)

Why Cloudjammer Studio?

Cloudjammer Studio is an interactive communications firm – we believe that we can create the most unique and persuasive corporate/product message only through a close partnership between you and the designer. Our designers use their creative expertise to bring your vision to life, through the mediums of identity, web, and print.

Cloudjammer Studio is committed to providing more than simply a functional or interactive experience – but one that effectively and uniquely communicates our client's message and personality. Cloudjammer works to maintain a creative work environment defined both by a fun and open-minded atmosphere and a high standard of personal and business ethics.

Why is Cloudjammer a good match your project?

Familiarity with non-profit businesses
Cloudjammer Studio works primary with non-profit corporations, be they entertainment-oriented organizations such as the Atlanta Opera, community-centric bodies such as Peachtree Road United Methodist Church, or public-service foundations such as the CDC Foundation or the Emory Vaccine Center. Cloudjammer is experienced with the different needs of non-profits communications compared to those of For-profit companies – different objectives, measures of success, and processes.

Flexibility and expertise in design and execution
Cloudjammer's designs and production artists are extraordinary flexible online and extremely knowledgeable about Internet technologies and creative techniques – Cloudjammer co-owner J.D. Jordan even taught Internet design at the Atlanta College of art for over two years, has guest lectured at other area schools, and has published a creative-industry column in Newsweek. We're not restricted to using one proprietary theme or technology – we can readily execute your project in any number of online formats and have no qualms about working with third-party editing software, other design firms, or even handling website maintenance ourselves as your website grows.

Driving traffic to non-profit website
Judging a new website by its increase in online traffic is a tricky issue. Good content and contentious design can create a "sticky" website – one that keeps visitors there and encourages them to return – but rarely can a website drive traffic to itself. Cloudjammer-designed websites have a great track record for swelling online visitation. As a case study: The Atlanta Opera leveraged promotions in mixed media – radio, TV, print, email, and online – to promote their online redesign. This marketing, reinforced by the website's new engaging design and easy of use, drove previously unprecedented traffic to the site – a 200% increase in traffic over the first three months following the website's launch – and stimulated online single tickets sales to over 50% of total!

Personality
Cloudjammer is defined by personality. We're personable, fun, and enjoy what we do. We want you to enjoy the process, too. Part of maintaining this healthy client-designer relationship is being honest, friendly, and professional.

Long proposal (page 3)

Relevant Portfolio Samples

The Atlanta Opera – www.atlantaopera.org

The Atlanta Opera faced the challenge of updating their online brand and making it relevant to new, more diverse audience segments Cloudjammer Studio was engaged to assist with this effort in order to bring a unique energy to the organization's website.

The new Atlanta Opera website is a radical shift away from their previous online brand. The new AtlantaOpera.org site is an immersive multi-media experience communicating the theme "A Night at the Opera." Visitors to the Atlanta Opera website can visit unique opera vignettes, each with specific performance information, imagery, and music. Performance imagery illumes the site, enhancing the rich theatrical theme. From anywhere in the site visitors may "Listen to the Opera" – an application that allows them to preview music from each of this season's upcoming performances.

The website makes special effort to reach out to both the novice opera-goer and the experienced aficionado. The site's "Plan a Night at the Opera" answers first-time expectations, explains opera etiquette, and gives creative and fun opera night ideas. Veteran opera aficionados can learn more about special events and the many ways to support the opera, online and off. Subscription, group, and single ticket information is also available online, with online purchasing coming soon.

The site also emphasizes the Opera's unique role in the Atlanta community, both in its outreach to children and adults. The Atlanta Opera's education and family programs serve local schools and teachers, offer traveling shows for children, Pre-opera Lectures and Opera 101 classes for adults, and myriad volunteer opportunities. An interactive opera glossary and quiz about the upcoming show make learning about opera fun and engaging.

The Atlanta Opera website also makes a great case study for swelling online visitation. The opera leveraged promotions in mixed media – radio, TV, print, email, and online – to promote their online redesign. This marketing, reinforced by the website's new engaging design and easy of use, drove previously unprecedented traffic to the site – a 200% increase in traffic over the first three months following the website's launch!

Long proposal (page 4)

cloudjammer

Cloudjammer's Design Process and Scheduling

Cloudjammer is dedicated to understanding the needs of your company, envisioning your message, and effectively communicating that message to your clients. To meet that goal, we use the process outlined below.

Scheduling and initial design 1-2 weeks
Upon approval of this proposal, we will meet with you in person or over the phone to establish a mutually amicable timeline for the completion of this project. At such time, we will clarify project objectives, identify subjective preferences, discuss possible thematic approaches, and uncover potential marketing problems. We would appreciate it if any previously developed materials or information regarding your company were made available to us.

Having established project goals, Cloudjammer will research media options and design objectives and present a series of initial design comps that will establish the design path for this project. We carefully research your company's background, future plans, and competitors.

> *Deliverables:* A series of initial design comps

Design Revisions 2-3 weeks
The initial comps allow you to see our interpretation of your vision. Once we have a strong understanding of your needs, we will begin to refine the design plans for your project through a series of creative revisions. We will work closely with you to revise initial designs and develop a navigation model until we have accurately captured your vision. Additional revisions can be added to the project as required.

> *Deliverables:* The final design

Production + Delivery 2-3 weeks after content delivery
Your final vision has been created and it's now time for your website to come together. Once final content is delivered to Cloudjammer, we will prepare finished web-ready files, oversee project fulfillment, and work to have the final product ready by our mutually agreed upon deadline.

> *Deliverables:* Web-ready files and the final materials posted online

Follow Up
Cloudjammer will follow up with you to make sure project objectives were met successfully and in a timely fashion. We will archive all files for future reference and make sure you have all the resources you need before we close the project.

A proposal to [project/s]
page 7 of 9

Long proposal (page 5)

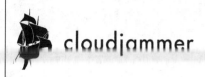

Working agreement

Estimates
The costs and expenses cited in this proposal are our best estimates given the information provided. If additional information is forthcoming, the project specifications change, or the scheduling changes, cost and expense estimates may change. Cost and expense estimates are appropriate for 30 days from the date of this proposal. Taxes are not included in cost and expense estimates.

Revisions & Alterations
Work not described in this proposal, including but not limited to revisions, corrections, alterations and additional proofs, will be billed as an additional cost at the hourly labor rate of $100 per hour. The client will be notified in the event of a price increase over 10% of the original estimated cost.

Terms
For first time customers, approximately one half of the total estimated cost in advance; the balance upon delivery. For repeat customers, approximately one third of the total estimated costs in advance; approximately one third upon acceptance of the design concept; the balance upon delivery. If any phase of the assignment is delayed longer than sixty days, we will bill for work completed to date. Special payment arraignments (financing, deferral, barter, etc) may be negotiated on a project basis.

Responsibility
Cloudjammer Studio, LLC will make every reasonable effort to assure the accuracy of the material produced, but are not responsible for the correctness of copy, illustrations, photographs, trademarks, nor for obtaining clearances or approvals. We will take normal measures to safeguard any materials entrusted to us. However, we are not responsible for the loss, damage or unauthorized use of such materials, nor are we responsible for the actions of the vendors and suppliers we utilize.

Ownership
All materials used in the production of this assignment—including original artwork and computer generated artwork, formats, and code—remains the property of Cloudjammer Studio, LLC. Unless otherwise agreed upon, all original photographic film (transparencies and negatives) will remain the property of the photographer selected. Unless otherwise agreed upon, all printing materials (primarily films, plates, and electronic files) remain the property of the printer selected. Ideas that are not accepted remain the property of Cloudjammer Studio, LLC and may be used in the future in the course of other assignments. Final product (finished print or web materials) becomes the property of the customer upon completion of the assignment and payment in full. In the event that an assignment is terminated before completion, Cloudjammer Studio, LLC will provide the client with copies of all pertinent materials used in production of this assignment.

Purchase Order
If this proposal is acceptable, a purchase order equal to the total estimated cost should be initiated. All invoices submitted against the purchase order will be net, payable within 30 days of receipt. Interest may be charged on past due invoices. We shall be pleased to begin work upon receipt of your purchase order.

Long proposal (page 6)

Outline the Scope of Services. What will you do? Not do? What deliverables will you produce? What do you expect the client to do?

Draft the Schedule segment next. Create a list of necessary steps. Sequence them and assign each a due date. Specify who will be responsible for what (you, the client, outsourcers?). Develop contingency plans.

Work your way through the rest of the body of the proposal. Get something—anything—down on paper, no matter how lame it is. You can always change it later.

Print a rough draft. Read, respond, refine, redo. As many times as it takes.

Create visuals. Place them in the text nearest to their reference point. Caption them.

Format. Work out headings and subheadings. Bullet and/or highlight. Use color. Break lengthy paragraphs down so they don't run over six to eight sentences.

Assemble the Works Cited and Appendix sections.

Once you have finished writing the body of the proposal to your satisfaction, it's time to write the Executive Summary. This part highlights the most important topics and data. Your objective is for your summary to answer every important question in your reader's mind.

Write the Table of Contents last. Make sure to include all first and second level headings, but omit smaller subdivisions of topics, such as third level headings. Double-check that all listings in the Table of Contents appear worded exactly as do the headings in your text.

SALES PRESENTATIONS

If you've been invited to make a presentation, chances are you've already invested a good deal of time and energetic capital into getting this account by responding to an RFP or participating in initial meetings. Now you're looking to close the deal. What are your best shots for succeeding?

Success lies in preparation, and this is true whether you're a natural-born speaker or not. Even those of you who have a gift for thinking quickly on your feet are apt to leave out an important detail, interpretation, or explanation if you haven't prepared.

And what about you shy, reticent types who wish you didn't have to stand up and present at all? Two surefire techniques for working through nervousness are preparation and practice.

Steffanie Lorig, executive director of Art with Heart in Seattle, recalls how she felt. "I was terrified for the first ten presentations I made." The audience size at her presentations ranged from one person to a group of twenty marketing executives who were resistant to her recommendations. "You have to really work on your verbal skills," she advises. "Preparing a lot helps, as well as thinking out beforehand how you'll respond to questions or opposition." What's Steffanie's greatest challenge now that she's an experienced presenter? "I have to communicate my enthusiasm while, at the same time, making sure I sell the concept," she says.

We also recommend you review your presentation afterwards to improve future performances. Make it a part of your performance routine to pinpoint objectively what you did well and what you didn't do so well. This self-review allows you to desensitize yourself to the whole performance over time. Notice that we wrote *objectively*. We don't want you sinking into the shame and despair cycle here. After all, 99 percent of us feel performance anxiety at least once in a while, so relax—you're in good company.

Follow-up self-reviews help you remember that presentation skills can be developed and improved. Margo Chase, creative director of The Chase Design Group in Los Angeles, told us she and her team practice this principle after every presentation as a way to evolve in their presentation skills.

Here are some more dos and don'ts for making successful presentations.

Prepare

- Do write a script for a *standard* sales presentation. Consider this a work in progress, one that you'll refine after each presentation. Here are some general guidelines.
 - Start with a strong introduction that focuses on your client's needs and expectations.
 - Show your designs in descending order from strongest to weakest. This is your best shot at getting your client's attention from the very start. If your presentation is interrupted, your client has seen your best work (and heard your strongest interpretation) already.
 - For each design you present, focus on client benefits and problem solving. (Organize these from most important benefits and issues to least important.)
 - Use your client's industry terminology and business jargon.
 - Keep your presentation simple and brief; figure out the crucial persuasive material and edit out the rest.
 - Conclude by asking for the business.
- Do develop a *customized* script for each presentation. Your standard script will help you organize and focus your specific presentation.
 - Learn more about the company culture. Do the decision makers prefer formal or informal presentations? (See primary research guidelines on pages 166–170.)
 - Check on and practice the correct pronunciation of your clients' names and products. Your mispronunciations indicate your inadequate attention to details and can be the deal-breaker.
 - Anticipate the questions and objections your client might raise and come up with responses in advance. Ask a colleague or friend to play the devil's advocate, so you'll be prepared for whatever your client throws at you.
- Do find out who else has been invited to present. Who is your competition? A simple phone call or e-mail should be sufficient to get this information.

- Do make notes in the form of an outline, bulleted sheet, or notecards for reference (not direct reading!) during your presentation. Format it in a large pitch (about eighteen) so you can find your place. Number all cards or pages in a different colored ink in case they get out of order.
- Do run through at least one dress rehearsal with your visuals before the presentation date.
- Don't memorize your script. Instead, learn it thoroughly by practicing repeatedly. This will help you maintain the flow and return to your place when you're interrupted for questions. (Remember, use your reference notes as a prompt, not a crutch.)
- Don't be overly concerned about your preperformance nervousness. Any actor will tell you that what you're feeling is normal nervous energy. If you prepare well and trust the process, you can transform that adrenaline rush into enthusiasm during your presentation. (See page 79 for relaxation exercises.)

Stand and Deliver
During your presentation, keep in mind these tips:
- Do arrive early for an equipment check and run-through.
- Do show your enthusiasm. Enthusiasm can be infectious. This is no time to worry about looking cool.
- Do take advantage of nonverbal communications.
 - Point to design elements as they are discussed.
 - Look at everyone in the room, not just the primary decision-makers.
 - Watch for nonverbal clues to your clients' interest. (Are they slouching or leaning backwards, multitasking, checking their watches?) If these clues are apparent, immediately ask for responses, change your pace, modulate your tone, or move to another design.
- Do answer questions as they are asked, instead of waiting until the end of the presentation.
- Do admit when you don't know something. Say you'll get back to them with an answer, and then be sure you get back to them.
- Do close by asking for their business.
- Don't rush. Respect silence in a presentation as you might use negative space in design. Leave room for questions to occur to the client, and give them time to think.
- Don't read directly from scripts or PowerPoint slides.
- Don't mumble. Be aware that speakers are especially prone to mumble their words in the beginning of a presentation, so make every effort to start out in your strongest, clearest voice.

- Don't attack your competition or your client's previous design work. When you compare your work with another's, use a neutral "like/unlike" construction that stresses the benefits of using your designs.

Afterwards

- Do review your performance for strengths and weaknesses.
 - Edit your standard presentation script to address your findings.
 - Put the revision date on your new script to avoid later confusion.
- Don't dwell on the past. If you didn't perform as well as you'd have liked, make your notes and move on. If you got the business, make your notes and get to work. Use both the good and the bad experiences to improve and strengthen your presentation skills. After all, you'll need to rely on them for the rest of your career.

Presentations are not only about business—they're about relationships. Don't send a printed sample if you can possibly help it. We try to get an in-person meeting and make a presentation. Our first meeting is usually a capabilities presentation that lasts an hour. It tells our history, discusses our strategic thinking in context of an appropriate case study, shows examples of other work, and describes results we have achieved for past clients.

Then, there are sales presentations, which focus on the work to be done and the impact sought for the client's business. We always start with research that clarifies the business problem. (Often it contains its own answers.) Next, we craft a strategy: who is really the customer for this product? Who could be? How can we reach them most effectively? Often a positioning change is needed for the company or product line. The creative direction comes next; it defines the visual and verbal messaging that will deliver on the strategy. Finally we execute the design work, which typically includes identity, packaging, point of purchase materials, and visual merchandising. This process, customized for each situation, is detailed in the proposals that we provide to clients.

We give presentations during projects too. For major retainer accounts, we might present every week; they're like working meetings. For small jobs we might just present twice during the project. At the end of a big project, we like to present to the rest of the company—to launch the work internally and get buy-in and enthusiasm. Branding is just as important inside the company as outside, influencing the way people feel about their work.

Different customers are comfortable with different styles of presentation and conversation. Always be prepared to adjust for each client and each situation. You may need to do this on the fly. Be present and alive so you notice when you are losing people.

After each presentation, we turn our focus back on ourselves to assess how it went. Clarity is such a big deal. There's always something that can be improved. We are evolving every day.

Margo Chase, Creative Director
James Bradley, President
Chris Lowery, Vice President
Henry Rosenblit, Director, Business Development

Chapter 11:
BUILDING A BIGGER BUZZ

Once you're familiar with the basics of attracting clients, which were discussed in the previous section, you can now concentrate your efforts on some more advanced strategies for developing your clientele.

ADVERTISING

As we pointed out earlier, when you're just starting out, leaders in the design field urge you to dump your dollars into print and electronic communication. Even when you reach the stage where you can comfortably pay the bills and add to your rainy day fund, the cost of advertising on television and radio or through full-page ads in design sourcebooks is probably still beyond your reach. However, you might want to investigate advertising costs associated with smaller newspapers, regional publications, and local access channels. You may be pleasantly surprised to find that these media fall within your financial reach.

Before signing on the dotted line for your first foray into advertising, remember what you learned in "Promotional Mailings"—that when it comes to advertising, frequency rules over impact. Tempted as you might be to borrow money from Aunt Tillie and design a truly sensational impact ad, don't give in to that impulse. You'll be further ahead if you opt for a smaller ad that runs more frequently. Studies show potential clients need to see your name at least six times before it registers with them.

How can you achieve frequency on a bare-bones budget? Good question. Here's where your negotiating skills can come into play. Say there's a trendy weekly paper that comes out, one that attracts the readership you want to access. What's to stop you from setting up a meeting with the newspaper editor and offering to barter your skills in exchange for free ad space? Or if you're looking to advertise to a particular ethnic market (for example, a Latino or African radio audience), perhaps a specialty radio station will trade air time for a new logo and ad design. It never hurts to try!

On the other hand, if you're trolling for a primarily local small business market, think about a listing in the yellow pages. Review your options for listing your services under multiple headings, such as Graphic Design, Logos, Corporate Identification, and Web Site Design. For now, hold off on flashy image ads, but do revisit the matter later when your business is stable and solvent.

Your most immediate concern in the early years of your business should be about creating display ads that will prompt potential clients to contact you. Here are some tips for writing ads that sizzle:

Guidelines for Writing Advertising Messages

1. *Analyze your audience* before you determine your exact message. (See pages 14–15).

2. *Aim for an informal tone.* It's okay to use contractions and punctuation to increase your ad's readability.

3. *Grab attention.* Create an arresting headline or a memorable visual image.

4. *Make every word count.* Use a thesaurus to locate the precise word that delivers the most evocative punch. Write *only* what is necessary to convey your message.

5. *Stress the benefit to your readers.* Think about the headaches they have and what relief you can offer. Use "you" and "your," not "we" and "our," so that your message is client-centered. Be concrete about the results you promise.

6. *Avoid clichés.* While you're at it, toss out superfluous words or expressions, such as "for the discriminating client" or "cutting-edge designs."

7. *Emphasize what distinguishes you from your competitors.* Are you a recent winner of a nationally known design competition? Do you have ten years' experience? Voted the Top Graphic Design Studio in your city's recent poll?

8. *Resist the temptation to promise the impossible.* Be credible.

9. *Specify a call for action.* Direct them to send in the coupon, visit your Web site, or call for a free initial consultation.

10. *Include all contact information.* Add your logo and/or tag line.

11. *Make sure the ad is grammatically correct.* Edit (and proofread) your copy ruthlessly. Several times.

12. *Take your ad for a test spin.* Ask trusted clients to read it and give you feedback. Listen to their comments; never argue or explain. Tweak accordingly.

PUBLICITY

Getting your name and services out in full view of the world doesn't always require money. The savvy designer uses any excuse as a reason to issue news releases or public service announcements (PSAs) to local radio stations. What makes the media perk up its ears and publish or air your news for free? The key words here are *newsworthy* and *timely*. These are some occasions that might capture their interest:

- Launch of your business
- Winning awards and/or competitions
- New clients
- New partners or hires
- Expansion of services
- Change of location
- Open house or other special events
- Doing *pro bono* (for free) or volunteer work
- Teaching workshops or classes

Regardless of the occasion, this template for preparing a press release offers some good advice:

TEMPLATE FOR A PRESS RELEASE

1. Make headlines punchy or direct.
WRITE THE BEST HEADLINE YOU'D LIKE TO SEE IN TOMORROW'S PAPER
Add a Subhead that Provides a Key Detail or Two

2. Put the news up front.
CITY AND STATE WHERE THE NEWS HAPPENED, ANNOUNCEMENT DATE
Company (include stock "ticker" symbol for public companies), the country's/world's largest/best at whatever you do, today announced in about ten words just what this is all about.

In the beginning of the release describe the benefits this development will have for specific audiences. Using bullet points is often a good idea. Some examples might include:
• More jobs for employees
• Better prices or products for customers
• Environmental benefits for the community
• Improved earnings and a higher share price for stockholders

3. Give them a quote.
The most senior executive possible said, "A pithy two to three sentences that comment on the importance of this announcement in a way that adds a personal dimension to the news." You're writing to persuade the media that the senior executive's quote is both insightful and succinct enough that they will want to run it as part of their story. If your release is going on to two pages, make sure the quote is on page one.

4. Write so your mother will understand it.
Make sure your messages and news are readily understandable by anyone who is likely to come across the release. Some additional supporting details—facts, figures, and so on—can be added to the body of the release. The media do need details, but don't get bogged down with minutiae in the opening paragraphs before you set the context and say why the news is important. Details come later.

5. Put additional data on a fact sheet.
If you have a great many details to report for your trade publications or the financial community, consider adding a separate fact sheet rather than trying to make sentences and paragraphs out of them. For example, for earnings releases—a type of press release intended for financial media—use tables for the income statement and balance sheet details.

6. Save "boilerplate" detail for the end.
Boilerplate should go at the end. This is a paragraph (or paragraphs if two or more companies/organizations are involved in the announcement) that states what the company does, what the principal lines of business are, how many employees it has, where its main operations are, and so on. The boilerplate is repeated at the end of every release you issue, and needs to change only as the business changes.

#
(A symbol to let the media know they've reach the end of the release)

Press release template. Schenkler, Irv and Tony Herrling, *Guide to Media Relations*, 1st edition, ©2004.
Adapted by permission of Pearson Education, Inc., Upper Saddle River, NJ.

Here are some tips we've learned over the years:

- Use letterhead
- Include all contact info in the top left corner
- Specify the shelf life, for example, FOR IMMEDIATE RELEASE or ON OR BEFORE JUNE 1
- Begin one-third of the way down on the page
- Double space
- Develop a strong lead (who, what, when, where, why, how)
- Frontload (place the most important information at the top as newspapers typically cut from the bottom up if they face space shortages)

Once you've written your release, it's time to proofread. You know the drill: Use spell-check. Then read your copy aloud; read it frontward and backward. Go over it ten times. It's ultimately your job to make sure it's error-free.

Because newspapers and journals sometimes run short on graphics, you'll increase your chances of being published if you send along a relevant photo, clearly captioned. Never send originals.

Once your news release is written, think strategically about where to send it. What publications are most likely to care about the press release you are issuing, much less print it? Chances are unlikely you'll manage to attract the attention of the *Chicago Tribune* or the *New York Times*. A better bet is to try the local papers, the giveaways, the weeklies, the trade mags, the area business publications.

Address the release or PSA to a particular person. You can find the right name by cruising mastheads of newspapers or magazines. If in doubt, call and ask the receptionist to whom you should direct your correspondence. Make sure you have the name spelled correctly and the right title—after all, wouldn't you be more likely to read something addressed directly to you rather than "Dear Graphic Designer"?

Update your Media Contacts List in your database regularly, keeping track of when and what you send and what results you get.

If your news release is printed, frame the article or laminate it for your wall of fame. At the very least, keep a tear sheet or, better yet, tuck away a couple of copies. These can be used in future promotional packages, or you can scan the articles and add them to your Web site.

PERSONAL SELLING

Somewhere along the way, you chose graphic design for a particular reason: your love of colorful images, the thrill of creating an awesome design, the allure of play that's part and parcel of all you do. Now that you're running a business, however, you're faced with all sorts of chores you couldn't possibly imagine back when design first stole your heart. Chores like hustling for clients. Most designers initially approach selling with some degree of trepidation, if not full-

blown anxiety; yet survival demands you overcome such resistance and hone your selling skills. Here's a primer to get you revved up.

Becoming Sales-Minded

The first place to begin is with your attitude. Illustrator Michael Fleishman shares a useful way to think about selling: "In truth, sales are the lifeblood of our business. . . . It might help to develop this mindset: You are calling on clients to see if you can help. So think, *How can I help you?* instead of *Do you want to buy?*"

Fleishman reinforces another point we've made earlier in this book: "You're not selling a service as much as you're solving communication problems." Whether the person you're calling is an Ad Director at a prestigious firm or a small business owner with only a few bucks for marketing, you must remind yourself that you're the Answer Man or Woman who can help them solve problems.

Adjusting your attitude is a positive step forward but certainly not the only one you need to take. "You must be able to look people in the eye, explain the benefits of your product or service and justify the cost. If you can't do that, or talking to potential customers makes you nervous or uncomfortable, you must prepare yourself," explains Jim R. Sapp, author of *Starting Your First Business*. How? The R word: Research. Again. Visit your local library to check out books and tapes on selling.

Next, develop your unique selling propositions, referred to as USPs (read more on page 88). How will you differentiate yourself from your competition? You need to design a pitch that speaks to your potential customer's needs first while also making an irrefutable case that using *your* graphic design services will impact their bottom lines.

Practice your pitch . . . in front of the mirror, on tape, in front of your friends and neighbors. Ask for—and accept—constructive feedback (there, doesn't that sound better than *criticism?*). If you learn best by direct observation, tag along with a friend or relative on any type of sales call.

Approach selling like the numbers game it is. That way you'll be less likely to take every rejection personally. In *The Small Business Handbook,* Philip Webb and Sandra Webb write:

> There is never a substitute for sheer hard work, as sales can simply become a numbers game. It is clear that if you normally make ten phone calls, get four inquiries, quote in one of these cases and then close one in three, you will need to make thirty calls on average to make one sale.

Warm Calling

Let's start with warm calling, simply because it is far easier to contact people you know or people-who-know-someone-you-know. We're talking former professors, employers, schoolmates, Uncle Bud's son-in-law at Ogilvy and Mather. Warm calling takes less *chutzpah* because you've already found a way to open the door. An example might be:

"Ms. Mazuki? This is Marita Surjk. My F.I.T. professor, Bill Grundy, said he understood you might be looking for some freelancers with animation experience. If that's still the case, do you have some time this week when we can meet for an hour?"

An excellent source of referrals can come from your former and current satisfied customers. It's okay to contact them by e-mail or phone and ask for referrals. Your conversation may go something like this:

Hi, Jeff, I've been updating my portfolio and I've added that brochure I did for your company. Since I'm looking to expand my client base, I was wondering if you could think of anybody you know who might have some graphic design problems that I could help them solve. Does anybody come to mind? Would it be okay to use your name when I contact them? Great. I really appreciate your help. And keep me in mind if any projects come up that I can help you with.

Warm calling can also occur with anyone you've met at a party, at a conference, or in the course of daily business, like your massage therapist or your accountant. "Marketing should permeate your life. Just about everything you do should, in one way or another, become a marketing opportunity," advises Jacqueline K. Powers, author of *How to Start a Freelance Consulting Business.*

Ronnie Lebow, former art director and now freelancer in Toronto, seconds that advice. In his article, "A Simple Way to Get Clients," on Creative Latitude Web site, he writes about converting warm contacts into clients:

I believe that the one thing a designer (or anyone) should carry with them at all times is a great looking business card. If I go to a party, I take cards. When I go on vacation, I take cards. When I am going to play golf, I take cards. I have met my clients in every place imaginable. The truth is that everywhere you go, everyone you come in contact with . . . may be in need of your creativity.

Really, it's okay to mention in casual conversation that you're looking to expand your client base and are actively seeking potential leads. People like to extend helping hands, so help them help you by asking for what you want.

Cold Calling

Cold calls are, in effect, a form of telemarketing. A more genteel term is *prospecting*. Regardless of what you call it, you'll be making an unsolicited contact: placing a phone call, sending a letter or e-mail describing your services, or showing up unannounced at their door for a brief (make that *very brief*) visit.

To be successful at cold calling, you need to grow a thick skin overnight since it's likely you'll encounter tons of rejections. Remind yourself (every two minutes if necessary) what you just learned, that for every thirty people who turn you down, there's one client out there who will say Yes. Your mission is to seek out that one Yes.

Creating a Cold Call List

If you've been faithfully doing the exercises as you read through "Getting Business," you've already amassed a cold call list. Review your answers to "Identifying Target Markets" on page 89 and "Mailing Lists" on page 95. If you skipped these segments, backtrack and complete them now to create your cold call list.

Making Contact

If you're the bashful type, you'll probably opt for sending a prospecting letter or e-mail (refer to examples on pages 27 and 109). If you're more confident of your selling abilities, opt for the phone or a personal visit (but don't just pop by and expect a busy working person to drop everything and meet with you). Whatever approach you decide on, make sure that you've polished your written message to a high gloss or that you've created a lively script that you can deliver in a confident manner.

Cold Call Scripts

If you're a beginner at cold calling, follow these scripts, developed by Mark Cain at Advertising Art Studios:

COLD CALL:
Hello, Ms. _____. This is Mark Cain from Advertising Art Studios here in Milwaukee. We have helped ConAgra increase their market share and portfolio of products to the point where frozen dinner dollar and unit volumes rose by 1 percent, and ConAgra remains among the top three in the frozen dinner category.

The reason that I'm calling you today specifically is so that I can stop by and tell you about how we have significantly impacted the bottom line for our clients through effective package design. I'm sure that you, like ConAgra, are interested in having more market share. I really think we should get together. How about next _____ at 2 p.m.?

Please let me know if this works with your schedule. I can be reached at (414) 222-6306.

Thank you.

DEALING WITH THE GATEKEEPER:
I would like to tell Mr. _____ about the success ConAgra and our other clients have had with our capabilities that help food companies like yours. May I speak to him, please?

REFERRAL:
Good morning, Ms. _____. This is Mark Cain from Advertising Art Studios. We provide graphic design to consumer product good companies like yours. The reason I'm calling you today specifically is that So-and-So at XYZ Company suggested I give you a call to set up an appointment. Would Thursday at 1 p.m. work for you?

FOLLOW-UP CALL AFTER MAILING BROCHURE:
Good morning, Mr. _____. This is Mark Cain from Advertising Art Studios here in Milwaukee. The reason I'm calling you today is when we spoke last _____, you asked me to send you a brochure on my firm and I did. So I'm calling today to set an appointment. Would next Thursday at 1 p.m. be good for you? Please let me know if this works with your schedule. I can be reached at (414) 222-6306. Thanks and I look forward to meeting with you soon.

Making the call is the first big step. Once you are connected to the right person, however, be prepared for the second step, wherein you encounter objections. Here are some of Mark Cain's standard responses:

I'M HAPPY WITH WHAT I HAVE:
It's great that you're currently working with a design firm. We recently spoke with Hormel Foods and they realized we could really impact their brands and bottom lines. You know something, you and I should get together anyway. How about next Thursday at 1 p.m.?

NOT INTERESTED:
Well, Ms. _____, a lot of people had the same reaction you did when I first called—before they had a chance to see what we could do for them. How about we get together next Thursday at 1 p.m.?

OKAY, SEND ME SOME LITERATURE:
Can't we just get together? How about next Thursday at 1 p.m.?

ANY OTHER RESPONSE:
Well, that's okay. Let's get together anyway. How about next Thursday at 1 p.m.?

NEWSLETTERS

Newsletters serve as a form of publicity, although it is unrealistic to expect a newsletter to produce an immediate direct impact in sales. It will, however, keep your name in front of the people who may be in need of your services. Frequency, remember?

Newsletters typically run four to eight pages in length. If you're just starting out, aim for a quarterly publication. Printed issues generally have a longer shelf life than electronic, but the decision may boil down to your budget.

Before you set off to produce your newsletter, search out other newsletters and study them. Notice how they're organized, what topics are covered. Analyze what design features appeal to you.

As you create your own newsletter, keep foremost in your mind that *It's about your readers, not about you.* Unless there's enough meaty content, your reader will go hungry and pitch or delete your future issues. Crafting newsletter items that read like press releases or, worse, puff pieces solely focusing on how great you and your designs are won't satisfy readers. Expand your thinking to include the following:

- What hot topics or trends are (or should be) of interest to your clients or prospective clients?
- What advice can you, as a design professional, share with them?
- What new techniques or processes will save them time and/or money at the printer?

Still unsure of what to include? Run your initial ideas by a few clients to see if your topics have appeal. While you have them on the phone, solicit ideas about what they'd like to know when purchasing graphic design services.

Bear in mind that people's attention spans are short, so keep the writing focused and snappy. Use checklists and numbered items as sidebars. To make sure you've got the right slant, run your first draft by an ad hoc committee of five or ten careful readers.

Last but certainly not least, proofread, proofread, proofread! Spell-check is only the first step; then it's careful word-by-word checking. Frontward. Backward. Aloud. The absolute last thing you want to broadcast to potential clients is that you're careless about your own work.

To cut cost in printed newsletters, work in one or two colors, unless you can economically produce a full-color issue in-house. If you opt for an electronic format, send it in PDF for easier access. Make sure it's a sophisticated piece with an appropriate subject line that won't be confused with spam.

Cloudjammer Studio's zine grabbed our attention. Check it out at *www.fightboredom.net.*

NETWORKING

Like it or not, networking is a priority in the life of any successful agency owner. *Who* you know is sometimes as important as *what* you know, particularly in our ever-changing world of mergers, acquisitions, and job-hopping. A case in point comes from Tucson's Don Regole. "My niche since the midnineties is working with shopping centers. I started by doing work for the Foothills Mall here in Tucson and then made contacts through the International Council of Shopping Centers. There's a lot of turnover in the field so people who've hired me in the past move around to new places and call me again," he says. "Actually, I've never even met some of them but they still call with work, wherever they go."

In today's shifting world, your Rolodex or PDA (Personal Digital Assistant) are tools that are as essential to your graphic design business as your Mac or your cell phone.

Another benefit of networking is that it can help you stay on top of your game. Michael Beall of True North Video Marketing says, "Your job as a graphic designer is to figure out how other people can help you. Ask questions of them. Get in relationships with people who have for-real knowledge. Keep your eyes open for who and what's hot. Don't rely on other people to tell you what's going on."

The bottom line is you must become—and remain—visible throughout your career. After all, your business success, especially in the beginning years, depends on your ability to maintain a high profile.

Here are some basic networking tips that we gleaned from design professionals:

- Never leave home without business cards and brochures
- Pass out your business cards at every opportunity
- Keep the cards you receive for your database
- Attend meetings or workshops to stay current about issues in your field
- Volunteer to write an article for your alumni magazine
- Offer to present a talk at a professional meeting

Advanced Networking Strategies

As you become more comfortable with networking, you quickly realize that the more people you know—and the more you involve them in helping you promote your business—the more money you save on attracting clients. Sharpen your networking skills even further by following these tips:

Make It a Priority. To get started on incorporating networking into your daily or weekly activities, we recommend you spend ten to twenty minutes each week jotting down information about the people you made contact with, above and beyond your current clients. This list will serve not only as a reminder of your intention to network but also as a scorecard that helps you see how you're pro-

gressing. In the first year or two of business, you need to devote a minimum of five or ten hours a week to networking activities. If you break that down on a daily basis, the task seems much less daunting; for example, set aside an hour or two each day to work the phones or send off networking e-mails, attend meetings, or update your contacts database.

Create an Elevator Speech. One of the most useful pieces of networking advice we ever received was from Deb Burwell, a group facilitator in Belfast, Maine, who emphasized the importance of creating "an elevator speech." Since elevator rides generally run about thirty seconds, that's how much time you have to focus on what you do differently or better and why this matters to your clients. Your message should be upbeat and never sound "canned," though you may have rehearsed it fifty times. Take your elevator speech out for a test drive on friends and get some feedback before you actually deliver it at networking occasions. When you have it nailed, commit it to memory.

Become a Joiner. Joining professional organizations and attending their meetings and conferences also offer great opportunities for networking. Although the membership costs often run high, the contacts you make are often priceless. Why not suggest your parents or friends gift you with memberships or trade publication subscriptions? That way you'll be able to move forward in your career and they'll receive the satisfaction of giving you a gift that you'll really appreciate—and one that might bring your financial rewards down the road.

If you're ready to join a design organization, the usual suspects include the perennially popular Graphic Artists Guild (GAG) and the American Institute of Graphic Arts (AIGA). Maybe you'll find a local chapter in your area. For illustrators, some options are the Society of Illustrators and the Illustrators' Partnership of America. For photographers, check with The Society of Photographers.

Other organizations to consider include the American Advertising Federation, Society of Publication Designers, American Marketing Association, Artist Representatives, Inc., Regional Magazine Association, Society of Typographic Arts, National Advertising Federation, and American Association of Advertising Agencies.

Becoming a member of these organizations can help you stay on top of hot issues in the design world, plus you can make some great professional connections.

Go with a Goal. The old saying about "see and be seen" is good advice when it comes to increasing your visibility at places where potential clients congregate. However, showing up is not enough. Go with a goal, advises Mariette Durack Edwards, author of the online article, "The Myths of Networking." In her article, she writes:

What is your primary objective in attending your next networking event? If you say, "to make a sale," you will probably be disappointed. If you say, "to connect with at least three people who could benefit from what I offer and arrange for a follow-up meeting or conversation to further develop the relationship," you've got the right idea.

Give and Take. Never forget that networking is a two-way street. That means listening and sharing a genuine interest in others and the work they do. Be generous in offering specific resources—and then follow through on what you said you'd provide, a habit that enhances your credibility. If you meet someone who does you a good turn, send a note of appreciation and look for chances to lend that person a helping hand, although it doesn't have to be right away.

On a final note, just to ensure that you're making friends and not enemies when you network, check out more pointers in the online article by Liz Ryan, "Networking: What Not to Do," at *www.businessweek.com*.

PRO BONO WORK

Since you're operating a business, paid work must remain your top priority. However, in the course of your networking, you may be asked to volunteer your services or do some *pro bono* work, a term that literally translates as "for good." Some examples might be designing a poster or entry form for a nonprofit organization or charitable event.

Well, if I can't get paid, you may be thinking, *how about a getting a tax write-off*? In a nutshell, Uncle Sam says no. The longer answer is taken from Topic 506 (Contributions) on the 2006 IRS Web site:

> Although you cannot deduct the value of your time or services, you can deduct the expenses you incur while donating your services to a qualified organization. If the expenses are for travel, which may include transportation and meals and lodging while away from home, they may be deducted only if there is no significant element of personal pleasure, recreation, or vacation in the travel. Actual costs of gas and oil can be deducted, or you can choose to take fourteen cents per mile for using your own car.

Financial considerations aside, such freebie work brings other types of benefits along with it, such as:

- Adding an impressive piece to your portfolio
- Working on a grander scale than usual, especially if others are donating their services as well (photography, printing, copywriting).
- Putting your name out in front of a wider audience, either by placing a credit line on the piece you design or receiving some acknowledgement in a program, newsletter, speech, press release, or link to your site.

PROJECT VALUE SHEET

JEFF FISHER

LOGO MOTIVES

Date: Job Number:

Company: Contact:

Address:

City, State, Zip:

Phone: Fax:

PROJECT DESCRIPTION:

COSTS:

DESIGN/ILLUSTRATION _____ hrs. @ \$ _____/hr. = \$ _____

ART DIRECTION _____ hrs. @ \$ _____/hr. = \$ _____

COPYWRITING _____ hrs. @ \$ _____/hr. = \$ _____

PRODUCTION _____ hrs. @ \$ _____/hr. = \$ _____

CONSULTATION _____ hrs. @ \$ _____/hr. = \$ _____

RESEARCH _____ hrs. @ \$ _____/hr. = \$ _____

MISC. CLIENT SERVICES _____ hrs. @ \$ _____/hr. = \$ _____

LABOR SUBTOTAL = \$ _____

RC PAPER/FILM/NEG OUTPUT = \$ _____

SCANS/CAMERA SERVICES = \$ _____

CONVERSIONS/COMPUTER SERVICES = \$ _____

MISC. MATERIALS/SHIPPING = \$ _____

TOTAL = \$ _____

Deposit − \$ _____

Discount(s) − \$ _____

TOTAL = \$ _____

Post Office Box 17155
Portland, OR 97217-0155

Phone: 503/ 283-8673
Facsimile: 503/ 283-8995

NOTE: This **IS NOT** an invoice, but rather a documentation of fair market value of work done as a donation by **JEFF FISHER LOGOMOTIVES**. Thank you.

jeff@jfisherlogomotives.com
www.jfisherlogomotives.com

Pro bono project value sheet

It's wise to negotiate such attributions upfront so you won't be disappointed later on. Also agree that you'll be notified of any changes to your design *before* it goes to press.

Logo-Motives designer Jeff Fisher of Portland, Oregon is a passionate advocate of *pro bono* work. He says, "Having executed *pro bono* work for over twenty-five years, I have learned that you must often make the recipient aware of the value of your work." To accomplish that goal, Jeff created a Project Value Sheet, which apprises clients of the value of his time. "Conveying this information to the clients has resulted in greater appreciation of my work," he adds.

Still unsure if the freebie route is for you? When you're approached with such a request, say you'd like some time to consider. Then answer these questions:

- Is this work my passion?
- Will there be contacts I can make who may hire me in the future?
- Will this be fun?
- Do I like them?
- Do they need a break?

If the answer is Yes to one or more of these questions, go for it! To ensure you and your clients have a smooth ride on the *pro bono* highway, download the invaluable "Guidelines for Creatives" and "Guidelines for Clients" developed by Larry Asher and provided as a public service by The School of Visual Concepts and AIGA Seattle at *www.svcseattle.com/probono/*.

COMPETITIONS

Receiving an award can be a boost to your ego as well as a means of garnering publicity.

You may decide to test the waters by entering some local or regional competitions first. Remember that true winners never give up—they always keep trying to reach new levels of creativity and originality.

Most of the larger nationwide contests or competitions charge rather stiff entry fees and the competition is keen. However, if you're talented enough to nab top honors, your work could wind up being published in an award annual. Exposure like that? Priceless.

Once you do become a winner, follow the advice of graphic designer and noted author Lee Silber, who wrote *Self-Promotion for the Creative Person*: "Keep a record of your award. Tell everyone! Include it on the cover of your marketing materials and on your Web site. Alert the media immediately. Don't depend on the organization giving the award to do it. Take your own photo, if you have to, and send it with your release."

TOOT! TOOT!*

19 April 2006
For Immediate Release

Jeff Fisher LogoMotives takes gold in Summit Creative Awards

The Portland-based firm Jeff Fisher LogoMotives was recently awarded the Gold Award in the Summit Creative Awards, in the category of black and white logo/trademark, for the Neighborhood Service Center logo created for the City of Portland. The Summit Creative Awards (http://www.summitawards.com/) were created 12 years ago to recognize and celebrate the creative accomplishments of small and medium sized advertising agencies and other creative companies throughout the world with annual billings of under $25 million. Thousands of entries, from 26 countries, were submitted for consideration this year. Since 1998, Jeff Fisher LogoMotives has received 15 of the honors.

The Neighborhood Service Center logo project was coordinated through the office of Portland City Commissioner Randy Leonard and the symbol initially identified the center housed in the historic Kenton Firehouse, located in North Portland. The service center program places neighborhood livability services personnel - including some inspections, crime prevention and permits staff - in city-owned facilities throughout Portland for easy access by residents. The logo is used on city street signage to direct citizens to the centers.

Designer Jeff Fisher, the Engineer of Creative Identity for the design firm, also served on the international panel of judges for the 2006 Summit Creative Awards. Other professionals participating in the judging process - from the United States, Kuwait, Dubai, South Africa, Canada, Germany, Bahrain, and India - represented Ogilvy and Mather, Paragon Marketing Communications, Avenue Inc, Stormhouse Partners, Memac Ogilvy, PUSH, Inc., Innocean World-wide, Mfx, Inc., Type A Learning Agency, Tribal DDB, Cocoon Branding, Promoseven Network, Inc. and the Art Institute. When it came time to review and score the identity entries, Fisher found it necessary to excuse himself from judging his own work and familiar logo design submissions from several other designers.

Jeff Fisher has received nearly 500 regional, national and inter-national graphic design awards for his logo and corporate identity efforts. His work is featured in more than 80 books on the design of logos, the business of graphic design, and small business marketing.

Fisher is a member of the HOW Magazine Editorial Advisory Board, the HOW Design Conference Advisory Council and the Board of Directors of Proscodi: Professional Society of Communi-cation Design. His first book, The Savvy Designer's Guide to Success, was released by HOW Design Books in late 2004. He is currently writing "Identity Crisis," also for HOW Design Books, which is expected to be on bookshelves in 2007.

Post Office Box 17155
Portland, OR 97217-0155

Phone: 503/ 283-8673
Facsimile: 503/ 283-8995

* If I don't "toot" my own horn no one else will.
For additional information about LogoMotives contact Jeff Fisher

jeff@jfisherlogomotives.com
www.jfisherlogomotives.com

News release

Designer Jeff Fisher is the personification of this principle. "About twelve years ago, I decided to no longer spend my marketing budget on print advertising or direct mail pieces," he says. "Those advertising dollars are now directed to entry fees for design competitions all over the world." Is this approach working for him? Big time. Over the past decade, he's racked up over five hundred regional, national, and international awards. When he does win top honors, he maximizes his exposure by issuing press releases like the one on the previous page.

By the way, as soon as you receive notification of your award, notify the client for whom you did the work. This can be an occasion to do something special: send flowers, go out to lunch, at least send a card. Who knows? It could prompt the client to think of more business problems you can solve for her.

You don't always have to nab the number one spot either, according to Lee Silber. "The bottom line is that awards can create more of an awareness and respect and can increase sales, even if you don't win," he says.

We firmly endorse celebrating even small victories. When Ruth was nominated for a Pushcart Prize, for instance, don't imagine for a minute that she didn't celebrate her brief moment of glory.

PART III: KEEPING YOUR BUSINESS

Once you've landed accounts, you'll want to concentrate on creating satisfied clients in order to encourage repeat business. Why? Because a returning client is more valuable to your business than a new client. Returning clients mean more profit for your business than new clients because you don't have to spend your time and money attracting and persuading them to try your services.

In fact, according to creative services consultant Maria Piscopo, "It can be five to ten times more expensive to be constantly looking for new clients than it is to keep the ones you already have. This can increase your profitability because repeat business can reduce expenses for self-promotion."

There are, of course, ways to increase your chances of creating repeat business, many of which require adjusting the way you relate to your existing client base. Business consultant Jay Abraham suggests that you think hard about the differences between a *customer* and a *client*. Sure, you use the word *client* in your business dealings, but do you really get the distinction? Abraham notes that a *customer* is someone who "purchases a commodity or service," but a *client* is someone who is "under the protection of another."

> [This] means that you don't sell them a product or service just so you can make the largest one-time profit possible. You must understand and appreciate exactly what they need when they do business with you—even if they are unable to articulate that exact result themselves. Once you know the final outcome they need, you lead them to that outcome—you become a trusted adviser who protects them. And they have reason to remain your client.

In order to provide leadership and, yes, even protection for your client (not to mention for yourself), you need to think independently and prepare yourself to be proactive in your business dealings with your clients as well as with freelancers and other specialists. This section shows you the best practices to achieve your goals.

Spotlight On
CATHY TEAL/FIREBRAND DESIGN: PUTTING CLIENTS AT EASE

I cut my teeth in the agency business before I opened my own small ad agency. Now I work solo. My business comes mostly through cold calls, referrals, and word of mouth.

Whatever I do—presentations, writing, communicating—it's really about putting people at ease. Before I meet with clients, I conduct independent research so I have an idea what questions to ask. At meetings, I always listen for verbal and nonverbal cues. A lot of designers are so busy saying how great they are, they don't listen to the client.

In presentations I speak directly to the clients' needs and wants. Dealing with objections is an important part of sales. If I don't get the account, I move on. Designers who don't take rejection well have no business in this business.

I disclose as much as possible about terms and conditions, like logistics and ownership and kill fees and what I will and will not do. I explain about copyright issues and intellectual property. If they don't issue a contract for the job, I do so that it's in writing.

When it comes to designs, clients often lack visual literacy. It's part of our jobs as designers to educate our clients so they know what they're looking at.

Some designers hold clients hostage over domain names, Web sites, and files. If clients want to work with other vendors and have paid up, I give them their property. Sometimes, if I have to tell a client it's not a good fit, I'll offer to set the client up with another designer. I don't believe in burning bridges.

In design they say you need to reinvent yourself every five years—well, now it's every year. I'm constantly re-evaluating and updating and improving.

Chapter 12:
WORKING OUT AGREEMENTS WITH YOUR CLIENTS

It takes time and effort to improve your negotiating skills and even more to follow up by putting agreements in writing, but it's time well-spent. If you observe these practices, you'll find that your working relationship with clients improves exponentially.

NEGOTIATIONS

Just the word "negotiation" causes consternation for many people, leaving them with a sense of vague distaste or unease. On the other side of the spectrum, some people actually enjoy a surge of energy and love the challenge of negotiations.

We can dispel much of the negativity that surrounds the negotiating process if we become aware of our own faulty assumptions. It's not true that:

- We all see things the same way
- We want all the same goals or outcomes
- If I win, you lose

The beauty of examining your assumptions is that it allows you to change your perceptions. That step combined with sharpening your negotiation skills paves the way for you to successfully navigate through your business dealings.

Al Silverstein, retired executive vice president of Jobson Publishing, gives some important pointers to people who want to become better negotiators. He says, "There are four things you need to do. Come in with a positive attitude. Be willing to compromise. Make sure you know your client's needs. Start high; you can always come down, but you can't go up." Now, let's consider each of these strategies more closely.

Come in with a positive attitude. Even though negotiations have an adversarial edge, it's good to keep in mind that you and your client already agree that you want to work together on the project. That's where your positive attitude comes in. You are simply working out the fine points of the agreement.

Be willing to compromise. No one is recommending that you compromise your professional standards or that you agree to concessions that threaten the successful completion of the project. However, there are some issues where compromises are possible. Part of your job as a negotiator is deciding what these issues are and how much room you have.

Make sure you know your client's needs. Your primary goal is to fulfill your client's needs, without sacrificing your own need to run a profitable business. To articulate your client's needs, focus on the project goals that you defined through your independent research and your meetings with the client.

Start high; you can always come down, but you can't go up. When all is said and done, you must know your bottom line. Don't start there when you begin to negotiate. Give yourself some room for compromise. Many people will get a certain sense of satisfaction from getting you "down" from your initial suggestion bid, or offer. (If the client you're negotiating with is someone you've done business with before and you know this ploy will annoy him, disregard this tip.)

The Three Stages of Negotiating
Successful negotiations have three stages: preparation, performance, and follow-up.

1. *Before Negotiations.* The biggest mistake you can make is to enter negotiations without a well-thought-out negotiation strategy and plan. Preparation is crucial for successful negotiations. That is why before you negotiate, you need to write down and prioritize the goals and objectives of both parties—your client's and your own.

Once you establish your common goals as a touchstone, you can then sort out what you want and need to do the job. Make a list of your needs, and then prioritize the items by dividing them into two categories: the must-haves (non-negotiable points) and the would-like-to-haves (negotiable points). Review the negotiable points for items that can be modified or omitted. In advance, work out explanations and descriptions of how modifications, alternatives, and omissions will affect the quality and power of the final project.

The point of this preparation is to have various scenarios in mind (and on a note sheet) when you are in the hot seat of negotiations. You don't want to give away what you (and the project) can't afford to lose. Keep your note sheets in your project file, so that you can find them easily. Whether you negotiate by appointment or via an impromptu telephone call or e-mail, first take the time to retrieve your file and review your notes before proceeding.

2. *During Negotiations.* Your previous preparations will allow you to be balanced and proactive during negotiations. First, you need to establish your overarching mutual goals. If you've done your homework, you should have a convincing and strong statement of shared goals. Your client may see these goals differently, so be prepared to work through to consensus. This means careful and objective listening on your part, but it's time well spent in the end. Once established, these mutual goals can and should be referred to throughout the negotiations.

Second, consult your preliminary notes, and negotiate with a pen in hand to jot down numbers, dates, processes, and whatever other significant information you are agreeing upon. Whether you meet in person or via the telephone, date your meeting notes, list who was present at the meeting, and take notes, paying particular attention to terms and due dates.

Third, separate the personalities from the negotiation points. As you well know, clients come in a variety of temperaments. Some people are a pleasure to do business with, and some are not. But you have chosen to take on this project,

and you want to create an agreement that will foster success. Therefore, when you negotiate with a difficult client, remind yourself of the reasons you wanted this project in the first place and focus on the project goals and how they relate to the points of contention. Doing this lends some objectivity to your interactions and helps you to maintain a neutral tone, which is important to your business relations and overall reputation. You don't want to burn any bridges. In almost all cases, you'll be able to work through to a compromise, and your cool-headed manner will have served you well. Even in the worst-case scenario, where disagreements over nonnegotiable issues result in an unsigned contract, you never know whom your client knows (or is related to). A pig-headed client might be a potential client's favorite golf buddy. Separating with no hard feelings is the best way to go.

3. After Negotiations. Immediately after your negotiation session, check the notes you've made and fill in any missing information, so that they are complete and accurate for your own files. Draft the points of agreement and share them with your client. If you receive feedback, incorporate it into the next draft until you have a document you can both accept.

While there are numerous books available on negotiation, one of the perennial favorites is *Getting to YES: Negotiating Agreement Without Giving In* by R. Fisher and W. Ury.

WRITTEN AGREEMENTS

Although experienced designers and consultants agree on the necessity of getting agreements in writing at the onset of your project, there is more than one way to accomplish this. We are going to address the five most often used forms of written agreements: the formal contract, the letter contract, the project confirmation agreement, the signed proposal, and the usage agreement.

CONTRACTS

Learning to find your way around a formal contract does more than protect you and your business (although that's reason enough). It helps you grow as a businessperson. As Jennifer Lawler points out in *Small Business Ownership for Creative People*, "Understanding contracts and how they work teaches you a great deal about your business and about how to be a better business owner." The time and effort you put into learning the ins and outs of contracts will be well spent. Lawler suggests that when you begin to read contracts critically, you use a legal dictionary to translate the legal jargon into plain English. You'll find specialized dictionaries at your local library. If you make the time to educate yourself in this way, you'll find that after the first few contracts, you'll have gained familiarity with contract terminology. This is a good thing, because the more you understand on your own, the better prepared you'll be to negotiate.

Whether the contract originates with you or your client, you should be sure these items are addressed in every contract before you sign it.

- A description of the project and the work you will provide
- Fees, out-of-pocket expenses, and rates for additional services
- A project schedule covering deadlines, approvals, and number of edits included in the fee
- A payment schedule, including advances
- Conditions of ownership and transfer of rights
- Client's responsibility for errors, delays, and rush work
- Materials and copyright clearances to be provided by the client
- Kill fee in the event that the project is cancelled

This list is not exhaustive and is meant only to suggest issues that you might otherwise overlook in your contract negotiations. To find more detailed information on contracts and various samples written specifically for graphic designers, you should consult the following books: *Business and Legal Forms for Graphic Designers* by Tad Crawford and Eva Doman Bruck and *The Graphic Artists Guild Handbook: Pricing and Ethical Guidelines*. Because other issues may need to be addressed in your contracts, we recommend that you consult an attorney before signing.

LETTER CONTRACTS

What if you are working with a client who has a casual way of doing business and prefers to shake hands by way of an agreement? While you may be tempted to follow your client's lead to show you're a kindred spirit, ignore that temptation. It's best to put even the most informal agreements in writing. Using a letter format that covers the key issues and responsibilities is a good way to protect yourself from a client who might turn out to be as casual about paying or canceling the job as he was about wanting to begin work with nothing more than a handshake.

A letter contract has a less formal tone than a traditional contract because you are writing the terms and conditions in plain English and addressing it to "Dear Bill" or "Dear Mary." The components are the same as with any other business letter. (See pages 23–26 for a discussion of the parts of a business letter.) But unlike other kinds of letters, a letter contract has a place at the end not only for your signature, but also for your client's signature as well as the dates you each signed the document. Make two signed copies so that both parties have the signed document for their files.

PROJECT CONFIRMATION AGREEMENTS

Another way of finalizing an agreement in writing is to issue a project confirmation agreement for both parties to sign. This type of agreement builds on a pro-

posal or estimate that you've submitted previously, which the client has accepted with some modifications. The modifications are noted in the project confirmation agreement. The form on pages 156–157 is from *Business and Legal Forms for Graphic Designers* by Tad Crawford and Eva Doman Bruck. Consult that book for a detailed discussion of the form and for an inclusive negotiation checklist.

SIGNED PROPOSALS

A possibility for those of you who want to lessen your paper load is to have your client sign your proposal. If you go this route, be sure that your proposal includes all of the key issues and conditions that are important to you. If a few changes are made to your proposal during negotiations, these changes can be written into the text or in the margins and initialed by both parties. See pages 113–127 for sample proposals.

DESIGN BRIEFS

While written design (or creative) briefs may not be necessary for routine or ongoing projects, they are crucial for major design projects. A design brief can range anywhere from a single page consisting of a summary and bulleted details to a prose narrative the length of a novella. The most useful and process-friendly design briefs are somewhere between the two extremes in length and format. As in all business writing, the format reflects the style and tone of the client or initiating department.

In general, the components of a design brief are:

- Objective—scope and desired outcome of project, business objectives, target audience
- Background—industry review, competitors, company profile, long/short term marketing strategies, existing company/brand material, stakeholders
- Format—design strategies, necessary specifications
- Design—overall visual image, required or available photos and illustrations, copy synopsis, identity rules
- Budget—broken down into project stages
- Deadlines—timelines, stages of project, approvals
- Legal requirements

Design briefs originate in various ways—for example, with a draft from a creative director or the client's team before you came on board as the designer, or with a questionnaire that you, the designer, had a client fill out to help you begin to scope out the project. Regardless of how the brief originated, most designers agree that once you have the job, the ideal development of the brief should be a collaboration between the client and the designer.

Project Confirmation Agreement

AGREEMENT as of the _____ day of _____, 19 _____, between _____,
located at _____ (hereinafter referred to as the "Client")
and _____, located at _____
(hereinafter referred to as the "Designer") with respect to the creation of a certain design or designs (hereinafter referred to as the "Designs").

WHEREAS, Designer is a professional designer of good standing;

WHEREAS, Client wishes the Designer to create certain Designs described more fully herein; and

WHEREAS, Designer wishes to create such Designs;

NOW, THEREFORE, in consideration of the foregoing premises and the mutual covenants hereinafter set forth and other valuable considerations, the parties hereto agree as follows:

1. **Description.** The Designer agrees to create the Designs in accordance with the following specifications:
 Project description_____
 Number of finished designs_____
 Other specifications_____
 The Designs shall be delivered in the form of one set of finished camera-ready mechanicals, unless specified to the contrary here_____
 Other services to be rendered by Designer_____

 Client purchase order number_____Job number_____

2. **Due Date.** The Designer agrees to deliver sketches within _____ days after the later of the signing of this Agreement or, if the Client is to provide reference, layouts, or specifications, after the Client has provided same to the Designer. The Designs shall be delivered _____ days after the approval of sketches by the Client.

3. **Grant of Rights.** Upon receipt of full payment, Designer grants to the Client the following rights in the Designs:
 For use as_____
 For the product or publication named_____
 In the following territory_____
 For the following time period_____
 Other limitations_____
 With respect to the usage shown above, the Client shall have ❑ exclusive ❑ nonexclusive rights.

4. **Reservation of Rights.** All rights not expressly granted hereunder are reserved to the Designer, including but not limited to all rights in sketches, comps, or other preliminary materials created by the Designer.

5. **Fee.** Client agrees to pay the following purchase price: $_____ for the usage rights granted. Client agrees to pay sales tax, if required.

6. **Additional Usage.** If Client wishes to make any additional uses of the Designs, Client agrees to seek permission from the Designer and make such payments as are agreed to between the parties at that time.

7. **Expenses.** Client agrees to reimburse the Designer for all expenses of production as well as related expenses including but not limited to illustration, photography, travel, models, props, messengers, and telephone. These expenses shall be marked up _____ percent by the Designer when billed to the Client. At the time of signing this Agreement, Client shall pay Designer $_____ as a nonrefundable advance against expenses. If the advance exceeds expenses incurred, the credit balance shall be used to reduce the fee payable or, if the fee has been fully paid, shall be reimbursed to Client.

8. **Payment.** Client agrees to pay the Designer within thirty days of the date of Designer's billing, which shall be dated as of the date of delivery of the Designs. In the event that work is postponed at the request of the Client, the Designer shall have the right to bill pro rata for work completed through the date of that request, while reserving all other rights under this Agreement. Overdue payments shall be subject to interest charges of _____ percent monthly.

Project confirmation agreement (page 1)

9. **Advances.** At the time of signing this Agreement, Client shall pay Designer ____ percent of the fee as an advance against the total fee. Upon approval of sketches Client shall pay Designer ____ percent of the fee as an advance against the total fee.

10. **Revisions.** The Designer shall be given the first opportunity to make any revisions requested by the Client. If the revisions are not due to any fault on the part of the Designer, an additional fee shall be charged. If the Designer objects to any revisions to be made by the Client, the Designer shall have the right to have his or her name removed from the published Designs.

11. **Copyright Notice.** Copyright notice in the name of the Designer ❑ shall ❑ shall not accompany the Designs when reproduced.

12. **Authorship Credit.** Authorship credit in the name of the Designer ❑ shall ❑ shall not accompany the Designs when reproduced.

13. **Cancellation.** In the event of cancellation by the Client, the following cancellation payment shall be paid by the Client: **(A)** Cancellation prior to the Designs being turned in: ____ percent of the fee; **(B)** Cancellation due to the Designs being unsatisfactory: ____ percent of fee; and **(C)** Cancellation for any other reason after the Designs are turned in: ____ percent of fee. In the event of cancellation, the Designer shall own all rights in the Designs. The billing upon cancellation shall be payable within thirty days of the Client's notification to stop work or the delivery of the Designs, whichever occurs sooner.

14. **Ownership and Return of Designs.** Upon Designer's receipt of full payment, the mechanicals delivered to the Client shall become the property of the Client. The ownership of original artwork, including but not limited to sketches and any other materials created in the process of making the Designs as well as illustrations or photographic materials such as transparencies and of computer disks, shall remain with the Designer and, if delivered by Designer to Client with the mechanicals, shall be returned to the Designer by bonded messenger, air freight, or registered mail within thirty days of the Client's completing its use of the mechanicals. The parties agree that the value of original design, art, or photography is $_____, and these originals are described as follows _____

15. **Releases.** The Client agrees to indemnify and hold harmless the Designer against any and all claims, costs, and expenses, including attorney's fees, due to materials included in the Designs at the request of the Client for which no copyright permission or privacy release was requested or uses which exceed the uses allowed pursuant to a permission or release.

16. **Arbitration.** All disputes arising under this Agreement shall be submitted to binding arbitration before _____ in the following location _____ and settled in accordance with the rules of the American Arbitration Association. Judgment upon the arbitration award may be entered in any court having jurisdiction thereof. Disputes in which the amount at issue is less than $_____ shall not be subject to this arbitration provision.

17. **Miscellany.** This Agreement shall be binding upon the parties hereto, their heirs, successors, assigns, and personal representatives. This Agreement constitutes the entire understanding between the parties. Its terms can be modified only by an instrument in writing signed by both parties, except that the Client may authorize expenses or revisions orally. A waiver of a breach of any of the provisions of this Agreement shall not be construed as a continuing waiver of other breaches of the same or other provisions hereof. This Agreement shall be governed by the laws of the State of _____.

IN WITNESS WHEREOF, the parties hereto have signed this Agreement as of the date first set forth above.

Designer_____ Client_____
 Company Name Company Name

By_____ By_____
 Authorized Signatory, Title Authorized Signatory, Title

Project confirmation agreement (page 2)

REGOLE DESIGN
USAGE AGREEMENT

620 N 7th Ave
Tucson AZ 85705
520-624-9577

DESCRIPTION: **USAGE AGREEMENT BETWEEN REGOLE DESIGN and URBAN ORGANICS**

The icons displayed below represent a proposed identity system created to date by Regole Design for the intended use of Urban Organics (UO). The proposed identity system was developed simultaneously to design and production of a DVD package, the latter of which was to secure funds for UO, a new upstart company. The proposed identity system portion (comprised of logo & icons) progressed with UO's direction simultaneously to production of the DVD package. However, the proposed identity portion was suspended and no fees were assessed or paid for by UO for any identity portion in the final invoice rendered for the DVD package. To meet the immediate need of completing the DVD package through to print, it was mutually agreed to utilize the proposed identity materials created to date as an interim solution for application in the DVD project only. With subsequent input from UO, the identity portion would then continue its evolution through completion at a later date with all associated fees billed to client at that time.

Urban Organics has since expressed that funds needed to promote its products in a test market were limited and prohibited the continuation of developing the company's identity — in addition to other projects — at this time. Therefore, Urban Organics has elected to develop the necessary initial sales materials in-house until a time that funding can be secured through outside investors.

This document is an agreement between Regole Design and Urban Organics for usage rights of the proposed identity logo and icons referred to above and displayed below. Usage rights will be granted by Regole Design for interim use by Urban Organics only as outlined below and until such time that the identity project for UO can be reinstated and taken to fruition with Regole Design.

urban**organics**

EXISTING LOGO
Initiated by
Urban Orgaincs

PROPOSED IDENTITY LOGO AND ICONS CREATED BY REGOLE DESIGN
© 2004 REGOLE DESIGN. Identity logo & icons remain the property of Regole Design.

USAGE TERM: August 22, 2005 through December 31, 2005 — at which time an extended term for interim usage can be negotiated.

USAGE FEES: $0.00 — No fees will be charged for usage during the term indicated above.

USAGE PERMISSION: Granted to Urban Organics and limited to the development of Point of Sales (POS) materials created by Urban Organics internally with the sole objective of securing outside investors and related funding.

AGREEMENT: X_____
 URBAN ORGANICS REPRESENTATIVE DATE

 X_____
 REGOLE DESIGN / Don Regole 08/17/05
 DATE

Usage agreement

158

The collaborative process goes a long way towards ensuring shared responsibility for the timely completion of the project's stages and the success of the project as a whole.

There are many who believe that the collaborative process should begin at the onset of the brief's development. Eric Karjaluoto, Director and Principle at smashLAB, believes in getting his designers involved from the very beginning. Because Eric knows that developing these language skills takes willingness and practice, he doesn't expect his new designers to come in with these ready-made skills. Most designers, he says, find design brief development and writing to be "quite overwhelming at first, [but] after a few campaigns they generally find it a logical and straight-forward part of the process." He recalls a designer (no longer part of the firm), who was unwilling to work on his writing skills:

> One of our past designers felt almost slighted that he had to waste his time writing briefs for projects. He often reminded me that he wasn't a writer, and that this was far out of the realm of a Senior Designer's duties. I must say that I found this horribly frustrating and difficult to comprehend. In my mind the greatest benefit a designer earns with experience, is the opportunity to be more highly involved and responsible for a project. That's where the choices are made and the fun seems to begin.

Design industry veteran Peter L. Phillips strongly argues for equal co-ownership of the brief, between "an owner who represents the group with the business need for the design work, and a co-owner from the design function that will meet that need." What he's calling for is a reframing of the client-designer relationship into "a strategic business partnership." For a detailed consideration of the opportunities and advantages of participating fully in the creation of a design brief, read Phillips' book, *Creating the Perfect Design Brief*.

Whether you are called upon to work on a brief from its inception, to modify an initial draft, or to recommend (or insist upon) changes and additions in a later version of a brief, the more you can contribute to a design brief, the better-equipped you'll be for the project itself. Your input may also help educate your clients, helping them understand the process of design.

USAGE AGREEMENTS

At times you may design identity logos or icons for a client and yet retain the right to approve or restrict their future use. In such cases, a Usage Agreement can be a valuable tool that clearly defines the terms to which you and your client agree. Designer Don Regole shares his on page 158.

Chapter 13:
PROVIDING QUALITY SERVICE

A major key to encouraging repeat business is making sure that your clients receive quality service. For some of you, that may mean adjusting your perspective to focus on your clients as much as on your projects. Quality service is based on building relationships with your clients through:

- Demonstrating understanding and empathy
- Offering expert information and education

To deliver such high-quality service requires great communication skills. You'll need to explain design terms and processes, and you'll need to do it in clear English. (See the section called "Think with Beginner's Mind" on page 201.) You'll also need to go beyond the information your client gives you by doing your own research.

SPEAK YOUR CLIENT'S LANGUAGE

It's up to you to help your clients understand the design process well enough to participate and provide their own explanations, when necessary. "It's all about making the client look good to their boss and to their clients," designer Cathy Teal says. Now that's a perfect example of empathy, isn't it? She goes on to explain:

> Most people aren't visual. They need to be told what they're looking at and won't understand your designs the way you do. Most communications and marketing people can't tell the difference between a design "eight" and a "five." They lack "visual literacy." One of our jobs as designers is to educate our clients.

This means that you need to speak and write in plain English, not jargon. It also means that you need to organize and edit your words so that your clients can follow and comprehend the concepts, issues, and processes you are trying to communicate.

Begin by working out a brief audience analysis. (See pages 14–15 and 247 for an introduction to audience analysis.) Here are four useful questions you can answer about your clients to help guide you in communicating with them:

What Do My Clients Need/Want to Know,
and What Do They Already Know About Design Issues?

Your first task is to set aside any preconceived notions you hold about your non-designer clients. Your clients can't be lumped into one category, because they

possess different levels of design knowledge and varying levels of interest in knowing and understanding design concepts and processes. "Early in the client relationship, establish how much the client wants to know," urges designer Christy White, "Treat each client as an individual and read his body language. Listen to his questions and opinions with great care to determine how much information is just enough. This will make the 'service' aspects of your business dealings that much stronger and more effective."

How Can I Use My Clients' Own Business Jargon to Explain the Design Process on Their Terms?

As you were researching your clients' industry and background materials, were you jotting down their technical terms and descriptions for later use? (See pages 35–42 for research tips.)

Have you developed a good general business vocabulary? Any time you can translate an issue or stage of a design process into bottom line (money) language, you will communicate more effectively.

Do My Clients Judge Me Based on My Language Usage?

By language usage we mean correctness, use of standardized English, verbal and written skills. Expect that many clients do, indeed, judge your intelligence (not to mention your attention to detail) by your use of language. You never know which clients will be turned off by ungrammatical, confusing, or incomplete messages—even if they also do it themselves. Clients may even equate your skills as a verbal communicator with your abilities as a visual communicator.

E-mail makes this issue especially important. Even if your messages aren't conveyed in formal letters or memos, you will use e-mail as a major mode of communication. E-mail gives your messages a permanence that the telephone does not, since e-mails can be printed and forwarded or filed for future reference. This means that a carelessly written and quickly sent message might wind up as an archived document with multiple readers.

Writing business e-mail presents a specific challenge to the generations that grew up writing personal and informal e-mail. Familiarity with the medium has bred carelessness with the format and content. Don't assume that errors are acceptable because they are prevalent among your peers. Remember, you're in a competitive field. Strive to stand out on all levels because of excellence. (See pages 28 and 200 for e-mail guidelines and strategies.)

Are My Clients and I from the Same Culture? Do We Share the Same Language, Expressions, Customs, and Values?

When you conduct business with clients from other cultures, communication challenges are compounded. Besides needing to translate design jargon into everyday English, you also should pay attention to idiomatic expressions, customs, and values from your clients' culture and your own that can lead to misunderstandings. For more information on working across cultures, see pages 207–215.

EXPLAIN DESIGN PROCESSES

In order to get your clients on board with deadlines, help them understand issues, and convince them to approve the changes that will arise as your project proceeds from beginning to end, they'll need to understand what the design process involves. This means that you've got some explaining to do, and just how much depends on the individual client.

Asking yourself these questions helps you get clear about the way you will structure your client communication as well as make decisions about the amount and depth of information you will provide:

- What will the client need to do with the information (make a decision, give approval)?
- How much of the process will the client *need* to know to do what he needs to do?
- How much does the client *want* to know (interest, patience, detail-orientation)?
- How much about the process does the client already know?
- Will the client need to share information about the process with others (and what and why will the others need to know)?

It's one thing to have internalized how a design process works, yet it's quite a different matter to explain that process to another person. This is particularly true because at least some of what you know about design probably comes from your intuition and visual acuity. However, if you are to break down the steps for your client, you must first become reacquainted with the various stages yourself. The ability to explain a process is a skill, and like any skill you can acquire it by learning or refamiliarizing yourself with the different stages.

When you explain a process, you're describing how something operates, how something is done, or why something happens (cause and effect). These explanations are often used in combination. For instance, you might describe how the printing process operates and how one stage depends upon another in order to explain why a certain deadline is necessary. The length and depth of your process description depends on the audience analysis questions bulleted above.

Don't rush right in to explaining the stages of a design process. Instead, introduce it with a brief overview. Providing a framework beforehand makes it easier for listeners/readers to comprehend a series of details. In this overview you should also explain why it's necessary for your client to become familiar with the process. Also describe how a process fits into the bigger picture; for instance, how creating a design brief leads to ultimately reaching a marketing objective.

You can explain the process in a few ways: sequentially (first "stage a" is done, second "stage b" is done, third "stage c" is done, etc.), chronologically (how the process changes over time), or by cause and effect (this happens when that happens, causing a certain result). We're breaking down the ways of explaining

into three discrete categories to help you get a handle on them, but remember that a good explanation often requires that you combine the methods.

As you explain the process, define any technical terms your client might not understand. Do this subtly; your goal is to educate your client without talking down.

To ensure that your client doesn't get lost along the way, occasionally ask for feedback, such as "Are you still with me?" or "Do you have any questions at this point?"

DEFINE DESIGN JARGON IN CLEAR, EVERYDAY ENGLISH

Let's talk about appropriate use of "jargon," and, just to make sure we're all on the same page about what it means, let's look at three definitions from *Webster's Dictionary*:

1. Language or vocabulary peculiar to a particular trade or profession
2. Unintelligible talk or writing, gibberish, or babble
3. Pretentious vocabulary and convoluted syntax, often vague in meaning

Talk about differences in perception! The first definition works for the in-crowd, those of you who are in the field—members of the club, so to speak. You've acquired your vocabulary through years of training and experience, so writing or speaking in jargon allows you to use a sort of shorthand that is accurate, specific, and professional, right? Well, not necessarily. It all depends on your audience.

The last two definitions speak to the feelings and judgments some people who are outside a field have about jargon. We've all been there. When we go to doctors or lawyers who can't or won't speak in plain English, we leave their offices feeling as much in the dark as when we first entered. We don't know about you, but all other things being equal, we don't return to those doctors or lawyers. We find other professionals who don't make us feel ignorant or powerless or angry. (Choose your poison.) We don't want gibberish thrown at us. We don't want to suffer through someone else's show of pretensions and insensitivity to our needs. We don't want vagueness when much is at stake. Do you? Would your clients?

Once again, it all depends on your particular client. "Appropriate use of jargon" is a relative term until you combine it with a specific client or group with their own needs, expectations, and knowledge of the design field (or, in the cases of intercultural communication, knowledge of English). What is appropriate for one client will be inappropriate for another, and your flexibility in deciding when explanations are needed and when they might be resented is important. Here are some key questions you should ask:

- How experienced are your clients about design? Is this their first design job? Their second? Their twelfth?

- Are your clients hands-on or hands-off people? How interested do they appear to be about acquiring new language and information? How comfortable are they in admitting what they don't know?

Answering these questions will help you to see things through your clients' eyes, and a little empathy goes a long way towards communicating clearly.

When meeting face to face with clients, it's easier to get a fix on their reactions and make the appropriate adjustments to your language. If clients are experienced, you can throw in some jargon and see how they do with it. Do they use the same or similar jargon back at you? If they're curious and unthreatened by what they don't know, do they ask questions or repeat a phrase or two? Those are good signs. Or do they avoid responding at all? That's not a good sign. Observe your clients' verbal as well as nonverbal reactions and respond accordingly.

Of course if you are writing to your clients, you don't have the luxury of trying out different language styles, because you won't have the visual facial cues and voice inflections to tell you how well you are being understood. In an e-mail, memo, or letter, use clear, everyday English, whenever possible. And always give your reader the opportunity to get questions answered, by concluding with just that phrase, "please contact me with any questions you might have" or a similar one. For the same reason, keep your telephone messages clear and jargon-free too in order to avoid misunderstandings and wasted time.

Now, the truth is, you may not know how to translate jargon into everyday language. You may only understand a concept yourself in the terms of your profession, so defining it might be a challenge for you. Here are some simple strategies for defining words, phrases, and terms.

- *Compare the word or term with something like or similar to it*
- *Contrast the word or term with something it is not like*
- *Describe it by breaking it down into its parts*
- *Explain its meaning within the context of design*
- *Define it by giving specific examples of the term*
- *Explain the term by giving its origin or root*

Still aren't sure your audience is getting it? Invite that all-important feedback by asking for a perception check. "I don't think I'm being clear" is a good way to start a dialogue, while letting your client save face.

TELL THEM SOMETHING THEY DON'T KNOW

If you want to provide high quality service, don't rely solely on the research and brief your client gives you. Instead of being a passive receiver, make your own critical judgment calls about your clients' industry, market, business history, and style preferences. We aren't saying that you can't get some of this information from clients themselves, but you'll need to supplement the information they give

you with some independent research of your own. "Get their research and vet it yourselves," advises James Bradley, president of The Chase Design Group.

Why? For one thing, it isn't their job to educate you about their field, market, or preferences. And for another, they may not be able to tell you what you need to know. Some clients are articulate and self-aware, but some clients aren't. In any case, establishing your own knowledge base from other sources will help you create better designs. That will make your clients look good to *their* clients or bosses. And that will mean repeat business for you.

Some questions you're likely to want answered through your own research are:

- What are the key moments in the client's business history?
- What have been the client's style preferences so far?
- What are the client's branding opportunities?
- What are the significant demographics?
- What designs are the client's competitor's using?
- What are commonly used terms in the client's industry (jargon, frames of reference)?
- What is the culture of the company?

We have already discussed research through the Web, books, newspapers, and journals in the section on "Building Up Your Research Skills." (See pages 35–42). Here we want to focus on primary research, which is the kind you collect yourself through interviews, focus groups, surveys, questionnaires, and site visits. With primary research, you are able to ask exactly the questions you want answered, so acquiring primary research skills and strategies is something you'll want to do.

INTERVIEWS

You'll optimize your results if you view primary research, such as interviews, in three stages: preparing, conducting, and following up.

Prepare for Your Interviews

Since you will be taking up someone else's valuable time, you should assume that you won't be able to "do it over" if you forgot to ask key questions or neglect to receive full answers. That's why it's important for you to write down all of your questions beforehand. Making time now saves you time later.

Draft your questions, jotting down everything you can think of, no matter how lame or intrusive your questions sound. Keep in mind that you are just creating a rough draft here. You can (and should) go back afterwards to revise. If you're worried that some of your questions are too intrusive, write them out anyway and run them by a colleague or friend to see if your doubts are valid. You might be surprised to hear that what you considered to be prying is professionally appropriate. Or you might get some help in reframing a question so that you strike a more assured tone.

Once you've drafted your questions, rank them. Some are bound to be more important than others. First, you'll want to ask the most significant questions at the beginning, in case your interview must be cut short. Second, by determining in advance what questions must be answered, you can give them extra attention. Highlight them in your notes, for instance. And rephrase them in a number of ways, so that if they aren't answered sufficiently the first time, you'll be prepared to ask again in a slightly different way. You may have noticed this when you've been interviewed (or surveyed). It's a tried and true strategy because interviews rely on memories, and memory is selective. You can't always count on the right memory popping up, which is why you need to ask again. If you ask in exactly the same way you asked before, you're likely to elicit the same exact answer. A different word choice could trigger a different part of the interviewee's memory. This could mean fuller answers to your most important questions.

While we're talking about rephrasing your questions, you should also edit your questions to invite an expanded response. Don't ask questions that require only a "yes" or "no" answer. Instead ask open-ended questions that are broad and unrestricting. (For example, instead of asking "Do you like this logo?" which will only get a response of "yes" or "no," ask a question like "What about this logo do you like and not like?")

When you call to set up your appointment, specify a timeframe (for instance, "this should take no more than half an hour"). Offer to e-mail the questions in advance. This is especially important if you have questions that need some preparation or research on the interviewee's part. Confirm your appointment by phone or e-mail a few days before your meeting.

During the Interview

Begin by thanking the person for taking the time to talk with you. Since some time has elapsed since you first set up the meeting and sent the questions, remind the person of the purpose of the interview.

If the person you are interviewing is agreeable, use a recorder, but take notes as well in case your recorder breaks down. If the person does not wish to be recorded, you will need to take notes while you interact with your interviewee. This is a bit like juggling tasks, but jot down statistics, interesting phrases, and whatever else you can capture in your notes. At the same time you are writing, you'll need to listen actively to your interviewee's answers. Active listening allows you to create more questions from the person's comments. ("That's an interesting point. Can you give me an example of when that happened?") Conclude by summarizing key points and thanking the person for his time.

After the Interview

Sit down with your notes as soon as possible to fill in the blanks, fill out the abbreviations, and elaborate on the brief phrases that will become more and more mysterious to you as time goes by. We often use the nearest café or diner for this purpose, but a lobby works just as well. Afterwards, be sure to send a thank-you note or e-mail.

SITE VISITS

A site visit simply means you are stopping by a place (another word for site) to check out a store display, an ad, or a Web site to draw your own conclusions about its effectiveness, creativity, and power. You make your own site visits to review and assess your client's past design choices (and his competition's) or to seek inspiration for your project. For site visit research, you'll get the best information if you visit a number of similar sites (for instance, numerous Web sites), in order to compare and contrast some of their key details.

Planning

When you are visiting a variety of sites, planning helps you follow a consistent method of comparing and contrasting key details. This preparation is important because it keeps you focused on your intentions.

In advance, prepare a reminder list of what you want to look for when you get to the site. Your list should include:

- Questions to be answered
- Assumptions and expectations to be tested
- Details to be filled in

Beside helping you remember to collect all of the information you need, your list will allow you to compare how different designers dealt creatively with similar issues.

On-Site

Keep an open mind while visiting the site. Although a list is important, we're not suggesting that you ignore unusual or original details. By all means, see what you can discover at any given site that you hadn't anticipated. Take notes while you are at the site instead of relying on memory.

Consult your list before you leave the site to keep your research on target. It's easy to be distracted by those bells and whistles so that you forget some of the key details you wanted to assess and record. This will save you time in the long run; you don't want to have to go back to the sites to get what you missed the first time around.

After the Visit

Fill in your notes while your observations are fresh in your mind, and review your list to see if your visit has suggested other details you might want to look for in subsequent site visits.

QUESTIONNAIRES, SURVEYS, AND FOCUS GROUPS

You have, no doubt, been exposed to numerous questionnaires and surveys that ask your opinion, questioning you in either written or oral form. They focus on

specific factors, for example, to determine how the new Zippy Cola product or advertising campaign stacks up against its competitors.

Another way to gather opinions is through focus groups, where ten to twelve people come together for a facilitated discussion about a product, idea, or issue. The topic may center on when, why, and how customers make decisions about buying things. Another example would be to test-market different advertising concepts for Zippy Cola, probing into specifics about the focus group's perceptions of the ads.

Planning

For all three of these research methods, preparation is an important first step since you won't be able to change your questions or add to them during collection of data. (The reason is that changes in your survey instrument can invalidate your findings). When working with questionnaires, surveys, or focus groups, the effectiveness of your questions will account for nearly all of the quality of your results. Here are some guidelines to follow:

- Arrange the questions from easy-to-answer to difficult-to-answer.
- Group together questions by theme similarity for easy answering and tabulation.
- Ask for factual information instead of opinion whenever possible (instead of "Do you like to go to coffee bars?" ask "How often per week do you go to a coffee bar?").
- When you need to ask Yes-No or Agree-Disagree questions, provide space to respond for those who may have no opinion.
- When including a rating scale, take the advice of Robert A. Page, Jr., author of the online article, "Taking Surveys to the Next Level." He writes, "Five points is standard if respondents will likely make broad, general distinctions. Six points is standard if respondents should have an opinion on the subject, and you do not give them the option·of a neutral midpoint. Seven points is standard if respondents seem capable of making subtle distinctions."
- If you want to read the entire article on creating surveys and questionnaires, visit *www.performancedimensions.com*.

During
- Begin by expressing gratitude to the respondents for their participation.
- Assure them of the confidentiality of the session and findings.
- Keep your voice and facial expression neutral so as not to influence their responses.
- Close the session by thanking them for their time.

Afterwards

When interpreting your data, it's important to keep an open mind so that you never force your results to conform to your predictions. After you've objectively sifted through the data, your next step is to draw conclusions. From those conclusions, you then develop recommendations.

Chapter 14:
WORKING THROUGH CLIENT CONFLICT

Even when all of the stakeholders in a project have the best intentions, there are times when things do not go as planned and you must write a message that might disappoint or irritate your client. You might need to state that the cost for making an adjustment is your client's responsibility. Or you might need to refuse a request he has made. Then there are the instances when you must devote your energies to fee collections in a series of what we euphemistically call "reminders."

At these times, there is the potential for tempers to flare and for your ability to communicate in a business-like manner to be compromised. It's important to back off for a moment or two and think about what you need to say to your client and how you should say it. Timeouts are particularly important to observe when you are conducting business by e-mail and voice mail, which are temptingly easy to send. This is how instant gratification leads to eternal mortification. Vow never to send an angry e-mail or voice mail to a client. An e-mail message can be forwarded, printed out, and filed, and a voice mail message can be forwarded and replayed. Who wants that on record?

No matter what delivery method you choose, remember that as a professional you have three goals to achieve when formulating your communication.

- Deliver the negative message to your client as soon as possible.
- Say it clearly so that your message will not be misunderstood.
- Keep open the possibility for future business dealings (if you decide you want them).

THREE KEYS TO FINESSING
Depending on the circumstances and what you have observed of your client's temperament, you can choose to write (or say) your message using the following strategies for organization, voice, and focus. At one end of the spectrum is the high impact message—direct and to the point, which works well for clients who are experienced and prefer their communications to be short and quick. At the other end is a kinder, gentler message—indirect in pattern and passive in voice, which is easier to accept for those clients who are less experienced or who respond well to handling.

Key 1: DIRECT VERSUS INDIRECT ORGANIZATION
Earlier in this book when we discussed the correct way to organize a business message, we emphasized the importance of getting to the point immediately,

which is the first rule of *direct organization*. Writing your main point first and following with reasons and support is the rule for the majority of your business e-mails, memos, and letters, but it is *not* the best way to deliver the messages we are talking about in this section.

Writing messages that are likely to disappoint or displease your client calls for some finessing. That is why we recommend that you learn to use an indirect strategy for organizing your messages. *Indirect organization* helps your reader to follow, understand, and accept the message and helps you to maintain as much goodwill as possible. Indirect messages are arranged in the following sequence:

1. *Introduction*—state the subject and establish a neutral (professional) tone
2. *Reason(s)*—prepare the reader by reviewing the facts that led logically to the refusal
3. *Refusal*—state your refusal based on the facts once and without apology
4. *Alternative*—when possible, offer a compromise or alternative solution
5. *Goodwill closing*—end with a positive statement

You will find specific applications throughout this chapter.

Key 2: ACTIVE VERSUS PASSIVE VOICE

In general, business writing uses the *active voice*, where the sentence construction is subject-verb-object. The reason that the active voice is preferred in American business writing is because it is clear, direct, and emphatic, and it signals energy and force. Here are some examples of the active voice:

I will complete phase four by March 1st.
The client must sign the approval for phase four by March 8th.

In contrast, the passive voice puts the object before the verb. As a result, it's not always easy for a reader to ascertain who is the subject and what is the object. In other words, the passive voice is not clear or direct. Sometimes the result is downright flabby writing. For example:

Phase four will be completed by March 1st. (This is unclear. We aren't told who will complete it.)
Approval must be signed for phase four by March 8th. (This is unclear too. We aren't told who must sign it.)
Approval for phase four must be signed by the client by March 8th. (Even though this sentence states who must sign it, it's too long and hard to follow.)

When to Use the Passive Voice

So why use the passive voice when communicating negative messages? Children and politicians know why instinctively. The passive voice makes it a little more difficult to trace the action to the culprit. Witness the child's answer to the ques-

tion "Where is your toy?" The child answers, "It got lost," (not *I lost it,* mind you). That is the genius of children. About politicians, the less said the better.

Sometimes it pays to be unclear. We aren't condoning ducking responsibility or passing the buck; that's not what this discussion is about. What it is about is taking responsibility without taking on the brunt of someone's anger. The occasional use of a passive construction in a negative message does seem to take some of the fuel out of a fiery situation. Here are some examples of negative or disagreeable messages constructed passively and actively:

PASSIVE	ACTIVE
The cost had to be raised.	*We had to raise the cost.*
It isn't possible to change the copy at this time and still stay within the budget.	*We can't change the copy at this time and still stay within the budget.*

The passive construction hints at forces at work beyond anyone's control, while the active construction leads the reader to wonder, "Maybe *you* couldn't find a better solution, but someone else might have been able."

Key 3: PUT YOUR READER FIRST

Because much of the writing you will be doing in these negative situations requires quick action under duress, you might forget the central rule of all business writing: keep your reader's needs and expectations in mind. Yet, using your client's business language and focusing on your client's goals are particularly important strategies when writing (or calling, for that matter) to communicate negative or disappointing news. Courtesy words, like *please* and *thanks,* go a long way in creating client goodwill in this regard, but putting your reader first requires more than the mechanical placement of certain words in your message. You need to write with a sense of empathy, which means asking yourself how you would react if you were the reader of the message you are writing.

Keep in mind that it's usually possible to phrase your message in terms of benefits to your client, even in negative message writing. Note the difference in the following examples:

- *The enclosed plans must be approved before we can proceed.*
- *So your project can proceed on schedule, we need you to approve the enclosed plans.*

The first example focuses on the designer's need to get a signed approval and comes across a bit like a hostage situation. (That's probably why the writer chose to use the passive voice—to soften the message.) The focus on the second example is on the client's need to have his project completed, and placing the phrase that refers to that need first focuses more attention and importance on

that client's need. The second example literally mirrors the message "you, the client, come first," at the same time that the message goes about meeting the designer's needs to get signed approval before proceeding.

RESPONSES TO CLAIMS AND COMPLAINTS

There are two basic responses you can make to a client's claim or complaint. You can either agree to make an adjustment or deny a client's claim. The way you choose to organize the message depends on the response (agreement or disagreement), the complexity of the complaint, and/or the way you have been doing business with the client all along. You can use the following patterns to create telephone scripts as well as written messages (e-mails and letters).

Direct Organization

In general, use a direct pattern of organization if you:

Agree to make an adjustment, in which case you should:
 1. State your agreement immediately
 2. Express your appreciation to the client for bringing her complaint or claim to your attention, noting that it helps you maintain your high standards
 3. Offer your solution to the problem
 4. Explain what happened
 5. End on an optimistic, future-forward note

Deny for the second (or third) time the client's claim, in which case you should:
 1. Restate your refusal immediately
 2. Summarize the reasons for your refusal
 3. End on a positive or neutral note

Confirm in writing a phone conversation in which you have already refused the client's claim, in which case you should:
 1. Restate your refusal immediately, referring to your previous phone conversation
 2. Summarize the reasons for your refusal
 3. End on a positive or neutral note

Indirect Organization

For most other situations where you must deny a client's claim, use the indirect pattern of organization.

 1. Begin with a positive tone, but don't say "no" until Step four. Avoid apologies. Be succinct. State your appreciation for your client's business and/or mention a relevant topic you both agree on.
 2. Restate the problem in your own words. This gives you the opportunity to broaden the client's perspective while mirroring the client's concerns.

3. Explain what happened. Support your denial of the claim *before* you actually say "no."

4. Just say "no." Be decisive. Avoid apologies and loose ends. However, be tactful at the same time by using the following strategies.

- Use the passive voice or else use "we"; avoid using "I."
- Subordinate your refusal in a larger sentence.
- Focus on what you are doing for the client rather than what you can't do.

5. Close with a positive, forward-looking tone. Avoid referring back to the negative decision. Look forward to the completion of the project and/or future projects.

REFUSALS

Another situation where the tone and organization of your message need finessing is when you must say no to a client's request for services beyond those agreed upon, a break on the contracted pricing, or other favors, such as *pro bono* work. Using the direct method is often appropriate when you know the client well, but in other cases the indirect method works well.

What do you do when your client calls you with a request that you can't grant? In a situation like that, you may feel pressured to provide a "yes" answer even though you don't really want to agree. If that's the case, say you'll get back to the client, hang up, and begin formulating your "no" answer. Use the same indirect organization for the main point and details of your message for a telephone script that you would use for an e-mail or letter.

1. State the reason(s) for the refusal first. If you have several reasons, think them through before responding and choose to give only the strongest and most convincing ones. It's necessary to edit your initial response. Not weeding out your weaker reasons will weaken your whole case.

2. Give the refusal.

3. Suggest an alternative, if possible.

4. Close with a positive look towards the future.

COLLECTIONS

Collection letters request payment of an overdue bill. Most of these letters are written using a direct pattern of organization (early contacts being the exception) and neutral language in order to keep channels open for future business or referrals. (Even if you never want to do business again with a particular recalcitrant client, you might want to work with her friend, congregant, or tennis partner, who thinks the world of her.)

Collection letters are generally classified into three stages—Stage one (early), Stage two (middle), and Stage three (late). These stages dictate the gentleness or severity of the tone you will use in your writing.

Collection agencies and the billing departments of larger firms also use the telephone to get their collection messages across. In fact, they tend to contact clients by phone first for a less litigious conversation that gives the client an opportunity to explain the situation and agree to rectify it. They send letters when phone calls (or e-mails) don't result in payments. If the situation worsens with no payment forthcoming, then phone calls are used in conjunction with letters. No matter what size your operation is, you should use the same consistent, business-like approach that the collection agencies do when you are faced with making collections.

Another practice you'll want to borrow from the collection agencies is not to leave much time between letters. The agencies don't wait more than a week or two before following up with another letter, and they make phone calls in between the letters—which you should do too. Otherwise, you're sending a nonverbal message that it's okay to keep the creditor (that's you!) waiting.

Use the following direct strategies to craft your phone scripts as well as your written e-mails and letters.

Collection Letters: Stage One

The first letter is the least aggressive of the collection messages, although some of your decisions about tone should be based on your own knowledge and instincts. (For example, what are your past experiences with the client and what tone have you used successfully with that client so far?). If this is your first experience with the client, your letter should be written under the assumption that a temporary glitch has been the cause of nonpayment. Stage-one collection letters are written more as reminders of payment due than as demands for payment.

- Use an indirect pattern of organization
- Assume an innocent mitigating circumstance
- Keep your message brief, no more than two or three paragraphs
- In the *first paragraph*, note
 - What simple error or oversight might have occurred to prevent the payment from reaching you
 - That you haven't received payment yet
 - How long payment is overdue
- In the *second paragraph*, when appropriate, allude to the next stage of the project or a potential future project

Collection Letters: Stage Two

A stage-two collection letter uses a direct pattern of organization, which focuses immediately on the overdue bill in the first sentence. Although more assertive in tone than the earlier message, a stage-two letter is not entirely adversarial. The

assumption that underlies the letter is that the payment is late, but that it is forthcoming. At Stage two, the creditor still attributes good faith to the client.

The letter suggests ways to salvage a "win-win" result from a potentially bad situation, that of the client's inability to pay the bill in full at the present time. It might refer to the preservation of the client's good credit rating or the continuation of a mutually profitable business relationship. It might also include an offer of a possible payment plan.

- Use a direct pattern of organization
- Keep your message brief, no more than three paragraphs
- In the *first paragraph*:
 - Refer immediately to the overdue amount
 - Allude to previous conversations and correspondence regarding this matter
 - Consider inquiring into special circumstances that have kept the client from paying on time
- In the *second paragraph*:
 - Refer to prior good credit and business relations as well as the importance of maintaining good credit
 - Consider offering a payment plan
- In the *third paragraph*:
 - Conclude by repeating your request for payment
 - Consider suggesting that the client contact you if he is unable to pay in full to discuss alternatives
 - Include your contact information (telephone number and e-mail address)

Collection Letters: Stage Three

By the time you reach Stage three in your collection process, options are over. Send a final notice with return receipt required, like the one from *Business and Legal Forms for Graphic Designers* by Tad Crawford and Eva Doman Bruck reprinted on the following page. For detailed instructions about collections procedures, see their book.

Final Notice

Date _____

To_____

Attention_____

Reference_____

This account is now seriously in arrears. We have repeatedly requested payment and have neither received payment nor have we been contacted with an explanation.

We must collect immediately, and, if we are not satisfied within ten days, we have no choice but to turn this account over for collection. Be aware that this process may result in additional legal and court costs to you and may damage your credit rating.

It is not too late to contact us.

Call_____ Telephone Number_____

Signature_____

Final notice collection letter

Chapter 15:
MAINTAINING CLIENT RELATIONSHIPS

Both designers and clients agree that an important key to client satisfaction is to keep your clients posted throughout each job. When you pay attention to building and maintaining excellent communications with your clients, they feel that you are providing excellent service. And that gives you a competitive edge.

STAY IN TOUCH

It isn't easy to keep up communication, which is why many designers let this important aspect of their business lapse. You need to be thoroughly organized, and you need to maintain an overview of the status of all of your jobs. Graphic designer Shamus Alley of New York City says it took him some time to find a tracking formula that really works. In the beginning days of his career, he came up with his own simple version, which he still uses years later.

> We had a dry erase board that we put all of our clients' names on. We used different colored markers, which depicted the status of each job. Green was finished, yellow was waiting for materials/revisions, and red was deadline coming, "get it done!" We also had symbols that reminded us of the pay status of each job. We developed a code so we could tell if there was money owed or if the client was all paid up; that way we could monitor the status of payment, but clients or visitors didn't realize what we were tracking. That system worked great for us.

Alley's scoreboard is especially appropriate, because it is on display as a constant visual reminder of his whole business picture at any given time. Visual reminders will obviously work better for visual people. (Other types might prefer to keep their files neatly tucked away out of sight.) Maintaining a visual overview like Alley's reminds the designer when it's time to be proactive—when to notify the client of changes or simple updates of the status of the job.

UPDATES

You should be sending messages to your clients that update them about the production stages that were agreed to in the contract or agreement you signed before beginning work. E-mails and phone calls are appropriate for these informal updates, in which you remind your clients of upcoming decisions and/or approvals they will have to make and set up appointments or meetings for that purpose.

Remember to be complete and correct when sending these informal e-mails. Use spell-check and grammar-check to ensure that your messages reflect your thorough attention to detail and high standards. Every day, clients voice their dissatisfaction about poorly written e-mails, noting that they don't respect a careless writer and don't trust him to pay attention to other details of the job. See pages 28 and 200 for e-mail guidelines.

When updating by phone call, write out all the information you want to convey before you make the call. Here too, you want to sound thoroughly professional and in control of your information. See page 198 for telephone guidelines.

STATUS REPORTS

A status report informs your client or his contact person in writing about the progress of an ongoing project. It gives your client information that he can then use to communicate to *his* clients or colleagues, and it allows your client to coordinate your project with others he is working on. You write status reports either in response to a request for information from your client or through your own initiative.

Basically, the information in a status report includes a description of the work that has been completed thus far and a forecast of how close you are to completing the entire project. It indicates whether or not you are working on schedule and maintaining your budget.

The form and length of this type of report will vary, depending on the complexity of the project and the type of communication preferred by the client. It is up to you to ascertain which form your client favors—letters, memos, or e-mails. Work in the form that is most comfortable to him. In length, it can range from a few paragraphs to several pages. As in any business message, you should be as concise and direct as possible, while including an introduction, a body, and a conclusion. These components were adapted from Philip Kolin's *Successful Writing at Work*.

Introduction

In general, you should begin your status report by:

- Indicating why you are writing (was this part of your agreement or is it a courtesy that you initiated?)
- Stating the project title and cogent details (this orients your client and his staff, who are dealing with numerous projects at the same time)
- Specifying start and completion dates

Body of Report

Keep in mind your client's purpose in reading this report—to be apprised of the project's status and any changes or problems that have occurred.

He also may be forwarding your report to others—his client or members of his staff, for example.

In the body of the report, note the stages of the project that you have already completed. Avoid including routine details, but don't avoid describing changes or problems that will affect cost, schedules, or quality. (You will have already discussed these changes or problems with your client via phone or e-mail, as discussed below in "Capture Work Changes." In your report, you are simply including a summary of the previous discussion.)

Set off each section in the body of the report with its own heading, for easy reading. They address updated

- Costs
- Materials
- Personnel
- Schedules
- Completed stages

Conclusion

Close with a schedule of pending tasks and the date of completion for the project. Note that these forecasts will happen if all goes as anticipated. Remind your client of upcoming decisions and approvals that he needs to make. If appropriate, ask for feedback or comments. When necessary, modify your contact information from the letter or memo head. (Will you be away? Whom can he contact in your absence?)

CAPTURE WORK CHANGES

"Not letting clients know the cost of changes may be the number-one source of lost business," notes designer Ellen Shapiro. She advises, "Send the client a memo [or e-mail or letter]. *Before* he gets the bill. Explain that the work is additional and was not anticipated in the proposal." At two panels that Shapiro moderated for the AIGA New York Chapter, which included both clients and designers, everyone agreed that changes are inevitable and costly. All the same, the clients were unanimous in their insistence. "Let us know how much. Let us know right away!"

"You might be under tremendous pressure to finish a job (it's especially crucial if that's the case)," Shapiro acknowledged, "but still take five minutes to write and fax" or e-mail a notification.

James Bradley, president of Chase Design Group, advises you to call first with the news and then follow up in writing. You can always script out a phone call in advance to ease the way.

Work Change Order

Client _____ Date_____

Project _____ Project No._____

Work Change Requested By_____

Stage of work

Sketches _____

Comps _____

Layout _____

Mechanicals _____

Bluelines _____

Printing/Fabrication _____

Typesetting _____

Art Direction _____

Other (explain) _____

Content Change

Conceptual _____

Copy _____

Illustration _____

Photography _____

Specifications Change

Typography _____

Colors _____

Size _____

Pagination _____

Reproduction _____

Shipping _____

Other (explain) _____

Remarks_____

This is not an invoice. Revised specifications on work in progress represents information that is different from what the designer based the original project proposal. The following estimated charges in time and cost are approximate.

Estimated Additional Time_____

Estimated Additional Cost_____

Kindly sign and return a copy of this form. The information contained in this work change order is assumed to be correct and acceptable to the client unless the designer is otherwise notified in writing within_____ days of the date of this document.

Approved by_____ Date_____

Work change order

DEBRIEF

Yet another way to ensure that you are providing the best service to your clients is to follow up after a project is completed. Depending on the nature of the work you've done, set aside time within a few weeks for some self-assessment. Ask yourself these questions:

- What went right?
- What went wrong?
- How can I take steps to ensure whatever went wrong doesn't happen again?
- What opportunities exist with this client that I hadn't realized before?
- What, if any, next steps can I take to obtain more work from this client?

After you have debriefed on your own by analyzing your performance, follow up directly with the client. Set up a time for the two of you to debrief, over the phone or in person, although face-to-face communication is definitely the preferred method. Such a check-in should take about five to ten minutes, particularly if you e-mail your questions ahead of time as a matter of courtesy. Questions you might pose include:

- What worked well?
- What could we have done that would have worked better?
- What type of feedback (or results) have you realized as a result of this project?
- May I use this work to enter design competitions or use in my portfolio to show potential clients?
- Are there any upcoming projects that you might need my assistance with?
- Have you ever considered . . . ?

Whether the debriefing occurs in person or on the phone, listen carefully to the responses you receive. Jot down notes. If you do receive some mild constructive criticism, acknowledge the comment by saying, "I appreciate your bringing this up." or "This is useful feedback for me to receive." Above all, maintain a nondefensive posture, never giving in to the temptation to argue or make excuses.

On the other hand, if the tone of the debriefing is glowingly positive, here's your chance to ask for referrals, perhaps with a simple "I'm always interested in new business. Can you think of anyone you know who may need my services?" Close the call by thanking the client for the work, as well as for the time spent debriefing.

RESPOND TO NEGATIVE FEEDBACK

Whether it seems to you that clients are critical of your concepts, prone to quibbling about billing, or abrupt and demanding after you've jumped through

hoops for them, the most important thing to remember is this: Don't take client feedback (no matter how bitter) as a *personal* attack!

Regardless of how satisfying it may be to counter with a blistering rebuttal of your own, damning them as the most empty-headed, indecisive idiots you've ever worked with, *don't do it!* As a quintessential problem solver who wants to remain in business, you need to

- Take a deep breath
- Listen fully to the clients' comments or complaints
- Acknowledge that you've heard the message the client sent you
- Never argue, and never make excuses
- Try to buy some time to solve the problem

When you're responding to negative feedback, strive for a neutral, honest response. You might say, "I had no idea you felt this way" or "I'm sorry our work didn't meet your standards" or "I can see where it might look that way from your point of view." Follow up with "I'm hopeful we can reach a mutually agreeable solution. Let me take a few days to mull this over and then I'll get back to you by Friday. Will that work for you?" End the contact with a little praise by saying, "I'm really glad you trusted me enough to bring this matter up."

If these types of soothing responses don't immediately pop into your mind when you're faced with a Situation, jot them down on an index card and tape them to your desk. Or put them on your screen saver until you've succeeded in adding them to your repertoire.

Handle with Care

What happens if, after introspection, you see that you did, indeed, make a mistake? First and foremost, own your mistake.

- Let the client hear you say these magic words: "I made a mistake and I'm sorry. Thanks for bringing this to my attention."
- Offer an adjustment—a reduction in the amount you charged or an additional freebie service. (If you work for someone else, check first and make sure you have a green light to negotiate in the name of customer goodwill.)

What happens if you conclude that you're *not* in the wrong? After reviewing the "Three Keys to Finessing" section on page 171 of this book, consider these questions:

- Evaluate your history with this client. Is the relationship a long-standing one? Is the account large? Is there potential for a lot more work?
- Could this powerful person harm your reputation?
- If you have a boss, will you be fired if you lose this account?

In cases like this, you might choose to acknowledge the client's dissatisfaction or negative feedback and still offer up something as an indication that you truly value the relationship. Maybe you'll say, "After reviewing the project, I honestly don't see where I did anything wrong. However, your goodwill is very important to me and I'd like you to tell me how I can make it right between us."

If the client draws a blank or comes up with an impossible demand, consider these options:

- Split the difference
- Donate a portion of your time
- Offer a discounted rate on the next project

Whatever terms you do eventually decide upon, confirm the offer to the client in writing so that you leave behind a paper trail in the file.

CONDUCT CLIENT SURVEYS

Who among us hasn't picked up the phone to hear the inevitable, "We're conducting a survey and we need only a few minutes of your time."

We receive these calls because surveys are useful and time-honored business tools to unearth information that can help a business retain its competitive edge. Through surveys you can discover trends, expand your menu of services, investigate the feasibility of new directions, and, hopefully, learn what your customers really think about the products you deliver and the service you provide.

Planning and Writing

Developing a survey should never be a slapdash effort. Here are some guidelines to follow:

- First determine exactly what you want to know *before* you design questions.
- Limit the questions; no one appreciates a lengthy inquisition.
- Structure the questions logically and sequentially so that you take the client through the various phases or steps they experienced in working with you.
- Avoid Yes or No questions; instead pose open-ended questions.
- Make your survey easy to answer, using *ranks* (prioritizing the responses), *scales* (with a five, six, or seven point scale, see pages 168–169), or *check off* lists (mark all responses that apply).
- Always end with a question like, "What *haven't* I asked that you'd like included in this survey?" or "Would you like to make any additional comments?"

Getting the Best Response

Now it's time to consider administering the survey. Will it be by phone, e-mail, or mail? If you're conducting a mail survey, be sure to enclose a self-addressed, stamped envelope.

Most of us responding to a survey prefer to remain anonymous. What can you do to ensure privacy? Will *you* make the calls or will you delegate someone else on staff or outside the agency to conduct the survey? Do you need to contact everyone you have ever worked for, or is there a target group you're going after? Will a random sampling of fifty from your client list of four hundred suffice? (Before you answer this last question, you should know that the average return rate for surveys is 15 percent to 20 percent.)

Once you've settled these questions, how about a heads-up to those you wish to survey? Perhaps an e-mail or mailing could alert them to the upcoming survey, along with a clear explanation of why you are conducting it?

You can expect your response rate to increase significantly if you offer some inducement to respond. Can you promise to share a report of your findings? Will you offer a free gift (such as a calendar, cap, or other promotional item)? How about a coupon for a one-hour brainstorming session?

Finally, be very aware that you shouldn't go to the same well too often. Only if there is *no other way* for you to obtain the information you need should you conduct a survey.

INVESTIGATE DISAPPEARANCES

"The clients you lose can tell you a lot about how you run your company and how you can improve it. . . . All you have to do is call. . . . If you find out what's wrong, you'll be a better, more professional business owner," advises Jennifer Lawler in *Small Business Ownership for Creative People.*

It's worth noting that we are *not* talking about your clients who fall into the Ships-Passing-in-the-Night category. If, however, you haven't heard from one of your biggest clients in what seems like eons or if you detected a certain coolness during your last encounter, you may want to screw up your courage and choose a proactive route, namely, the check-in call.

We encourage you to make the check-in by phone rather than e-mail, simply because there is much more opportunity for a give-and-take discussion. If you're shaky at the prospect of making such a bold move, you can always leave a voice message after hours and hope the client returns your call promptly. Another option is to write out a script ahead of time about what you want to say so you won't be stumbling around.

Begin with a neutral opening, along the lines of, "I was thinking about the work we did together last fall, which prompted me to give you a call and see how things are unfolding on your end." You can then proceed more specifically with, "How did that job we did together turn out anyway?"

Listen closely to what *is* said and what *is not* said during the call, which will help you determine if you keep this particular client in the Do Not Call Again file or on the Stay in Touch list.

If you have a knot in your belly after you hang up, you should probably let the situation go, the only reasonable solution when you encounter a client who bears a grudge but won't confront. Console yourself with the fact that at least you tried.

Chapter 16:
WORKING WITH FREELANCERS
AND OTHER SPECIALISTS

As a result of living and working in a virtual world, it's easier than ever before for work teams to form and disband, depending on the client's needs. Outside experts can help you pull off a rush job or pitch in when you're inundated with too much work. Often the "expertise" will consist of other creatives who possess skills that you need to get the job done, such as designers, copywriters, editors, photographers, illustrators, cartoonists, or animators. Outside specialists like printers, typesetters, coders, back-end programmers, audio or video production companies, or service bureaus also bring their own expertise to projects.

SOURCING
Before you even open for business, devote time to forming these important linkages. Contacting or meeting with these experts *before* you need their services gives you a leg up. Collect samples of their work, obtain rates, and inquire about credit lines.

Once you're in operation, always keep an eye out for bylines and credits of work you admire. Ask those in the know for names of people they recommend. For example, your printer is likely a good source of information about talented photographers or proofreaders.

WORK PLANS
Noted author Stephen Covey urges his readers to "Begin with the end in mind." This observation is worth heeding as you mastermind a project that relies on the expertise of others. Since you are in charge, you're the lucky stiff who develops the work plan, which will serve as a blueprint that guides you and your team onward toward the completion of the project at hand.

Planning is a left-brain function. As taskmaster you must break down the smaller, sequential steps and assign mini-deadlines. Once you've tweaked your work plan, write it down and share it with the client and your freelancers and other specialists so everybody is on the same page. If delays occur (and they inevitably will), revise the work plan accordingly.

WRITTEN AGREEMENTS
Just as you should never take on a new client without a contract or some other form of written agreement, the same applies for your working relationships

with outside help. Putting it in writing offers you legal protection. Furthermore, it's a legal necessity if the job will take more than a year to complete or if the bill exceeds five hundred dollars.

We recommend going over the terms together first verbally, then following up in writing. Keep a copy for your records and mail or fax one to your outside expert. Steffanie Lorig of Lorig Design in Seattle uses the Independent Contractor Agreement shown on pages 192–193.

Another choice is to draft your own letter of agreement about the work. Include these elements:

- Scope of work
- Clear description of the deliverables (including file formats)
- Time frame, including process and deadlines
- Fees and expenses
- Terms of payment (will you or the client pay?)
- Sign-off lines for both you and the other party

The Designers Toolbox Web site at *www.designerstoolbox.com* offers a version of a freelance agreement, along with a *nondisclosure agreement* (NDA), a standard document signed by those who hire you or those whom you hire. An NDA insures proprietary and sensitive business information is kept confidential.

MONITORING

Imagine that you've landed a large assignment to produce a sixty-four-page four-color annual report. The client specifies that you are to use their regular freelance copywriter. You're also in charge of providing design services, arranging a photographer for shots of the new corporate headquarters, selecting a new printer, shepherding this project through on an accelerated timetable, juggling competing demands, and resolving bottlenecks. Whew! Good luck. Here's where organizational skills can make or break you. More times than you'll care to count, you'll feel like the ringmaster in a three-ring circus, trying to keep track of all the projects, players, and activities.

Let's say you've already drawn up your work plan and issued your written agreements. Let's further suppose you've provided each player with an overview of the project, your work plan, and all necessary information or materials. Congratulations! The project has officially begun.

However, planning only takes you so far. As you move the project through all the stages from conceptualization to production, it is equally important that you monitor the whole thing in order to deliver the goods on time and on budget. Additionally, you'll be expected to troubleshoot at the first hint of a glitch.

How can you possibly pull this off? First, follow through on your work plan and carefully monitor the budget. Religiously schedule tasks and due dates into your print or digital calendar, scheduling log, or To Do list.

"You have to have a mind like an octopus," advises Lorig. In addition to computer files, she maintains three-ring binders with everything relating to the history of the project inside. She says she works from a Daily To Do list and that where she stops is critical. "Sometimes I have to work three more hours until I can get to that place where I know I'll be able to pick the project up again the next day without feeling lost."

The point here is that you need a monitoring system, one that makes sense to you and one that you will actually use. Why? Because when you're on overload and cranking eighteen hours a day, you simply cannot rely on your memory alone. (See "Stay in Touch" on page 179 for one designer's methods.)

Another way to stay on top of projects is to pose three important questions to each member of your team periodically:

- "Do you see any potential problems we need to be aware of?"
- "What do you need from me?"
- "How can we make this happen?"

Finally, make sure you are the one who keeps the communication flowing in all directions, from client to contractors to production. This way you can anticipate and deal with any unforeseen problems before they mushroom into nightmares.

MEETING NOTES
Preparing meeting notes is a particularly useful organizational tool. Whether it's writing an e-mail or a letter or a report, you are the one who is responsible for keeping everyone informed and, at the same time, leaving a paper trail, which can come in handy later on if someone missteps in your carefully orchestrated production.

Your meeting notes should be clear, complete, accurate, and impartial. Basically, record the *who*, *what*, *when*, *where*, *why*, and *how* of what goes down. Meeting notes usually contain the following information:

- Date/Time/Type of interaction
- Who was present or participated
- What was discussed/suggested/proposed
- What decisions were reached
- What was put on hold or tabled
- Follow-up required and/or future meeting date

INDEPENDENT CONTRACTOR AGREEMENT

This Independent Contractor Agreement (the "Agreement") is made and entered between, _____ an independent contractor hereafter referred to as "Contractor", and Lorig Design, Inc ("Lorig Design").

In consideration of the covenants and conditions hereinafter set forth, Lorig Design and Contractor agree as follows:

1. Services. Contractor shall perform the following services for Lorig Design (the "Work"): conceptual studies for logotype work for Sky Bank.

2. Reporting. Contractor shall provide a weekly written report to Lorig Design on the progress of all assignments.

3. Term. This Agreement shall commence on July 7th, 2003 and the Work shall be completed on or before July 11, 2003. Lorig Design may terminate the use of Contractor's services at any time without cause and without further obligation to Contractor except for payment due for services prior to date of such termination. Termination of this Agreement or termination of services shall not affect the provisions under Sections 5 through 12, hereof, which shall survive any termination.

4. Payment. Contractor will be paid for Work performed under this Agreement as follows:

 Contractor will be paid for Work performed under this Agreement at the rate of $ 75.00 per hour for no more than 10 hours of work. If less than 10 hours is performed, Lorig Design will pay only for those hours worked. Contractor will submit an invoice for the Work by the last day of each calendar month and, in no event, later than ten (10) days after the completion of this project. Invoices will be paid by Lorig Design within 30 business days of receipt.

5. Confidentiality. Contractor recognizes and acknowledges that Lorig Design possesses certain confidential information that constitutes a valuable, special, and unique asset. Accordingly, Contractor agrees to treat any information received relating to Lorig Design, its business processes or its clients as confidential and not to disclose such information to third parties.

6. Work for Hire; Ownership. All work performed by Contractor under this Agreement shall be considered work-for-hire under applicable copyright laws and all concepts, ideas, copy, sketches, artwork, electronic files and other related materials shall be considered the exclusive property of Lorig Design. To the extent any such materials do not qualify as "work for hire" under applicable law, and to the extent they include material subject to copyright, trademark, trade secret, or other proprietary rights protection, Contractor hereby irrevocably and exclusively assigns to Lorig Design, its successors, and assigns, all right, title, and interest in and to all such materials. To the extent any of Contractor's rights, including without limitation any moral rights, are not subject to assignment hereunder, Contractor hereby irrevocably and unconditionally waives all enforcement of such rights. Contractor shall execute and deliver such instruments and take such other actions as may be required to carry out and confirm the assignments contemplated by this paragraph and the remainder of this Agreement. All documents, magnetically or optically encoded media, and other tangible materials created by Contractor as part of its services under this Agreement shall be owned by Lorig Design. Lorig Design hereby grants Contractor a limited license to include work Contractor produces for Lorig Design in Contractor's portfolio of work; provided however, all such work is clearly identified as having been created at the direction of Lorig Design.

7. Return of Materials. Contractor agrees that upon termination of this Agreement, Contractor will return to Lorig Design all drawings, blueprints, notes, memoranda, specifications, designs, writings, software, devices, documents and any other material containing or disclosing any confidential or proprietary information of Lorig Design. Contractor will not retain any such materials.

8. Warranties. Contractor warrants that (a) Contractor's agreement to perform the Work pursuant to this Agreement does not violate any agreement or obligation between Contractor and a third party; and (b) the Work as delivered to Lorig Design will not infringe any copyright, patent, trade secret, or other proprietary right held by any third party.

9. Indemnity. Contractor agrees to indemnify, defend, and hold Lorig Design and its successors, officers, directors, owners, agents and employees harmless from any and all actions, causes of action, claims, demands, cost, liabilities, expenses and damages (including attorneys' fees) arising out of, or in connection with any breach of this Agreement by Contractor or any Work provided by Contractor.

10. Relationship of Parties. Contractor is an independent contractor of Lorig Design. Nothing in this Agreement shall be construed as creating an employer-employee relationship, as a guarantee of future employment or engagement, or as a limitation upon Lorig Design's sole discretion to terminate this Agreement at any time without cause. Contractor further agrees to be responsible for all of Contractor's federal, state and local taxes, withholding, social security, insurance, and other benefits. In the event that the Internal Revenue Service should determine that the Contractor is, according to I.R.S. guidelines, an employee subject to withholding and social security contributions, Contractor shall acknowledge, as the Contractor acknowledges herein, that all payments to the Contractor are gross payments, and the Contractor is responsible for all taxes and social security payments thereon.

/ja

Independent contractor agreement (page 1)

11. **Other Activities.** Contractor is free to engage in other independent contracting activities, provided that Contractor does not engage in any such activities that are inconsistent with or in conflict with any provisions of this Agreement or Contractor's Non-Disclosure Agreement, or that so occupy Contractor's attention as to interfere with the proper and efficient performance of Contractor's services thereunder. Contractor further agrees (a) not to recruit, interview, or hire any persons who are current employees of Lorig Design or to induce or attempt to influence an employee of Lorig Design to terminate his/her employment and work for any other person or entity; and (b) not to solicit the business of any of Lorig Design's clients for which Contractor provided Work or for which Contractor received confidential or proprietary information.

12. **Miscellaneous.**

 a. Attorneys' Fees. If a suit, arbitration or other proceeding is instituted in connection with any controversy arising out of this agreement, the prevailing party shall be entitled to recover its attorneys' fees and all other fees, costs and expenses actually incurred and reasonably necessary in connection therewith.

 b. Governing Law. This Agreement shall be governed by and construed in accordance with the laws of the State of Washington without regard to conflict of law principles. Contractor consents to the exercise of personal jurisdiction by the courts of the State of Washington and agrees that venue for any action arising hereunder shall be in King County, Washington.

 c. Entire Agreement. This Agreement supersedes all prior discussions, agreements and understandings between Contractor and Lorig Design regarding the subject matter hereof, and constitutes the entire agreement of Contractor and Lorig Design. This Agreement may be amended, modified or supplemented only by a written instrument executed by the parties.

 d. Successors and Assigns. The terms of this Agreement are binding upon, and inure to the benefit of the parties hereto and their respective successors, heirs, administrators and assigns.

 e. Severability. If any term, provision, covenant or condition of this Agreement, or the application thereof to any person, place or circumstance, shall be held to be invalid, unenforceable or void, the remainder of this Agreement and such term, provision, covenant or condition as applied to other persons, places and circumstances shall remain in full force and effect.

 f. Assistance. Contractor shall, during and after termination of services rendered, upon reasonable notice, furnish such information and proper assistance to Lorig Design as may reasonably be required by Lorig Design in connection with work performed by Contractor; provided, however, that such assistance following termination shall be furnished at the same level of compensation as provided in Section 2.

IN WITNESS WHEREOF the parties have executed this Agreement, effective this 8th day of July 2006.

LORIG DESIGN, INC: CONTRACTOR:

By: _____ By: _____

 Steffanie Lorig, President [Signature]

 Name: _____

 [Please Print]

 SSN or EIN: _____

 Address: _____

/ja 2

Independent contractor agreement (page 2)

Here's an example:

On January 15, at 3:15 p.m. I initiated a conference call with Bob from XYZ Corporation and with Barb who is providing copywriting services on the revised brochure. Since Bob had to cancel two meetings with Barb due to a Brazilian business trip, we're now three weeks behind our projected schedule. In our discussion Bob agreed to FedEx background materials to Barb today and they will meet Wednesday at 10 a.m. to finalize an outline of topics. I will call the printer today to give him a heads up about the delay in delivering materials, which we now anticipate handing over on or before February 7. The three of us will do a phone check-in on the afternoon of January 22.

DISPUTES

Ideally, your working relationships with your crew of outside experts will always proceed without a hitch. However, should trouble rear its ugly head, you may be forced to write either a *complaint* letter (you've got a beef with one of your subcontractors or vendors) or an *adjustment* letter (acknowledging you're in the wrong).

Before you begin drafting, back up to page 171 and reread the section called "Three Keys to Finessing."

Complaint Letter

If you feel you've been wronged (which usually boils down to coming out on the short end of the proverbial stick in one way or another), you have every right to bring the matter to the other party's attention and ask for redress. For example, let's say your printer was two weeks late in delivery, which caused you untold sleepless nights and loss of face with your client. When you addressed the matter with him in a phone call, he blew it (and you) off. After reviewing your prior written agreement (aren't you glad you had one?), you decide to write a *complaint letter*, asking him to reduce his bill by 25 percent. Here's what you include:

- Describe the situation in detail, including names, dates, times, and responses
- State what went wrong in exact detail
- Briefly outline the inconvenience this snafu caused you
- State precisely what you want done
- Ask for a prompt response

Of course, it's out of your control what kind of response you'll receive. But if your printer wants to retain your business, hopefully he'll make at least a counteroffer. It's up to you whether to send a copy of this letter to your disgruntled client either before or after the printer's response to show you did attempt to address the situation.

Adjustment Letter

What if the shoe is on the other foot? What if your work-for-hire photographer sends you a letter reminding you that you verbally agreed to pay a rush fee but when she invoiced you, you disallowed that charge and cut her a check for the specified amount in your written agreement? You realize you slipped up. Now what? Your response should be an *adjustment letter*. Such replies typically cover four points:

- Apologize for the inconvenience
- State exactly what corrections you are making
- Offer an explanation of why the snafu occurred
- End on a positive note aimed at leaving your working relationship intact

Only you can decide if it's worth it to go the extra mile in attempting to resolve the dispute with the independent contractor or outside expert. Sometimes the answer is yes, in which case you write the claim or adjustment letter. Other times, let your feet do your talking.

Chapter 17:
WORKING AT A DISTANCE

Virtual commerce raises the stakes for any designer who wants to remain competitive. When a client's impression of a designer's professionalism comes mainly from phone calls and e-mail messages, the language and presentation has to be clear, correct, and precise.

 Spotlight On
CHRISTY WHITE/ALPHA MARKETING: WORKING VIRTUALLY

I am the Creative Director for Alpha Marketing, a full-service marketing firm established in 2000. Our major clients are wireless communication companies, and we specialize in sales promotion marketing. With our largest client based in North Carolina, and with the business growth in the area, we decided to make Raleigh our headquarters. This is also where I live. Only four of our team members are based here in Raleigh. Our president is in Maine, our VP is in Iowa, and our senior account director is in L.A. We have support staff in other parts of the country as well.

Even though we are a virtual team, we all collaborate on the same projects for the same clients. I am the only full time graphic designer within the firm, which is usually sufficient for our needs. As needed, we outsource design support with freelance designers, copywriters, and a couple of other design firms. They may be local or in another part of the country as well.

Working virtually has been an adjustment. Mostly we work by e-mail and phone, and we conference call for brainstorming. E-mail is the best way for us to bridge the distance. On a slow day I'll get thirty to forty e-mails while on a busy day more like one hundred to one hundred fifty. Basically, everything I do is electronic. Because the turnaround is so quick, I rarely print out mockups for our clients; instead I use PDF & JPEG files of the project and share these electronically for comments and approval.

When your clients are at a distance, it's important to establish in the beginning how much they want to know. We outline the communication process protocols upfront. We encourage online approvals through e-mail and are beginning to use online digital signatures through the use of Acrobat.

Because we work virtually, documentation and communication systems are very important for us and for our clients, to keep everybody on the same page. For example, we use Contact Reports to summarize meetings and document action items. Like most graphic designers, I dislike paperwork so the more streamlined and simple a process is, the better. But I've learned the value of putting things in writing; it's a necessity in doing business.

BUSINESS TELEPHONE

Your work phone may look like your personal phone (it may, in fact, be the same instrument you use for personal calls), but you need to differentiate between the two. You will be using your business phone for all sorts of professional reasons—getting and leaving information, negotiating the terms of a contract, clarifying issues, etc. Marianne Rosner Klimchuk, associate chairperson of the Packaging Design Department at the Fashion Institute of Technology, discusses the need to develop skills and tact in order to communicate in a professional manner on the phone.

> Young designers entering into the work environment often take an informal approach to communication and cross the boundaries of professionalism. A formal, respectful, and courteous manner should always be followed. Casual communication is only appropriate *after* a professional relationship has been established.

Guidelines

With cell and home phones doing double duty as business/personal telephones, it's especially important to regulate the atmosphere of your business calls. Lee Silber, author of *Self-Promotion for the Creative Person*, has this advice, "Answer the phone like a business person. (No screaming kids, loud music, or eating.) Be professional but remain personable. Have a signature salutation when you answer the phone. Your voice/answering machine is a marketing tool. Treat it as such. (Upbeat and updated is good.)"

When your phone call involves multiple details, decision-making, negotiating, or other complicated issues, you should prepare for the call as you would for a business meeting. Plan in advance what you want to cover and what you hope to achieve. Don't try to keep this in your head. Instead, write up a simple agenda or checklist that will keep you on track. Otherwise you might end up focusing on the other person's agenda and forgetting important items of your own.

The Agenda. An agenda is simply the written outline or list of the topics you want to cover during your telephone conversation. Before the call is made, write down the date, time, purpose, name of the person you are speaking with (if you don't know this in advance, get the correct spelling, title, and telephone extension), and the items you want to cover. If negotiation is going to be part of your conversation, write down your desired outcomes. One effective executive we know prepares by grading potential outcomes into: 1) the ideal outcome, 2) an acceptable outcome, and 3) an unacceptable outcome or, in other words, a deal breaker.

If you are good at thinking fast and coming up with quick and grounded responses, an agenda or list is probably all you need to stay focused and conclude your phone conversation satisfactorily. If you are not at your best in confronta-

tions (even on the phone), you can still increase your effectiveness by anticipating a few different ways the conversation could go and figure out how to respond most productively. Write your responses down like mini-scripts until you get the hang of it.

Meeting Notes. Take notes while you're on the phone. Write down, for example, adjustments on costs or timeframes, the names and numbers of new people coming into the project, or referrals and resources.

As soon as you hang up, look over your notes and add to or clarify what you've written. Even if you have a great memory, you don't need to tie it up with details of the projects you're working on. Paper trails are a part of good business practice. Save all of your phone notes in your project files.

Voice mail

When leaving a message, take care that yours is professional and complete. Identify yourself and give your voice mail recipient your telephone number, even if you know that she already has it. You want to make it as easy as possible for her to return your call. Always say the date and time you're calling too.

Keep your message simple and brief, and indicate when you are expecting a follow-up phone call or action. If you do require a follow-up call, be sure to state the best time(s) to call you back.

As you no doubt know, it's annoying and time-consuming to receive voice mail messages that omit crucial information, so take care to cover all the necessary points when you leave a message. Keep this crib note by your telephone to remind yourself:

- Your name
- Your phone number
- Your purpose in calling (briefly stated)
- Best times to call you back
- Date of the call
- Time of the call

Conference Calls

A conference call is a formal meeting using a telephone system that is set up to allow three or more people to participate. Conference calls save travel time and expenses, and they are used more and more as global commerce broadens prospective markets. For best results, one person should coordinate the call.

If you are coordinating the conference call, it is up to you to establish the agenda, which serves as advanced confirmation of the call's date and time. The agenda should also include the purpose of the meeting, the names and titles (or responsibilities) of the participants, and the topics planned for discussion. Take notes during the call. After it's over, review them to decide what notes should be distributed to the other participants as minutes of the meeting

and what information is for your eyes only. You should e-mail or fax the minutes with any follow-up requirements to the other participants within the next day or two.

If you are not the coordinator, you still need to set aside time to review the agenda and prepare in advance for the conference call. Jot down your ideas and requirements on agenda items so you can refer to these reminders at the meeting. During the conference call, take additional notes for future reference and filing. Review them after the meeting and add relevant items to your work schedule and/or calendar.

If no one is formally coordinating the conference call, you can still optimize your own participation and outcome. Try calling the secretary or gatekeeper to ask for the names and titles of the other participants as well as a tentative list of topics. You can also create your own list of agenda questions in advance. You can be organized even if others aren't. During the call, take notes, and review them afterward to make sure nothing slips by you, like due dates, work assignments, or future meeting dates.

E-MAIL

You can find guidelines for formatting business e-mail on page 28. Here we offer five critical e-mail rules for composing your messages.

1. *Keep your reader's needs in mind.* Focus on your reader's needs and your business purpose as you write (and review before you send) e-mail. (Go back to the audience analysis section on page 14 if you need a refresher course.) Business e-mail should be as brief as possible, so focusing on what must be said and omitting unnecessary language are crucial. Also, don't assume your reader will understand the abbreviations that you use with friends; in fact, avoid them. Abbreviations such as BTW (by the way) or IMHO (in my humble opinion) are not appropriate in business e-mail.

2. *Take care with your spelling, grammar, and punctuation.* You don't want to compromise your professional image. Once your message is received, what you dashed off without much thought could be printed out, passed around, and even filed for future reference. It can also easily be forwarded to other people without your knowledge. You may be writing to a client, boss, or associate who equates clear, correct language with superior intelligence (many do) or who is not willing to plow through misspellings and ungrammatical writing to try to make sense of your message. If the mechanics of writing are not your forte, have someone you trust proofread your message before you hit the *send* button.

3. *Be careful with your tone.* Tone is a lot like voice. In other words, don't write anything in e-mail that you wouldn't write in a letter, memo, contract, or other business correspondence. Business e-mail should be neutral in tone. Avoid

sending an e-mail when you are angry. Avoid sarcasm, gossip, and flaming too. Seems almost too obvious to mention, we know, but we've heard too many stories about the trouble some of our colleagues have gotten into when they dashed off an e-mail in a fit of anger or in the midst of a long, hard workday when they were too tired or busy to watch what they were saying. A couple of seconds of instant gratification can cost you clients and break up your relationships with business associates. Develop your own self-editing radar when e-mailing. Keep your radar running in the background at all times, like an antivirus program, and run a quick check with it before you hit *send*.

4. *Maintain your privacy.* E-mail is not set up to be confidential, so protect your privacy. Don't include information in your e-mail that you wouldn't want others beside your recipient to read, now or in the future. Remember that it's easy for your recipient to forward e-mail to other people without getting your consent and, for that matter, without your ever knowing about it. Even if your designated recipient is careful to keep your e-mail confidential, e-mail can be intercepted by others. Keep in mind also that e-mails are never really deleted. Many businesses make it a practice to back up and save all e-mail generated and received through their equipment. They're legally entitled to monitor it too!

5. *Proofread your message.* In light of what you have just read, this bears repeating—reread your e-mail message before you hit the *send* button. Check for content, organization, spelling, grammar, and tone. Revise when necessary. Practice this rule: If in doubt, rework the message.

E-FILES

If you snooze, you lose, especially in graphic design. As a visual communication professional, you must always strive to be at the top of your game, proficient with the latest computer applications and technological advancements. Keeping your edge takes a significant outlay of time and money. You are also expected to keep on top of the ever-evolving intricacies of various image formats (like EPS, TIF, GIF, JPEG, and PDF) as well as graphic compression tools.

While it's true that recently some forward movements in technological creep have occurred, there's still a ways to go before resolving computers' abilities to "speak" the same language. You run into this problem time and again when your client hands off e-files to you that are in barely usable form. Worse yet, when you try to enlighten your neophyte clients about formats, they respond as though you're speaking a foreign language. And, from their perspective, you probably are. (See page 163 for tips on talking to nondesigners.)

Think with Beginner's Mind

To bridge the gap and become a proficient translator of technological terms, you first need to develop what Zen masters call "beginner's mind." In other words,

you must assess how much or how little your client knows and—just as important—*needs to know* in order for you to get what you need to do the job right. The two most prevalent problems you run up against with neophyte clients are their lack of understanding about picture resolution and their confusion about text files.

While JPEGs (short for *joint photographic experts group*) are an almost universal picture format, beginners fail to realize that not all photos are created equal. Let's say your client ships you a batch of photos for a brochure, totally clueless that the 72 dpi is unusable unless you are able to salvage matters through resampling to an acceptable 240 dpi.

Neither will the client realize that once you resample, the picture size will undoubtedly be altered in its height and width. Moreover, neophyte clients won't realize that adding digital information isn't possible nor will they know how to compress files.

They're also fuzzy about file format and file size. "You don't know how many times I get sent images that should be GIFs but that are saved as JPEGs. Over and over I have to explain this to clients who don't understand that GIFs are best used when there is no photograph in the image," graphic designer Shamus Alley of New York City says. "The file size would be considerably smaller if they were saved as GIFs because JPEGs give more image quality, which is unnecessary for solid colors or text."

Three Approaches to Teaching Your Clients

What's a designer to do? Buddy Chase of Studio 3 in Ellsworth, Maine, suggests three approaches. One is to pretend you're teaching first grade, repeating the basics over and over (without losing patience, of course) until your "student" makes a breakthrough and finally comprehends what you're saying. You can also write up a Format Specifications sheet with step-by-step directions to be sent just as the project kicks off. If your relationship with the client appears to be a long-term one, a third option is to invite them in to your studio for a hands-on demonstration and mini-lesson geared to saving them money once they learns to deliver photos you can actually use.

Addressing Glitches

Now for the second most frequent problem: text and cross-platforming. If your client is a Microsoft Works user, he won't know that some files still cannot be read by Macs. Even in ASCII (short for *American Standard Code for Information Interchange*), blips still occur. The buzz is that in the very near future this problem will be alleviated with chip advancements, but for now you can teach your client the very basic Neanderthal technique of copying the file and pasting it into an e-mail, which he sends to you. Don't forget to warn the client that cross-platforming glitches can still crop up on the galleys so he should proofread very closely. If the client does paste text into an e-mail, and he has used "smart" quotes, accents, and certain other complex punctuation marks, it's very likely

that the message you receive will be filled with junk. In that case, call the client back and walk him through saving the file as an RTF and resending it to you.

Graphic designer Marty Lyons of Studio 3 shares an important lesson he's learned the hard way: "*Before* you ever start importing the client's text into your layout, first stop and check for consistency of punctuation styles." If he forgets, Lyons says he's resorted to copying and pasting the text into an e-mail, which he sends back to himself. "Luckily, my e-mail program turns the text into an ASCII file and that's been the only way I've been able to shake off some of the weirdness of formatted text."

Designer Shamus Alley adds his hard-earned wisdom. "The bottom line is that there is no bulletproof system for cross-platform or even cross-program text yet, so I still have to double check everything. Never assume. As the owner of a small design business, I consider proofreading critical because if something needs to be reprinted, it comes out of my pockets . . . and when you're just starting out and living on mac and cheese, there's just no budget for reprints."

Stay with the beginner's mindset a bit longer as we tackle electronic proofs. Go back to square one and ask if the client has Adobe Acrobat and, if so, what version so you can send PDFs (short for *portable document format*, in case your client asks). Chances are the client lacks a factoid you already possess; namely, Acrobat's quirk of reading *down* but *not up*. Before you launch into a mini-lesson about how a later version of Acrobat software *can* read a PDF made with an earlier version of Acrobat, but an earlier Acrobat version *cannot* read a document created in a later Acrobat version, first ask yourself if the client even seems capable of comprehending what you're saying. If not, save your breath.

But, then again, who knows? Maybe some of your clients will surprise you with their ability to *edit* PDFs online. Other clients might not ever reach that point. For some, even downloading free Acrobat software in order to receive PDFs may prove too challenging. If that's the case, pop a laser-printed hard copy of the proofs in the mail and vow to fight the technology battle another day.

Whether your client reviews the electronic proofs or hard copy ones, it is essential that you get him to sign off that the copy has been reviewed and approved. Studio 3 uses the handy electronic approval form shown on the following page.

The final problem we'd like to address in working with neophytes is their inability to previsualize the finished design. While seemingly onboard right up until the moment they see the proofs, they suddenly wince and groan, "That's not what I wanted. *At all*. You'll just have to change it." In this situation, pull out the work order (aren't you glad you have one?) or quote, and gently break it to the client that redoing means spec changes, which means price increases. Good luck with that one!

Shamus Alley offers another suggestion for dealing with clients who don't know what they want. "Sometimes I show them two approaches. The first is what I've designed (what I think looks best) and the second option is what they say they are looking for. Make the buttons as big as possible, take every last bit

✓ APPROVALS
Mandatory on printing jobs

Client:

Job:

	Client Initials	Date
Design		
Proof Read		

STUDIO 3
98 Main Street
Ellsworth, Maine 04605
207-667-5351 • Fax: 207-667-7513
e-mail: studio3@acadia.net

Electronic approval

of white space out and increase the size of the font just as they requested. Then when they see the two options, they generally agree that the one I created looks better than the one they dictated. After a time or two, they generally learn to trust your design sense and give you a bit more wiggle room for creativity."

Working with Advanced Clients

Fortunately, not all your clients will fall into the neophyte category. Some will operate at a far higher level of technological sophistication; these are the folks who share your lingo. For example, if you're contracting with an agency, you'll probably meet once with the account executive, who then hands the project off to the in-house production, charged with overseeing the job. Nine times out of ten the production team speaks your language perfectly. You all can delve into the finer points of GIFs, TIFFs, and EPSs to your heart's content. "You won't even have to tell them that when TIFF files are corrupted, the fix is to set it in EPS because they already know that!" Buddy Chase adds.

Chapter 18:
WORKING ACROSS CULTURES

You have only to walk down a busy city street, leaf through ads in a magazine, or travel through an airport to understand what a multicultural society America has become. Experts tell us by 2010, 50 percent of the U.S. population will be comprised of minorities. Over half the future workforce in America is predicted to arrive as immigrants. Even smaller cities and towns throughout the country are experiencing a population shift that reflects newcomers from other cultures.

Today's business climate is heavily influenced by current trends towards global markets, cultural diversity, and rapidly changing technology. What's this have to do with you as a graphic designer? A great deal. Chances are that your customers, your co-workers, your colleagues, your vendors, and/or your prospective clients may belong to a different culture that you do. Simply put, *intercultural communication* means sending, receiving, and interpreting messages between people from different cultures.

You need to cultivate a cultural sensitivity so that you are able to vary both your design as well as your approach to clients. "You really must do your home-work first," advises Avantpage's Denise Denson. As Marketing Manager for the Davis, California, company specializing in translation and multilingual format-ting and output, Denson elaborates about the importance of research:

> Why are some products and not others marketed successfully to a partic-
> ular cultural audience? It has to do with the ability to connect with the
> audience in their own language and on their own cultural terms. You
> have to use images, colors, concepts, values, ideas, and language that the
> target audience can relate to. For instance, Hispanics value their family
> most. So, a car manufacturer trying to sell a car to the Hispanic audience
> needs to highlight the car's family-friendly design (i.e., spacious back seat
> for the kids), and feature images of families and vibrant colors (Hispanics
> love color). Every culture is different, even among those that speak the
> same language; Mexican tastes are different from Colombian tastes.
> Basically, it takes a lot of time, research, and care to launch products and
> services abroad.

Only *after* you complete your research will you be prepared to create designs for specific cultural audiences. Occasionally you may find that you will need to outsource some services. As Denson points out:

Translation is simply converting one language to another, and does not necessarily always take into account cultural differences between the original intended audience and the target ethnic audience.

Localization is basically adapting documents and multimedia for foreign countries so that they read and look as if they were created by natives of that country. The process includes translation, but it also encompasses looking at many cultural and country-specific norms, such as: date/time format, references to holidays, differences in units of measurement, telephone and address format, currency, cultural symbols and signs, abbreviations, acronyms, use of color, verbal expressions, humor, etc.

RESPECTING CULTURAL DIFFERENCES

"Culture" is a term used to define the values, beliefs, attitudes, norms, and behaviors under which a person or community operates. One's culture is primarily an internalized system, usually instilled during our youth. Culture tends to inform our perceptions and, hence, the way we conduct ourselves in the world.

Take a minute to reflect about your own culture. What have you been taught, both explicitly and implicitly, about these hallmarks of culture?

- Language
- Body language
- Gender differences
- Time
- Space
- Decision-making
- Ethics
- Manners
- Traditions
- Status
- Negotiations
- Problem-solving

In considering the many ways we may differ from others, it's easy to conclude that the greater the cultural divide separating us, the greater the possibility of a communication problem occurring.

For example, in her job as Art Director for *Time* magazine, Andrea Costa is called upon to make presentations to clients in Asia and Europe. "You have to be aware of the protocol," she warns. "For instance, in Asia, when you are presented with a business card, you hold it in both hands, conspicuously appreciate it, and then bow. Don't stick the card in your back pocket—that's an insult."

From our own experience in working with other cultures, we know that even while operating from the best of intentions, we can nonetheless make a cultural misstep without even registering it. For example, when Ruth was teaching business communications in Malaysia, she was honored to be invited to the home of a high-ranking official. Realizing she needed to arrive with a gift, Ruth visited a floral shop and selected a large bouquet of fresh white flowers. However, even though the bouquet was already beautifully arranged, the florist, who inquired where she was headed, refused to allow her to take the white flowers out of the shop, explaining that the color white represents mourning to Chinese. He quickly switched to red flowers, the color of good fortune.

Another time, Ruth's Singapore hosts gave her a beautifully wrapped gift at a dinner in her honor. She accepted it graciously and then placed it on the floor by her seat. Oops! She had no idea that placing gifts on the floor was considered a major insult until a student respectfully filled her in later.

These examples are cited to remind us that, regardless of which culture we come from, we must consciously avoid falling into the trap of *ethnocentrism,* the inclination to judge others through our own ethnic or cultural lens, believing our way is the right way.

As an illustration, in the United States the following concepts prevail in business:

- Time is money
- Get right to the point
- New is better
- Men and women are equal
- Concentrate on the bottom line
- Focus on the big picture, not the details
- Say what's on your mind
- Make decisions fast
- Go with *what* is said, not *how* it's said
- Put it in writing
- Avoid taking criticism or rejection personally
- Display status trappings to convey your worth

All the above are indicators of a *low-context culture*—one that relies heavily on forthright verbal communication, distinguishes tasks from relation-

ships, and favors individual initiative and decision-making. (Edward Hall, a leading figure in intercultural communication theory, developed these and other indicators.)

Imagine the complications that can arise when you, as an American from a *low-context* culture, do business with Japan or Spain, *high-context* cultures that rely more on subtler clues like nonverbal language or setting. Your adherence to doing business the American way could, to say the least, cause the other party to feel uncomfortable, embarrassed, or totally turned off.

When you are doing business cross-culturally, you also need to take into account the differences between individual and collective cultures, as described in the book *Guide to Cross-Cultural Communication* by Sana Reynolds and Deborah Valentine. As you study the chart on the following page, you may notice the reappearance of some similarities we've already touched on, while other characteristics are addressed for the first time.

DIFFERENCES BETWEEN INDIVIDUAL AND COLLECTIVE CULTURES

Individual Cultures	Collective Cultures
Transaction oriented (focus on results)	Relationship oriented (focus on process)
Short-term gains	Long-term growth
Emphasis on content (facts, numbers, ratios, statistics)	Emphasis on context (experience, intuition, the relationship)
Reliance on linear reasoning	Reliance on circular reasoning
Independent	Interdependent
Competitive, decision-driven	Collaborative, consensual
Direct, explicit communication	Indirect, circuitous communication
Personal accountability	Protection of "face"
Private offices	Open office plan
Linear time, impatient	Flexible time, patient

Reynolds, Sana and Deborah Valentine, *Guide to Cross-Cultural Communication*, 1st edition, ©2004. Adapted by permission of Pearson Education, Inc., Upper Saddle River, NJ.

WRITING ACROSS CULTURES

The Guide to Cross-Cultural Communication also contains some very useful pointers on how to achieve effective written communication between cultures. Here is an excerpted version of their suggestions.

General Writing Guidelines

Adjust your writing style.
Remember that other cultures may not value directness or immediacy and may define clarity differently.

Change your opening.
A more personal opening provides context to statements or analyses; avoid requests to assign responsibility or blame to individuals.

Become familiar with patterns of logic and organization used in other cultures.
Adjusting to your reader's pattern of logic and organizational flow can go a long way toward making your written document more accessible.

Use technology with care.
Establish the relationship on a sound footing; once it's in place, the misunderstandings and discomforts caused by technological issues diminish significantly.

Make your written documents accessible and reader-friendly.
Other ways to prevent cross-cultural communication snafus include double spacing documents (for ease in reader translation), utilizing headings and subheadings to break up text, double-checking spellings of names and titles, writing out dates (June 28, 2008, instead of 6/28/06), and punctuating large numbers carefully since some cultures use periods in numbers whereas Americans typically use commas.

Writing Web Sites for Different Cultures. If you would like to learn more about writing and designing Web sites for readers from different cultures, we refer you to the following useful resources:

- *Beyond Borders: Web Globalization Strategies* by John Yunker; New Riders Press, 2002.

- *The Culturally Customized Web site: Customizing Web sites for the Global Marketplace* by Nitish Singh and Arun Pereira; Butterworth-Heinemann, April 2005.
- The AIGA Design Forum on Cross-Cultural Design at *www.aiga.com*

Degree of Formality

As we've pointed out, Americans tend to behave less formally than many other cultures. When you're working cross-culturally, be more mindful of the people you're working with and what their comfort levels may be. For instance, don't automatically assume that using first names is a way to make friends, particularly if there is an apparent age gap. Monitor the amount of time you spend talking, perhaps deferring to the other party to begin conversations or take the lead in other ways. Mind your manners and your speech (think of how you'd behave or speak with your grandparents' friends). When in doubt, err on the side of being more conservative than you otherwise would.

Spelling Differences

Earlier in this book, we've cautioned you about the importance of proofreading, how one small error in spelling can cost you an account or create a negative impression. This is still true.

However, when you work across cultures, park your assumption that there is only one correct spelling of a certain word. Many countries utilize British spellings; for example *colour, grey, centre, catalogue, storey, analyse, theatre, favourite*, and *programme* are all spelled correctly. You don't have to spell the words the way people from other countries do. However, be smart enough to refrain from making judgments about the other party's ignorance or carelessness.

Slang and Other Puzzling Expressions

Let's consider the latest expressions or slang you normally use in your everyday speech, terms such as "hook you up," "amazing," "that rocks," and "amped up." Probably not suitable for your more high-context crowd, right?

Lucky for us, English is the predominant language of commerce, both in speaking and in writing in most parts of the world. That does not, however, mean that all people speak and comprehend exactly as we do. For example, as Americans we routinely sprinkle common expressions (also known as "idioms") in our speech or letters. What might a person from another culture make of these puzzling expressions?

- Off the top of my head
- Push the envelope
- Give you a heads up

- Piece of cake
- Shoot the breeze
- By the seat of my pants
- Thinking outside the box
- Off the grid

Confusion can run in the other direction as well. It's likely you may find yourself on the receiving end of a puzzling message from a client from another culture. Imagine you have a client abroad, say in London or Singapore or India, and you must attempt to decipher this message:

I've posted to you the pricing scheme that will be used at tomorrow's launch. Please arrive by 5:00 and take the lift to the ground level from the car park so that you will be at the head of the queue.

True, you are both speaking English—but it's not your garden-variety American Standard English that we Americans are accustomed to.

Acronyms

Think for a moment about the dazzling array of *acronyms* (words formed from the initial letters of a name) American people throw around so cavalierly. Here are just a few that regularly crop up on the nightly news or in magazines: AA, AAA, AARP, ASAP, ASPCA, BBB, BYOB, CIA, CNA, CNN, COD, CPA, DSL, EKG, EPA, ERA, ETA,FBI, FEMA, FICA, FYI, GPA, GNP, IRS, MRI, NAFTA, NASA, NASCAR, NASDAQ, NBA, NCAA, NRA, NWA, NYSE, PBS, PDQ, PETA, RN, RSVP, S&P, SBA, SCORE, SUV, TBA, TLC, UPS, WOM, WTO, YMCA.

The picture becomes even murkier when you toss in abbreviations or verbal shorthand used in certain fields, such as aeronautics, accounting, or acting.

If you're working across cultures, a good rule to follow is first spell out the complete wording of any abbreviation, followed by parentheses that hold the abbreviation.

Once you've observed this nicety one time, you can then use the abbreviation in future references. For example, you'd write World Trade Organization (WTO) and then use the abbreviation afterwards in that e-mail or letter. If you're speaking on the phone or in person, police yourself to eliminate these references.

Humor

As you already know from your own experience, humor is an extremely subjective matter. What cracks you up may indeed fall flat with others—or, worse yet, offend or alienate. It's best to refrain from any jokes, comments, or cartoons

that are of a political or ethnic nature. Once again, we caution that it's better for you to err on the side of conservatism until you have a clear reading on the person you're working with from another culture. When in doubt, let the other party lead.

Communicating with Global Graphics

The checklist below will guide you in your efforts to communicate graphically with global audiences.

Writer's Checklist: Communicating with Global Graphics

☐ Consult with someone from your intended audience's country who can recognize and explain the effect those elements will have on readers.

☐ Organize visual information for the intended audience according to whether they read visuals from left to right, top to bottom, or otherwise.

☐ Be sure that the graphics you use have no religious implications.

☐ Use outlines or neutral abstractions to represent human beings. For example, use stick figures for bodies with a circle for the head. Avoid representing men and women.

☐ Examine how you display body positions in signs and visuals. Body positioning can carry unintended cultural meanings very different from your own.

☐ Try to use neutral colors in your graphics. Generally, black-and-white and gray-and-white illustrations work well. Colors can be problematic. (For example, red indicates danger in North America, but symbolizes joy in China.)

☐ Check your use of punctuation marks, which are as language specific as symbols.

☐ Create simple visuals and use consistent labels for all visual items. In most cultures, simple shapes with fewer elements are easier to read.

☐ Explain the meaning of icons or symbols. Include a glossary to explain technical symbols that cannot be changed, such as company logos.

☐ Test icons and symbols in context with members of your target audience or cultural experts.

Time Differentials

Ever been startled awake in the wee hours of the morning by a phone call from a friend who is traveling halfway around the world and wants to share road stories? If so, then you know how important (and courteous) it is to factor in the time differential when you're placing long-distance calls or conference calls. Taking into account what can be a twelve-hour time difference is also important if you're looking for a quick turnaround response. It is hard for people to respond immediately to a business question if it's the middle of the night and they're fast asleep. Fortunately, when you use faxes and e-mail, you can more easily address the problems with time differentials. However, think twice before faxing overseas to a person's office located in the home. Trust us, no one likes to be jolted awake in the wee hours of the morning by the irritating beep of a fax coming in from someone on the other side of the world.

PART IV. GROWING YOUR BUSINESS

So you're thinking about expanding your current business and wondering where to start. We suggest you begin with—what else?—writing, which will help you assess and plan for this new growth stage. You'll also need to work out financial plans and contemplate a new (or expanded) supervisory role for yourself. Another element of growth involves stepping up your efforts to encourage and reward client loyalty. Of course, expansion means attracting new clients as well, and so, in this section, we also suggest effective ways for you to publicize your business and increase your public profile.

Spotlight On
STEFFANIE LORIG/ART WITH HEART:
DESIGN AS AN INSTRUMENT OF CHANGE

When I graduated with a Visual Communication degree in 1989, I began in a copy shop, and worked my way up to Hornall Anderson Design Works, a large design firm in Seattle.

Despite my career success, I found myself longing for more meaning in my life. I decided to develop a personal mission statement, which led me to do *pro bono* work for nonprofit organizations. At the same time, I joined the AIGA/Seattle board of directors in 1996, where I became the chair of community outreach. That opportunity grew into Art with Heart, a way of reaching youth in crisis through the power of art and design. I had found my passion, and devoted more and more of my free time to this endeavor. After seven years, it became increasingly clear that Art with Heart no longer fit neatly within AIGA's core mission.

In 2003, I took a huge leap of faith and quit my design job to freelance, while establishing Art with Heart as its own 501(C)3 nonprofit. In 2006, Art with Heart celebrated its tenth anniversary—and I feel very fortunate to be at the helm as Executive Director.

Everyday, through Art with Heart, I utilize *all* the skills I learned as a designer: project management, proposal writing, budgeting, design, illustration, printing—all of it—to empower children and change the course of their lives by fostering self-expression and self-confidence. It's an amazing and fulfilling thing to be able to use design as an instrument of change and leave an indelible mark in the world.

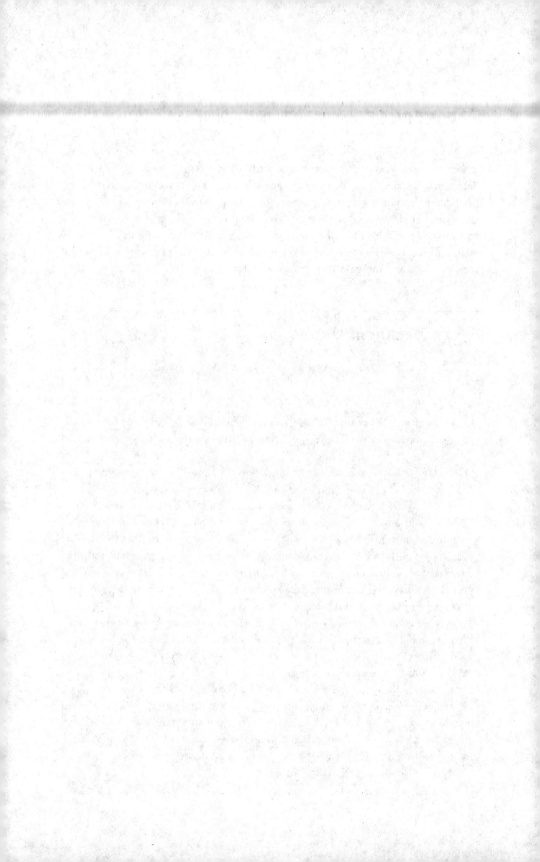

Chapter 19:
PLANNING FOR GROWTH

At certain points in your career, you might find that your current business struc-
ture doesn't fit you too well anymore, and that you'll need to reassess your place
in the graphic design business. You may start thinking about growing (or down-
sizing, for that matter), changing your role within your firm, or realigning your
organization to reflect special strengths and interests. (If you are considering
opening your own business after working for others, see chapters 8–11.)

RE-VISIONING
People alter the range and course of their businesses all the time, and those who
are most successful are the ones who work out their plans with careful intention
beforehand and who refer to their written records during and after the changes
have taken place.

It's good to keep records to remind yourself of the short-term and long-term
goals that you envisioned before the challenges and responsibilities of running a
business took over. In addition, your records will keep you in touch with your
formative thought processes and aspirations.

Who Do You Want to Become?
We put this question first because it's important for you to take measure of the
ways your individual (or group or family) goals and beliefs will impact on your
business as well as the ways in which your business decisions impact on other
aspects of your life. Creative Director Steve Adolf advises, "Know what you're
getting into and what you're giving up."

If the following questions seem too obvious for you to bother answering,
then we congratulate you on having a keenly developed degree of common sense
and bid you to move on. If you haven't given the following questions much
thought, then do so now.

- How will enlarging my business fit into my personal life?
- How will enlarging my business impact on my design life?
- What core values do I want to instill in my company?
- How much money do I need to make?
- How much money do I want to make?
- How important is stability to me?

How Do You Want to Serve?
In designating areas of potential growth, it's important to assess your USP or
unique selling proposition. Likely, your firm has many laudable traits (and

many of those traits are shared by other firms), but your USP focuses on those characteristics that are part of your identity or brand. Your ideal USP should be a combination of the high quality of your service and deliverables and your areas of specialization. It is the basis of your marketing message—and may need revision as you embark on organizational changes.

CRUNCHING THE NUMBERS

In his book, *The Creative Business Guide to Running a Graphic Design Business,* Cameron S. Foote says there must be four factors working effectively before your company can grow.

- *Billable efficiency* is determined by dividing "actual billable hours by total payroll hours" with an optimum result of 50 percent to 75 percent. Any ratio lower than this range suggests ineffective management. A high result indicates poor attention to logistics or other details. Either way, it's a warning of problems that should be corrected before attempting to expand your business.
- *Pricing*, in Foote's opinion, should be no less than ninety dollars an hour, regardless of location. (Keep in mind he wrote this in 2001.) Attempting to grow with cheaper rates might flood you with work without commensurate payment.
- *The "60/6 Rule"* refers to having supplementary help as you grow. It is recommended that you hire temps or freelancers or else pay overtime to your existing staff, rather than taking on the responsibilities of new staff members. The "60/6 Rule" refers to Foote's recommendation that you and your staff should be working sixty hours a week for six months in an attempt to keep up with all of your work before you consider hiring new staff.
- *Cash reserve* should be at least 10 percent of Agency Gross Income (AGI) to cover expenses during shortfalls.

MISSION STATEMENTS

Your mission or vision statement is a description of how you want your company to look in the near, mid, and far future. You should be able to use it for the next five to ten years. A well-written mission statement can serve as a touchstone for marketing and provide guidance for you and your staff as you chart your way to the future.

You may have built your business by taking on whatever accounts you could get in order to develop your portfolio and pay your bills, but it's only now when you are considering your growth structure that you can stop and reflect on your past and plan with intention for your future. You needn't do this alone. We recommend consulting with as many people as possible—your

staff; your accountant and lawyer; your friends in the design business and beyond (business people from other fields will bring much-needed perspectives to the planning process); small business advisors; and last, but definitely not least, your family.

The more input you get, the better off you'll be. Growing your business is not merely a business venture, but a lifestyle choice as well. After careful consideration and soul searching, you may find that the structure you choose is not bigger, but more focused on certain niches, or that you have decided to take on a different role in your business while delegating some of your current responsibilities to others.

Your mission statement needs to be whittled down from a listing of all of your goals and intentions into a short powerful statement that speaks to your vision for your company. It may help to think about your mission statement as a branding or identity statement. Here are some focusing questions to ask yourself as you work out your mission statement.

- What are the current strengths and weaknesses in my business?
- What has made my business successful so far?
- What are my present niche markets?
- Who are my competitors?

For example, here's J. D. Jordan's mission statement for Cloudjammer Studio:

Cloudjammer Studio is committed to providing more than simply a functional or interactive experience—but one that effectively and uniquely communicates our client's message and personality. Cloudjammer works to maintain a creative work environment defined both by a fun and open-minded atmosphere and a high standard of personal and business ethics.

There may be times when a personal, rather than a company, mission statement is appropriate, as in the following one by Steffanie Loring. She integrated her personal ideals with her work goals to create this mission statement, which eventually led her to found Art with Heart. (See page 217 for details.)

My personal mission is to make my design career of lasting benefit to others, not just temporary personal gain (money, peer acceptance, accolades). My path must have active depth, so that the journey has lasting merit, memory, and balance. I must leave fingerprints of goodness. I must share the richness given to me, and make a lasting and consequential difference in the world.

After you have worked through the steps of planning your business growth, below, review your mission statement, and, if necessary, revise it.

BUSINESS GROWTH PLANS

We strongly advise you to develop your own growth plan, even if you hire someone to edit a final draft. The act of writing will push you to think more clearly and deeply about this important set of business decisions—to grow or not to grow, and in what ways do you want to grow. You should be brainstorming your own questions and, in the process of answering them, coming up with more questions. Explore as many possibilities as you can, and jot down notes so you'll remember your ideas. Thinking on paper is one of the best ways to avoid making costly mistakes.

Think Before You Write

Before you begin to write your business growth plan, you should set about answering all or most of the following questions. Not all of these answers will make it into the final business plan. (The final business plan will be used for potential investors and for management purposes.) These preliminary questions are designed to help pull you out of the demand and response cycle that comprises much of business life and, instead, give you an overview of where you've been, where you are, and where you intend to go.

- How do I want to expand or change?
- How much capital do I need to raise?
- What additional people are needed to meet my goals?
- What are the current strengths and weaknesses of my business?
- To what categories do my clients currently belong?
- Who are my competitors?
- What factors beyond my control could undermine my business?
- What new opportunities are arising for my services?
- What challenges must be met?
- How can I increase sales?
- How can I build more name recognition and customer loyalty?
- How can I cut costs and increase profits?

The Elements of a Business Growth Plan

A business growth plan is a valuable tool for helping you map out a strategy for growing your business. It's also necessary for potential investors and/or partners and people within your firm. These elements, adapted from *Growing Your Own Business* by Gregory and Patricia Kishel, provide you with a guide to follow. Please note that the first three sections should be written *after* you have completed the body of the plan.

- *Title page*—This presents company and contact information, the date the plan was finished, and the owners' names.
- *Table of contents*—This is important to help your readers locate information. Obviously, the pages of the plan need to be numbered to make this table useful.

- *Executive summary*—Your summary should be about two pages. Keep in mind that it is the only section some people will read to decide whether or not they are interested in your plan. Therefore, it needs to be persuasive and to the point. Once again, write your summary only *after* you have finished writing the body of your plan, and pull out the relevant details and data. It should include:
 - *Mission statement*
 - *Background and industry information*
 - *A breakdown of your services and deliverables*
 - *Target markets*
 - *Competitive advantages that will enable you to succeed*
 - *Short-and long-term objectives*
 - *Management capabilities*
 - *Financial projections*
 - *Capitalization needs*
- *Business/Industry Profile*—Include the purpose and objectives of your business; its legal structure, location(s), and number of employees. Some of your readers will not be familiar with the graphic design industry or the major industries you work with and will need to be brought up to speed. Give information that reflects credit on your business—awards, positive press, community involvement—as well as potential growth factors.
- *Services provided*—Highlight what makes your services unique or superior to the competition. Indicate types of work and sales figures. Name some of your clients and the range of project costs.
- *Sales and marketing*—Describe how you market your business and the methods you'll use to get a larger share.
- *Competitive analysis*—You will have compared your strengths and weaknesses with those of your competition in your prewriting exploration. Here, you should emphasize the factors that give you a competitive edge.
- *Management structure*—Show how your business is organized and managed. Include an organizational chart with job descriptions. Describe outside consultants or advisers. Project estimated personnel needs for expansion.
- *Operations*—Describe your facilities and equipment as well as your relations with suppliers and subcontractors. If you are using new technologies or shared equipment that gives you a competitive edge, include that information.
- *Finances*—Bankers as well as potential investors and partners will scrutinize this section, so be thorough with your information. You may want to set this off so it can be easily omitted when circulating the general plan to your staff and others who don't need to have this information. Include income statements, balance sheets, and cash flow projections for the next three years, as well as financial statements for the past two years.

Chapter 20:
BECOMING THE BOSS

Remember when you made the decision to open up shop and become your own boss? How easy it was back then (in some ways at least) to call your own shots and please only yourself and your clients! When faced with the multiple challenges of growing a business, you may find yourself sorely missing the good old days, those early years.

Nowadays, fulfilling your role as The Boss will take up much more of your time.

Big decisions have to be made about what you do and what you delegate to employees.

Spotlight On
BOB WAGES/WAGES DESIGN: DO WHAT YOU LOVE

Back in the early 1970s when I graduated from Georgia State University, graphic design was not yet a stand-alone profession. In those days, illustration was the hot ticket.

I was hired on my first interview at the ad agency McDonald & Little. I'll never forget the first two assignments I was given: designing the Atlanta Hawks logo (used for over twenty years) and creating a campaign for then-unknown state Senator Sam Nunn.

After seven years, I left the agency to found Wages Design, which is still regarded today as Atlanta's premier source for corporate identity, interactive, collateral, and package design. We're quite proud of our firm's client list: Cox Communications, Delta Air Lines, DuPont, Georgia-Pacific, CBL Properties, and Antron. But we take our success in stride because we believe creative professionals have to prove themselves every day. Now, more than ever, designers everywhere must be solution-driven and strategic thinkers.

Our firm is headquartered in a former plow factory turned arts center, and we've got nine employees on staff, whose average tenure is ten years. Ninety percent of the time, I hire designers right out of school. I like their youthful enthusiasm. And I like the nurturing and mentoring that this firm is able to provide for them.

Years ago I hired a creative director so I could focus on growing the business. The trouble was I found I really missed the creative work so I had to take back that position. I just love getting in there on every job and directing the creative part of it. That's my passion, that and pushing beyond the expected. And I love to hit the mark. Most times you know instinctively when you hit it.

RETHINKING YOUR ROLE

To reduce the number of headaches and hassles that often crop up when adding employees, we've compiled the following sections that focus on the various documents you will be expected to write or fill out in your new role as The Boss.

Let's start with you. Why do you need to rethink what *you* do? Primarily because you can't delegate work until you figure out what you want to keep for yourself.

Skills and Preferences

You've gotten as far along as you have because you've been carrying the whole load. Expanding operations is a great time to capitalize on your strengths and to clarify which tasks are better delegated to someone else.

	SKILL PREFERENCE			
Business Activities	**Strong**	**Weak**	**Like**	**Dislike**
Designing	____	____	____	____
Researching	____	____	____	____
Planning	____	____	____	____
Writing proposals	____	____	____	____
Meeting with clients	____	____	____	____
Prospecting for new clients	____	____	____	____
Managing projects	____	____	____	____
Phones and e-mails	____	____	____	____
Bookkeeping	____	____	____	____
Filing	____	____	____	____
Networking	____	____	____	____
Staying current in the field	____	____	____	____
Janitor/upkeep	____	____	____	____
Other _____	____	____	____	____

Next, answer the following questions.

- If I only did what I *enjoy and like* in my business, I'd . . .
- Which trivial or repetitive tasks eat up my time and keep me from tackling more important work?
- What tasks do I constantly put off or never seem to get around to doing?
- What three biggest work headaches would I just love to pass off to my Fairy Godmother?
- If I were able to, the biggest change I'd make in my business is. . . .

Writing Job Descriptions

Now that you have a clearer picture of what work activities you hope to concentrate on, as well as those you wish to offload onto your new employee, write your own job description first. Only after that is it time to focus on what you want somebody else to do, which will require another job description. Here's a worksheet to get you started:

Job Title: _____

Reports to: _____

General Description of Job: _____

Major Duties: _____

Other Occasional Duties: _____

Qualifications:

Education/Experience _____

Background or Previous Work _____

Skills Needed to Do the Job _____

Things I'd Like (but might not get) _____

COPING WITH PAPERWORK

You're allergic to paperwork, you say? So sorry. But there's a whole heap of it that has to be filled out before, during, and after you hire employees.

An easy way out is to engage a payroll service that will process all the necessary paperwork for you and make sure taxes are paid by required deadlines. However, you and they should be very specific in the beginning about *who* will do *what*. If you decide to shoulder this burden yourself, realize that failing to send in the employer share of withholding contributions in a timely manner can lead to dire consequences like penalties, liens, bad credit reports, or (worst case scenario) having your business shut down.

In your quest to stay legal, consult these helpful resources:

- Secure an Employer's Identification Number (EIN) by filing IRS Form SS-4, which you can file online at *www.irs.gov*.
- Educate yourself about the Occupational Safety and Health Administration (OSHA) and demonstrate good faith compliance.
- Find out if you are required to register with your state's Bureau of Taxation. The Application for Tax Registration initiates the process of withholding for state income tax. You may also be required to file an

Employer's Status Report, used for initiating unemployment compensation contributions.

- Obtain federal Labor Posters (and display them prominently in your place of business).
- Pick up a packet of standard employee applications at an office supply store or download one at *www.creativebusiness.com*.

THE BASICS OF EMPLOYMENT LAW

Next you need to bone up on the basics of employment law. Who better to shed some light on this often-confusing subject than a lawyer? We recommend you read an online article written by Attorney Andrew J. Sherman, a partner with Dickstein, Shapiro, Morin & Oshinsky LLP. The article, which appears on the Ewing Marion Kauffman Foundation E-Venturing Web site, can be accessed at *http://eventuring.kauffman.org* or at Attorney Sherman's Web site at *www.growfastgrowright.com/resources_articles.htm*.

Illegal Interview Questions

Attorney Sherman offers two warnings aimed at keeping you legal during the interviewing process. First, it is your responsibility to observe *state* antidiscrimination statutes, which may require even more from employers than federal regulations do. Furthermore, avoid asking illegal questions like these during the interview:

- Are you married?
- Do you have children?
- What day care arrangements will you make?
- With whom do you live?
- What does your spouse do?
- How old are you? (It *is* legal to ask, "Are you legally old enough to work?")
- Were you born in this country? Were your parents?
- This job requires some traveling. Will that cause problems for you at home?
- Have you ever filed for bankruptcy?
- How tall are you?
- How much do you weigh?
- What's your religion?
- What is your military service status? Were you honorably discharged?
- What is your sexual orientation?
- Are you physically handicapped?
- Have you ever been arrested?

EMPLOYEE ORIENTATION

Prior to your new employee's arrival, it is your responsibility to assemble an orientation packet that contains all necessary information, including:

- IRS Form W-4, Employee's Withholding Allowance Certificate
- Form I-9, also known as Employment Eligibility Verification Form, U.S. Immigration and Naturalization
- Specific forms required by state law (check your state government's Web site for more information)
- Benefits information, like insurance forms and enrollment information
- Information explaining pay schedule, deductions from pay, sick leave, or vacation time
- Promotional materials or background about your studio, including your company's principles and policies
- Job description
- Written information about a probationary period (usually a good idea, particularly if this is your first employee); some employers prefer ninety days; others opt for six months.
- Sample of the employee performance evaluation that you will be using

On the first day, go through the orientation package together. Process each and every one of those state and federal forms (or suffer the consequences, up to tens of thousands of dollars in fines!).

Next share your expectations for your employee, both when you are present and when you're away. Go over opening and closing procedures. Explain project tracking systems and review procedures for accessing client databases. Brief your employee on pressing projects and high-maintenance clients. Assign some work so the new employee won't be sitting around watching you all day. Be sure to end the orientation by booking a time within the next few days when the two of you can address any questions or problems.

Because all of us have different work styles, understand that it will take time for you and your new employee to establish work rhythms that mesh. Especially in the first few weeks, resist the temptation to rescue your new staffer or over-explain policies and procedures. "Directing the work of other people is a lot like being a coach. And knowing when to be hands-on and when to step back and let team members make—and learn from—their own mistakes is a huge challenge," advises Pat Matson Knapp in an article entitled "Lost in Translation," which appears on *www.howdesign.com*.

NONCOMPETE AGREEMENTS

When hiring a new employee, consider having her sign a *noncompete agreement*, basically a written statement that delineates parameters on disclosing confidential information or poaching clients when your association terminates.

(print on letterhead)

Dear (name of new employee):

We are pleased to offer you a position of (job title) at (name of company).

Before entering our employment (as a condition for continued employment), (name of company) requires employees to understand and agree to the following provisions:

1. During my employment with (name of company) I will not independently accept, nor work on (graphic design/writing/illustration) assignments for payment, except as may be approved by (principal's name) or his (her) designee.

2. During my employment with (name of company) or thereafter at any time I will not disclose to others or use for my own benefit any trade secrets or confidential information pertaining to any of the business activities of (name of company), or its clients.

3. Upon termination of employment for any cause whatsoever, I will not continue to work on assignments that I began at (name of company), except as may be approved by (principal's name) or his (her) designee.

4. Within 180 days (six months) of termination of employment for any cause whatsoever, I will not solicit nor accept work from any individual or firm that has been a client of (name of company) within the past year, except as may be approved by (principal's name) or his (her) designee.

5. Upon termination of my employment for any cause whatsoever, I will surrender to (name of company) in good condition any and all records in my possession regarding the company's business, suppliers, prospects, and clients. Further, I will not make nor retain copies of these records.

If signed, this becomes a legally binding agreement. If you do not understand it, seek competent advice.

Sincerely,

(name)
Principal

I fully understand and agree to the above mentioned employment requirements.

_____ Date:_____

Employee noncompete agreement

Is such a document necessary? Cameron S. Foote, author of *The Creative Guide to Running a Graphic Design Business*, thinks so. He writes, "Can or should you prohibit an employee from taking clients with them when they leave? The answer is a somewhat qualified 'yes' . . . What noncompete agreements are very effective at doing is making employees (and vendors which appropriate) aware that you take your business seriously and will fight to keep it."

On the previous page is an Employee Noncompete Agreement that Foote developed. Before you implement it, we suggest you adapt this document to fit your own situation and then run it by your lawyer.

Despite this effort to protect yourself and your firm, things can still go wrong. If they do, realize that enforcing a noncompete agreement can be a difficult legal process, one that is both time-consuming and potentially expensive.

EMPLOYEE RECORDS

In order to protect your business, you must file the necessary paperwork at the initial hiring as well as maintain up-to-date employee records throughout (and after) the employee's tenure. Create a personnel file for your new employee, into which you'll insert documents such as employment application, performance appraisals, salary changes, records of promotion, attendance records, and evidence of disciplinary action.

Any time there's a doubt in your mind about whether or not to commit information about an employee to writing, play it safe by doing so and then file that paper in the employee's file. This probably sounds paranoid but it's entirely in your best interests to follow this advice. Properly maintained employee records can protect you from lawsuits, serve as a written record of agreements you've made (or forgotten), and generally help you run your business more efficiently—and, most important, within the boundaries of the law.

To protect an employee's privacy, medical information must be kept in a separate CONFIDENTIAL file that only you (and no other employees) have access to. If this means locking one lonely file or two in a drawer or taking these files home with you, that's what you should do.

Once you have the employee records set up, your paperwork is not over. As a new employer, you must strictly observe certain form-filling responsibilities and timely financial contributions. Delays can cost you penalties . . . or worse. You should also be aware that the IRS does not accept ignorance as a valid excuse for noncompliance. For these reasons, we strongly recommend you obtain assistance from a payroll service or accountant, particularly when hiring for the first time. Here are some examples of current reports or forms that you may be required to file (but do know that changes occur frequently):

Federal Taxes:
- Income tax; use Circular E to compute tax
- Social Security and Medicare (FICA)

- Make deposits using Form 8109; file using Form 941
- Federal Unemployment Tax (FUTA); file annually using Form 940
- W-2 and 1099 Miscellaneous; file annually, provide to employees and file summary statement with copies to IRS

State Taxes (if applicable in the state where you operate your business):
- State Income Tax
- State Unemployment Tax

EMPLOYEE PERFORMANCE EVALUATIONS

Part of your role as boss includes conducting periodic performance evaluations. We hope you won't approach this necessary management task with all the dread of a teacher giving a bad report card. Instead, if you approach evaluation with the right spirit, it serves as a useful tool for both you and your employee. It's an opportunity for you to point out strengths as well as areas needing improvement, so that your employee is clear on how to reach higher levels of performance.

Businesses differ in the timing for evaluation. Some choose thirty days, others pick ninety days, or every six months. With a new hire, opt for a shorter period, just to make sure problems are addressed early on and not left to fester. Afterwards, every six to twelve months should suffice.

A sample evaluation developed by Cameron Foote as well as numerous other handy forms are available as free downloads at *www.creativebusiness.com*.

WARNINGS AND TERMINATIONS

Especially in the first few months of employment, supervise your new employee closely to make sure the person is adjusting to the new position and performing work in a manner that meets your standards. Check in with your employee at least weekly, if not daily, to see if there are any questions or points needing clarification. From time to time, throw out an open-ended question, such as, "So how's it going?" or "Are you settling in okay?"

While your employee faces a steep learning curve in adapting to a new environment, so do you, particularly when it comes to shouldering your new supervisory responsibilities. However well-intentioned you may be, chances are you'll make some mistakes along the way. Here's where having a mentor or a network of support outside the agency can come in handy. Not only can you let off steam, but also you can tap into somebody else's expertise. So do seek out help when you're feeling in over your head or don't know how to finesse a tricky situation involving your new employee.

Warnings

Swamped by the day-to-day pressures of running a design firm, meeting payroll, and trying to grow your business, you may overlook early-warning signals that indicate problems are brewing. However, if any of the following situations occur, deal with it right away. Causes for you to take disciplinary action include the following:

- Shoddy design work
- Repeatedly missing deadlines
- Poor attitude or negative interactions with clients
- Sharing confidential client or company information outside the organization
- Coming in obviously impaired from drugs/alcohol use
- Disappearing without notice or reason
- Unexplained absences or frequent tardiness
- Repeated deceit
- Theft
- Insubordination

When it comes to addressing such situations, you have five choices:

- Oral warning
- A written warning
- Probation (shape up in X amount of time or else)
- Suspension (time off without pay)
- Termination

Whatever option you choose, it is of paramount importance to document such action in the employee's personnel file (which you've been keeping all along, right?). Otherwise, you could wind up with no proof in the event your employee ever does file a lawsuit against you. We've said it before but it bears repeating: Paperwork is your best defense in avoiding legal action.

Termination

Sometimes, despite your best intentions and your most skillful interventions, you still have no choice but to bite the bullet and fire someone. When it comes to termination, you have three options:

- Immediate termination without notice
- Termination with notice
- Termination with severance pay in lieu of notice

Whichever one you choose, you absolutely *must* put the termination in writing. Clearly state the reasons for and type of termination. If you fail to do so,

your state's Human Rights Commission can come after you for wrongful discharge. (That may happen anyway, but at least you'll have a paperwork trail to back up your actions.)

Once you've fired an employee, learn from your past mistake. Take time to reflect on these questions:

- Was there some action I could have taken along the way that I didn't?
- Did I make sure the employee was aware from the beginning what our grounds for termination were?
- What did I learn from this situation? What will I do differently next time?
- What else do I need to find out or learn before I hire again?

The authors gratefully acknowledge Keith Small and Washington Hancock Community Agency, who were the genesis for the origination of this material.

Chapter 21:
REWARDING CLIENT LOYALTY

There is no question that technology has revolutionized the way people all over the globe do business. Yet few software programs or new gadgets can begin to compete with the mileage you can get out of a handshake, a relaxed chat over a good meal, or a handwritten note that cheers someone's day.

No time for the human touch? Not your style? Think again. We believe if you're not investing the time to show your clients how much you value them, your competitors will be more than happy to do so. As your focus shifts to growing your business, you must not neglect the necessity of strengthening relationships with your current clients so they will be right there beside you as you expand operations.

On the subject of client loyalty, Bob Wages, who opened Wages Design in Atlanta in 1979, clearly knows what he's talking about. "In this city, the key to success is not letting success go to your head," he says. "I learned you never take people for granted: not your family, friends, colleagues, or vendors—and especially not your clients. They are the people you keep."

In his bestseller, *The 7 Habits of Highly Effective People*, Stephen R. Covey emphasizes the importance of attending to relationships in our professional as well as our personal lives. He uses the expression Emotional Bank Account, which he defines as "the amount of trust that's been built up in a relationship."

"If I make deposits into an Emotional Bank Account with you through courtesy, kindness, honesty, and keeping my commitments to you, I build up a reserve," Covey writes. "Your trust towards me becomes higher, and I can call upon that trust many times if I need to. . . . When the trust account is high, communication is easy, instant, and effective."

According to Covey, there is no "quick fix" when it comes to building and repairing relationships. That's why he cautions us to make regular deposits in our Emotional Bank Accounts with those with whom we wish to stay in a good relationship.

Resolve now to make it a priority to let your clients know that you know that they are the very foundation of your business. Here are five useful strategies for reaching this goal.

ADVANCE NOTICE OF EXPANSION
Before going public with your expansion plans, give your current and former clients a heads up that you're adding new partners or staff members.

Business consultant, money coach, speaker, and author Olivia Mellan of Washington, D.C., offers some advice on accomplishing this task. "You can deliver the news in one-to-one meetings or invite all your clients over to meet and greet the new staff. Either way provides you with an opportunity to explain your motivations for making the changes and briefly discuss your firm's new mission and goals. Most of all, clients will want to hear how your growth will affect them, so be sure to address that, too."

A second point to emphasize is that you will be relying on your clients to help you succeed in your growth. Enumerate some ways they can assist you, such as referring new business your way.

Once your new employees are in place, check in with your clients periodically to see how things are going and to ensure the transition is glitch-free. As your staff takes on more responsibilities, you can devote more time to relationship-building by increasing communications with clients through phone calls, e-mail, letters, face-to-face meetings, or by hosting client appreciation events.

PERSONAL NOTES

"Anything you can do to remind people you're alive and available, without being too obvious about it, is valuable. A note is something tangible that keeps your name in front of present clients and those you're courting," Florence Isaacs writes in her book, *Business Notes: Writing Personal Notes That Build Professional Relationships.* Personal notes also work well as a subtle reminder that you're still around for former clients who have gone off the radar.

Why notes? First, they're more permanent than e-mail, letters, or phone calls. Second, in an age of spam and flooded in-boxes, personal notes are a reminder of a kinder, gentler time when we all had more time to breathe, when manners mattered as much as, if not more than, speed. Finally, personal notes offer you a way to stand out from the pack.

When to send a personal note? Here are some special occasions in your clients' lives that you may wish to acknowledge with a note:

- Awards
- Promotions
- Landing new accounts
- Mergers
- Expansions
- New products or services
- Milestones in the company history
- Relocation

When a client has taken action on your behalf, you have another good opportunity to send a note. Some examples might include:

- Advice
- Referrals or leads
- Serving as a reference
- Supplying information

Personal notes can also be a means of networking. For example, you may send a note along with an article, newspaper clipping, or statistics that may be of special interest to your client. Your note can accompany work-related photos, quotations, or upcoming events that may have relevance to the client. You can also recognize milestones in your working relationship, such as working together for five, ten, or twenty years.

Finally, depending on how personal your relationship is with your client, you may want to recognize such momentous occasions as these:

- Marriage (or divorce)
- Additions to the family
- Degrees, certifications, or licenses
- Death of a family member
- Health problems
- New homes

According to Florence Isaacs, condolences and thank you's are *always* hand-written (blue or black ink). On other occasions, you have the option of writing or typing. On what do you write or type your personal notes? Perhaps your business already has printed correspondence cards (sometimes referred to as "informals"), which work well for this type of correspondence.

Another wise choice is Monarch size stationery, 7¼" × 10½" of a good quality (meaning high rag content). Using this type of non-standard business stationery differentiates your message from standard business fare.

Don't confuse personal notes with e-cards, generic cards, or video clips. We all get way too much of these anyway and whatever uniqueness they once possessed has long ago faded.

In your note, you'll be using a more warm and personal tone than the wording and expressions you would otherwise write in a standard business letter. Your note will also be shorter than routine office correspondence. You can omit a return address, an inside address, and more formal business closings, such as *Yours truly*, in favor of a simple *Sincerely* or *Kind regards*.

GIFTS

At certain times in a business relationship nothing communicates your deep regard for a client as well as giving a gift. The subject, however, is not without some potential fallout so tread lightly when it comes to gift-giving. For example, sending liquor or a wine basket could be a disaster if the recipient is in recovery.

Similarly, chocolate would be wasted on a person observing a restricted diet. The more you know about your client, the easier it becomes to give a gift. If you're really clueless, sometimes a query to the administrative assistant at your client's place can yield informed suggestions.

Safer options may include taking a local client out to lunch or dinner, a treat for both of you. How about flowers or edible bouquets? A best-selling book? Tickets to a sports event, art exhibit, or theater or musical performance? And don't forget donations. Following September 11, 2001 and in the aftermath of Hurricane Katrina, many gift-givers opted to make a donation to the relief recovery effort in their clients' names.

Gift-giving can also be a great opportunity for you to show off your creativity and design skills. A striking calendar showcases your talent and keeps your name out there year-round. How about embossed gift bags or gift tags? Or framing a clever illustration or one of your own photos? The possibilities are as endless as your imagination. And you know what? Gift-giving allows you to reconnect with the fun of making things for others, a welcome break from the restraints of design briefs or project specs.

If you are giving gifts to corporate clients, be aware that the scene has changed dramatically since the passage of the Sarbanes-Oxley Act of 2002. This act, passed by Congress, came about as a result of the scandals involving Enron, Arthur Anderson, WorldCom, and other publicly traded corporations accused of financial malfeasance. As a result, corporations now spend millions of dollars a year proving that they are aboveboard in their corporate governance and financial disclosures.

What's this Sarbanes-Oxley thing got to do with me, you're probably wondering.

In a nutshell, it means that most corporations have severely tightened their policies on employees receiving gifts. Of any kind. When in doubt, make a subtle inquiry to the company as to whether giving gifts is allowed; otherwise, you're just wasting your money. In one case we heard from an Atlanta employee, money wasn't the only thing wasted. She received a shipment of live Maine lobsters from a grateful client, but, in accordance with her firm's policy, she had to return the gift. Still alive. Sad but true.

Whenever you do give gifts, we suggest you keep a written record, either in a general file under that subject or in the client's folder. Note the date and describe the gift. Such recordkeeping serves as a jog for your memory, as well as a time-saving tool around tax time since you can write off the cost of gift-giving as a legitimate business expense (check with your accountant for guidelines). You can also stick in ideas for future gift-giving occasions.

If you're traveling to other countries on business or working with high-ranking clients from other cultures, conduct an Internet search beforehand so you'll be up on the customs and practices of gift-giving in that culture. You wouldn't want to arrive empty-handed, only to learn when it's too late to take action that client gift-giving is *de rigueur.*

SPECIAL OFFERS

Ever receive a coupon for a discount? It makes you think about buying right away, doesn't it? The same holds true of limited-time offers you can make to your clients.

Of course, designers don't agree on the subject of discounts. One side believes that if you offer a discount even once, clients will tend to wait for another one before they're in a buying mood. Some say it can also lead the client to think you've over-priced services to begin with. However, supporters of discounts and special offers maintain that if you're in a slow period and the offer generates some business, why not go for it? Or perhaps you're touting a new service or product and are offering the reduction in rate in an attempt to spur your clients to experiment.

Ultimately, it's up to you to decide where you stand on the issue of discounting. Maybe before deciding, you'll want to do a bit of research on your own, either online or by calling or e-mailing colleagues to bat this subject around.

If you do decide to implement a discount or special offer, be sure to track your responses so you can determine if the effort is worth the cost.

Customer appreciation gestures are certainly not limited to discounts. For example, how about offering a free in-house training session for your client's staff? Or, if you change your location, expand operations, or want to showcase cutting-edge equipment, use it as an occasion to conduct an invitation-only open house featuring a demonstration or presentation that enlightens as well as energizes your customers. Two pointers for attracting participants who will actually show up: one, specify they must call ahead to enroll and, two, call or send a reminder to say you're expecting them.

On the subject of special offers, Sherry Christie, former Vice President of Strategic Planning at the advertising firm of Fahlgren, Inc. in Columbus, Ohio, contributes a terrific idea. "Periodically give your clients something they didn't ask for," she advises.

One of the ways Fahlgren strengthened client relations was to call the creative team together at least once a year for an account review and brainstorming session focused on each highly valued client.

"Then we'd invite the client over for a light lunch meeting," she says. "We'd give them our ideas—new products, new ad concepts, new media strategies, new theme lines, etc. These don't have to be developed in depth but should definitely be outside-the-box ideas. The clients loved it! More often than not, they would authorize us to go ahead with one or more of the ideas. If they didn't bite, then you're out the time you spent, but at least you showed the client you love them."

PROMOTIONAL ITEMS

If your budget allows, design promotional items (also known as *freebies*, *giveaways*, or *keepers*) as ongoing visual reminders of your creativity and services.

You can turn your clients and friends into walking billboards for your services every time they wear or display these items. Clever T-shirts, quirky mugs, gorgeous calendars, handy sticky notes, screwdrivers, mouse pads, frames, fantastic screen savers—your options are limited only by your budget.

Chapter 22:
STEPPING INTO THE SPOTLIGHT

You are synonymous with your business. Heighten the public's awareness of your design expertise and specializations through the media and public appearances.

INCREASING PUBLICITY

"Publicity is the most overlooked promotional tool and the least expensive!" Maria Piscopo writes in *The Graphic Designer's and Illustrator's Guide to Marketing and Promotion*. The beauty of publicity is that it's a free or extremely low-cost means of getting you or your business in front of hundreds or even thousands of readers who may realize they need your design services.

Increasing publicity for your business requires you to keep your eyes open for opportunities to blow your own horn. Trust us on this: *Everybody* needs to celebrate their achievements, even if you're a shrinking violet or behind-the-scenes kind of person. After all, you're in the design business and the name of the game is attracting attention to your work and services, right?

James Bradley, president of Chase Design Group, told us he takes a broad view on the subject of public relations. He says, "My PR goals are much loftier than news releases. I prefer stories written about clients—their problems and solutions—that just happen to mention that we did the work. Another category I like involves articles we write; for example, we have had a column called 'Trend' in the last several issues of *Create* magazine. A third category of PR pertains to articles where one of us is quoted as an expert."

NEWS RELEASES

News releases (also known as press or media releases) do remain the backbone of publicity. To improve the chances that your releases will appear in print, start by asking yourself two important questions:

- Is this *timely*; namely upcoming or in the very recent past?
- Is this a topic that will be considered *newsworthy* to my intended audience, in this case newspaper or magazine publishers?

Once you've passed these two tests, review the press release basics, including a template, found on page 135.

Triggers

Unsure about which occasions warrant a news release? Any of these ten situations can serve as triggers:

- Changing your location
- Expanding services
- Adding staff
- Winning awards
- Announcing a new client
- Launching clients' new logos, Web sites, or campaigns
- Marking a milestone anniversary
- Hosting an open house
- Sponsoring a special event
- Making public presentations

Media Lists

If you don't have a list of appropriate newspapers, magazines, online journals, and organizations updated and ready for immediate use, shame on you! Drag out the phone books and professional directories or do some online research to put one together.

Sure, we can all dream about seeing our news releases appear in *The New York Times* or *HOW* Magazine; however, chances are far greater that the smaller venues will yield better results. Think local newspapers, regional publications, business journals, trade magazines. If your client is located in another city or state, send a release to that locale as well.

Photos

With the advent of digital cameras and computer technology, taking and editing quality photos is easier than ever. Savvy promoters tell us that you increase your news release's chance of getting published if it's accompanied by a clear, relevant photo. For instance, maybe it's a shot of you delivering the new logo to the client (with their banner or signage in the background, of course).

If you do send a photo, don't forget to include a possible photo caption at the bottom of your release. Double-check that all names are spelled correctly and that you've used the right titles.

Snail Mail Versus E-Mail

There are opposing view points on this topic. Yes, it's cheaper and easier to circulate your news releases via e-mail; however, with spam a growing pain, realize your message might not reach its destination. If you do opt for e-mail, you can increase the chances that it will get through by pasting instead of attaching, but be sure to limit the size of your release to avoid clogging or shutting down your recipient's e-mail system.

Some designers prefer to stand out from the pack by sending a news release the old-fashioned way, by snail mail. That way you can use your own letterhead, include your logo, and jazz it up with color to catch the editor's eye.

Publicity Optimization

When the publicity gods smile on you and you make it into print, by all means optimize your exposure. Secure several hard copies for future use as press packet pieces. Of course, you'll want to send one of them to your client, along with a brief personal note. (Refer to "Rewarding Client Loyalty" on page 237.)

You can scan the article into your computer and send out an e-mail to your preferred mailing list . . . make mom or dad proud while at the same time reminding your current and previous clients of your presence.

Don't forget to post the article on your Web site either.

If you already have a Wall of Fame in your studio, add this enlarged and framed article to it. Both regular and prospective clients like to see that you share the glory. If you don't have a Wall of Fame, think about instituting one in your reception area or work space. Where else will you display all those awards for your designs?

SPONSORSHIPS

The more well-known your graphic design business becomes, the more often you'll be approached for a variety of causes. We're not talking the garden variety "Will you donate to Buckworth Junior High's booster club?" nor *pro bono* projects (covered on page 144) but rather the times when you are asked (or volunteer) to underwrite special events. These occasions range from sponsoring a benefit for a worthy cause, contributing prize money for awards, trophies, or scholarships, or hosting a hospitality room at a designer conference.

"Keep in mind, sponsorships are an indirect method of both advertising and public relations," Robert Spiegel advises in *The Complete Guide to Home Business*. "You get to put your name out but you don't get to send your message. Sponsorships work best if you are already reaching your market through more direct forms of advertising and are using the sponsorship to underscore your name and distinguish your company from the competition."

As you are considering this sponsorship "opportunity," you'll want to run down these five points to ponder before deciding:

1. Finances (*Do you have sufficient financial resources?*)
2. Passion (*Is this a cause about which you are passionate?*)
3. Time (*What time commitment are you being asked to make?*)
4. Exposure (*How will your contribution be recognized?*)
5. Contacts (*Will you make useful contacts that you might not otherwise meet?*)

ENHANCING YOUR PUBLIC IMAGE

As an experienced designer, you'll want to consider establishing yourself as an authority in the public arena through appearances, lectures, interviews, and/or published articles. In exchange for the time and effort you put into developing a public persona, you will get back more benefits than you can imagine.

Obviously, going public will support your business growth through networking, but it can also pay off in enhanced professional growth. Stepping up to the plate to share your design expertise and opinions with the public also challenges you to think more creatively and broadly than you would if left to your own private musings.

When you present or appear at guest lectures, seminars, and panels, you'll give less experienced designers and students the benefit of your expertise. Writing for your peers allows you to communicate your ideas, experiences, concerns, and questions and, in general, to become an active participant in the design dialogues of your day. Along the way, you'll be earning prestige and appreciation.

Other public appearances and publications should be targeted to potential clients. Articles in trade publications, newspapers, and online journals; appearances at small business programs and trade shows; and lectures at continuing education seminars are all excellent ways to build your reputation as an authority and to make it easy for prospective clients to seek out your business acumen.

PRESENTATIONS AND LECTURES

Once you start to look around, you'll find plenty of opportunities to give professional presentations and lectures. If the thought of performing in public makes you nervous, you can build up your courage and performance skills by starting with a low-stakes presentation. For instance, you might seek out a colleague who teaches at a local college and offer to make a brief appearance as a guest lecturer. Talk about what you know—the business of graphic design—and the students will be captivated. Since many college programs focus primarily on design skill development, you're likely to be bombarded with practical questions at the end of your presentation, and your confidence will soar.

If you find that you enjoy the classroom environment, go on to the next step, such as teaching a short course at a continuing education program for adult learners at a local high school, community college, or learning annex. Propose a one- or two-session minicourse in, say, visual marketing strategies or branding trends. Short-term courses like these are geared toward local business people, and, if marketed well, could put you in touch with many potential clients. Pick a topic that interests you and that you'd like to know more about, because you'll need to do some research to prepare your presentation.

Another option is getting in touch with your Chamber of Commerce, community board, other regional alliances, or economic development organizations. Many of them welcome guest speakers and would be eager to hear you speak about creating a shared visual identity or branding a region. You'll be enhancing your reputation and promoting your business at the same time that you help your audiences develop their visual literacy.

Find other potential audiences through professional and trade organizations that hold national and regional conferences. By presenting some general design strategies and forecasting to the audience at large, you can whet their appetite for your more customized personal design attention.

These avenues may lead you to feeling ready to present to your peers at your own professional design conferences. As a presenter on this level, you'll have a platform from which to speak about your ideas and beliefs, concerns, and professional experiences.

Preparation

So, how can you create presentations that are clear, well-organized, and appropriate for the audience? Most of the work that contributes towards giving an excellent presentation takes place *before* you say the first word to your audience. But all too often, nervousness and avoidance make it tempting to wait until the last minute to prepare, but that's a temptation to avoid. Instead, working through these six stages will help you to create the best possible presentation:

Analyze Your Audience. Identifying and analyzing your audience is the first step in preparing your talk, whether it's to traditional students, adult learners, business alliances and civic groups, professional organizations, or colleagues. Here are some pertinent questions you'll need to answer.

- *Is my audience composed of people who have similar interests and expertise?* If so, you can pick out examples, terminology, and other details that are relevant to their interests.
- *What does the audience know about me?* Don't assume that your experience and credentials are at the forefront of the audience's mind, even if your bio is printed in a conference program. Come up with a way to demonstrate your credibility in your introductory remarks.
- *What do they know already and what do they need to know about the topic?* Once you analyze their level of expertise on your topic, you'll know what definitions and explanations are necessary and how much design jargon is appropriate. You'll also be better prepared to decide how to organize your lecture.
- *Why are they coming? What do they hope to achieve or learn?* Has your audience come to be educated, informed, entertained, or persuaded? Although these categories are not mutually exclusive, you need to decide on the audience's primary purpose for attending your presentation. Then you can use this purpose as a guide for choosing what to include and exclude, what tone to use, and how to organize your talk.
- *Approximately how many people are expected to attend?* This information can help you prepare the most appropriate format and visual supplements for your presentation.

Identify Your Purpose. What do you hope to accomplish? What information do you need to communicate in order to accomplish it? For example, if you want to impress small business owners with your business savvy and experience, you should allude to past projects and tie bottom-line achievements to the design elements you created.

Once you've analyzed your audience's purpose and relevant characteristics, do some brainstorming to identify your own goals and objectives. These may seem self-evident, but if you're aware of the advantages you hope to gain, it will help you stay on track as you plan and give your talk. After all, you're only allotted a certain amount of time to make a good and lasting impression.

Define and Research Your Topic. Even if you think you know your topic well, you can always enrich your presentation by researching for up-to-date examples and relevant details. You might even find yourself changing or modifying some of your opinions if you are willing to research with an open mind.

Plan your research by asking yourself what you already know about the topic and what you need to know to make an effective presentation. Of course, a good percentage of your answer will come from your audience analysis and identified purpose. (What do they need to hear from you in order to react the way you'd like?) See chapter 4 on page 35 for guidance to carrying out research.

Outline Your Presentation. Outlining is an important step in preparing a presentation, because it helps you visualize it in terms of proportion and balance. You will be able to see at a glance the points that are adequately explained and the ones that are not. That's because writing an outline forces you to collect supporting details for each topic you intend to discuss. An outline can also be used as a written prompt when you give your talk, but we'll discuss that further in the following section. First, let's brush up on the characteristics of an outline.

An outline is the backbone of your presentation. Roman and Arabic numerals as well as uppercase and lowercase letters introduce each new topic or supporting detail. Here is the order in which the numerals and numbers appear with some possible subordinating details.

I. Introductory main idea
 A. Supporting detail
 1. description
 2. statistic
 3. example
 B. Supporting detail
 C. Supporting detail

II. Next main idea
 A. Supporting detail
 B. Supporting detail

This outline will continue through the body of the presentation until the conclusion. Because you are writing for listeners and not readers, you will need to keep your outline fairly simple. Focus on main ideas and supporting details.

Presentations are composed of three major parts: the introduction, the body, and the conclusion.

Introduction

- Unless you are going to be introduced by someone else or are well-known to your audience, include your professional credentials and relevant experience somewhere in your introduction.
- Let your readers know what they can expect to hear in order to make it easy for them to follow you.
- Begin with a hook. Start out with an interesting statistic or story; ask an engaging question; and/or provide information that demonstrates your relevant knowledge, skills, and experience.

Body

- Arrange the body of the presentation according to the organization strategy that works best with your topic. You might find that different parts of your talk call for different arrangements. Here are your choices:
 - Chronological—use when discussing procedures, directions, or instructions
 - Spatial—use when working with descriptions in conjunction with visuals
 - Cause and effect—use when discussing problems and solutions
- Use transitions to move from point to point
- Relate your subject to the audience's needs
- Use short sentences, familiar words, and concrete examples

Conclusion

- Offer a call to action or describe next steps
- End on a positive note
- Provide adequate contact information for yourself
- Anticipate questions

Choose Your Method of Delivery. *Speaking from notes* (rather than reading from a full report) is the most effective way to give your presentation because you will be able to look at your audience without losing your train of thought. It's important to be able to keep eye contact with your audience because you will be able to pace yourself appropriately.

If you are using your outline for this purpose, be sure to write it in short-sentence or long-phrase form to remind you of your thought process when you

were creating it. Use a larger pitch to be able to find your place more easily back on the page as you look away from your paper to make eye contact with the audience. When Barbara gives presentations, she prints her notes in eighteen pitch and quadruple space for ease of reading, a trick she learned when she was a speechwriter for Marvin Feldman, the late president of the Fashion Institute of Technology.

You can also use index cards for your notes. Write down key words, phrases, and sentences, as well as quotations, statistics, and examples. Number the card sequence in a color of ink that's different from the text just in case the cards get out of order.

Using your prompts from a PowerPoint presentation is another possibility. WARNING: Don't just read aloud what is written on the screen. Doing that will bore and distract your audience. Instead, use the points on the screen to lead into details and examples.

Reading directly from your paper. This is not a good choice for delivery, but we are addressing it because many of you will be tempted to do it for reasons of shyness and stage fright. But reading directly from a written paper will only make your nervousness worse, because your talk won't go over as well as it would have if you had just spoken from your notes.

When you read directly from a text, your eyes do not leave the page, which results in no eye contact with the audience and, therefore, no sense on your part of the audience's nonverbal feedback. You can't detect whether they are following you, laughing with you, nodding at interesting parts of your speech, reacting to controversy. You don't know because you aren't watching their facial and body language; you're too busy staring at your papers.

Practice Your Presentation. Before your actual delivery, you should rehearse to feel comfortable with your language and message. Here is what the experts recommend:

- Give your talk by speaking into a tape recorder to review for speed and tone. If you find that your speech is rushed, mumbled, or monotoned, you'll have time to adjust and practice a better, clearer delivery.
- Time yourself to determine whether you have enough to say and not too much for the allotted time.
- Practice using your visuals and equipment.
- Have yourself videotaped. Watch the tape yourself and show to a friend or colleague for critique.

Delivery

You've already done the hardest part of the work for this project. Now it's time to give your presentation. Just remember the following strategies.

Make eye contact with the audience. Before you say your first word, stop and look into your audience for five or ten seconds. That gesture with its accompa-

nying pause allows the audience to settle into your talk and you to begin from a centered place.

Grab their attention. When you cite a current event, provide a dramatic example, or tell a relevant personal story, you draw your audience in right away, thereby increasing your rapport with them.

Start slowly. A common mistake for novice speakers is to rush into their presentations, speaking too rapidly for the audience to follow. Remember, there is lag time in listening. If your audience is lost from the beginning, they may never catch up with your presentation.

Vary the speed and pitch of your delivery. Pause to check for audience feedback and ask some questions to help you avoid speaking in a monotone throughout your presentation.

Be aware of your body language. Use your hands to indicate relationships, size, and directions. Turn your head to face different parts of the audience.

Clue your audience that you are finished by thanking everyone for their attention. Be ready to take questions, but stay within your time limit.

SEMINARS AND WORKSHOPS

Seminars and workshops are interactive sessions. They differ from lectures and presentations, which are primarily one-way communications where the presenter speaks and the audience listens. Leading a seminar or workshop is a good way to get the word out about your business. You'll find a variety of organizations that offer seminars and workshops—learning annexes, community colleges and universities, conferences, corporate training programs, small business services, or you can put one on yourself. No matter who hosts your seminar or workshop, you should optimize attendance by doing your own promotion through your Web site, flyers, community e-boards, and other advertising. If you don't, you could wind up talking to yourself.

Although there are some differences between seminars and workshops (seminars are advanced, specialized discussions whereas workshops feature hands-on work), the content often overlaps. Because the skills and processes involved are similar, we'll discuss them together.

Preparation

The interactive nature of seminars and workshops requires you, the leader, to be flexible in reacting and responding to group dynamics and individual personalities. Here are some strategies to stay focused while still giving your participants room to learn. They require that you prepare in advance so that you have the freedom during the seminar or workshop to keep groups on task and facilitate discussions.

- Make notes about the points you want to cover during the session. Some people prefer note cards, others an outline or a checklist.

- Plan activities for group work that help participants understand the major concepts and learn to apply them to their own situations and concerns. Decide how much time you will allot to each activity. (Leave some time for the unexpected—questions, tangential discussions, etc.)
- Develop open-ended questions that encourage discussion.
- Create helpful hand-outs. Be sure to print your name, business, and contact information on every sheet. (While you're at it, make sure that you have enough business cards to hand out at the session.)
- Create evaluation sheets for feedback and demographic collection, unless the host is taking care of this task.

Leading the Session

If you have prepared sufficiently, the actual session will be simple to lead. Still, you may have to work at the following tasks.

- Manage the time. You have decided in advance how much time you will allot to each activity. Let the group(s) know at the beginning of each activity so that they can pace themselves. (For example, *you have twenty minutes for this exercise, which means five minutes per person or task.*) Remind them at the five-minute mark of time left.
- Direct each group to choose a timekeeper, recorder, or other taskmaster who will keep them on target.
- During small-group work, walk around from group to group to check on time issues, answer questions, and monitor key points that arise for later large group discussion.
- Don't second-guess yourself. Remember that people get better with practice. If you're well prepared, the workshop participants will remember the activities and instruction you provided, and they won't dwell on your nervousness.

After the Session
- Hand out evaluation sheets for feedback.
- Pass out contact information via business cards
- Remain around for those who may want personal time with you
- Shortly after your presentation, review the evaluation sheets and comments.

PANEL DISCUSSIONS

If you have been asked to participate in a panel discussion, your hosts already value your expertise (or appreciate your availability). Still, you'll improve your impact and enhance your image if you consider these questions before and focus your attention during the discussion.

Prior to the Session
These questions will guide your preparations:

What Don't You Know About the Discussion Topic? Are there key issues that you need to consider before you step onto the stage? Are there statistics you would be better off knowing?

- If you need to think about key issues, set aside time to work out your opinions and reinforce your thinking in writing.
- Do research on the Internet and in current journals and papers to see what others are saying and get a broader view of the issues.
- If you realize that knowing current statistics will make your contributions stronger and more valuable, plan for research time to obtain the numbers. Be sure to write down your sources and the dates of publication. (See chapter 4 on page 35 for research strategies and tips.)

Are There Special Points You Want to Contribute?
- Think this through on paper beforehand.
- Use note cards or a bulleted sheet to refer to during the panel discussion. There's no need to pretend that you can remember all of your research and thoughts; some of our favorite speakers refer quite publicly to their research and notes.

Who Are Your Copanelists and Do You Have an Allotted Amount of Time?
- If you know some or all of your copanelists and like them, you're in luck. You might be able to cocreate your remarks.
- Find out about time limits beforehand and practice to stay within them.

Where Will You Be in Order of Presenting?
- If you're scheduled for the beginning or even the middle, you'll have the opportunity to speak more broadly.
- If you're towards or at the end, you should prepare more remarks than you'll need so as not to repeat what was already discussed.

During the Panel Discussion
- Refer to your notes so that you say what you intended to say.
- Listen carefully to the others so you can stay flexible. When somebody before you scoops your point, edit your notes so you won't repeat. Jot down what others refer to that you could elaborate on; this could open up new ground for you to cover.

GRANTING INTERVIEWS

Imagine this scenario: Your local newspaper is doing a feature on businesses in the community, and a reporter calls "just to ask a few questions." You're busy at the moment, but decide to drop what you're doing and grab the free publicity while you can. You can't wait to see the results. But when your words appear in print, you come across as inarticulate and unsure of yourself. It isn't that you were misquoted. You remember saying what the reporter wrote in the article. You just weren't prepared and said the first thing that came into your head. Now your first thoughts have been recorded for all to read, and you're left to do the damage control.

What *should* you have done? Here are some tips for achieving good results when a reporter approaches you for an interview:

- When asked for an impromptu interview, schedule it for later, as you would a meeting request. (Remember, if there's a pressing deadline, you may miss the chance to be included.) Choose a time when you will be able to give the interview your full attention, and give yourself time to prepare.
 - Think about ways to get your business message across, even if the reporter doesn't ask directly.
 - Write out sound bites that demonstrate your best ideas and abilities.
 - Set aside fifteen undisturbed minutes before the scheduled interview to focus and look over your notes.
- Find out the storyline of the article (or radio or television show).
 - What is the focus?
 - Who else is being interviewed?
- Ask for the questions in advance.
- Have your presentation folder (biography and business information) ready to give to the reporter.
- Become familiar with the publication (or radio or television show) before the interview.
- Request an interview by e-mail, which gives you a chance to edit your first thoughts.

WRITING FOR PUBLICATION

Writing about your design ideas, opinions, missions, and strategies is a great way to promote yourself and your business. Basically, people read design articles, editorials, and columns to be informed or entertained. Some readers want to expand their thinking and explore new ideas for their own businesses. Others will read because they enjoy knowing about design trends, subliminal messages, and the many ways design intersects with culture.

Whether you are writing an article about refining a business identity or an editorial about the role that image design plays in a political campaign, your published words have the potential for lasting impact. Your words might be

quoted by other writers or speakers. You're more likely to be thought of as an expert to tap for interviews, panels, and presentations. For that matter, you can include copies of your latest writing (or links to it) in client mailings. When you publish your best thoughts, you create the opportunity to move up a few notches in prestige.

Let Others Publish Your Writing

If you haven't published yet, begin by looking through local newspapers and magazines or start-up Web sites, blogs, and zines for potential placement. Don't read the way you usually might—as a consumer—stopping at whatever strikes your interest. Instead, focus on finding places where your writing might fit in. Check out *The Writers' Market*, too; it's an annual publication that lists both consumer magazines and trade journals that accept submissions, as well as guidelines and tips for getting published.

Pitch your own story. Take the advice of designer and author Ellen Shapiro, who advises you to present your design work "as solutions to environmental, social, economic, or other problems" to make your news relevant and interesting to businesses and the general public. Another option she suggests is to be available to be part of a story if you can't sell a whole story.

Here are links to two articles by designers whose writing achieved national attention.

J. D. Jordan, owner of Cloudjammer Studios published a piece in the "My Turn" column in *Newsweek*, titled "I'm an Artist, But Not the Starving Kind." It's archived at *www.msnbc.msn.com/id/9287027/site/newsweek*.

Scott Dadich, creative director of *Texas Monthly* magazine, wrote an Op Ed, "What You See Is What You Get," which first appeared in the *New York Times*. Access it through *http://brandautopsy.typepad.com/brandautopsy/2004/10/dissecting_the_.html*.

Plagiarism and How to Avoid It

Plagiarism, which means taking credit for someone else's work, is unprofessional and unethical. Give credit where credit is due. In fact, citing your sources for the research, ideas, and creations of others reflects credit back on you because it shows the variety and depth of your own research and reading.

But of course there are other good reasons to document your sources. Giving yourself a pat on the back for your due diligence is just one of them. Your sources deserve to be recognized for their work. Besides, your readers might want to follow up on the quote or summary you've provided in your article. Your documentation will make it easier for them to look up the book, article, Web site, or blog where it appears in its entirety.

Although plagiarism of designs is a concern, it's not within our area of expertise. What we can tell you about is when and how to give credit for other people's words, whether in writing, speeches, or interviews. You should give source information when you:

- Quote directly from someone else's written or spoken work
- Paraphrase or summarize another person's work
- Present someone else's ideas, opinions, or interpretations
- Use statistics or other data collected by someone else

The simplest way to credit a source is to include her name and title/affiliation with the quote or summary. While you're at it, write where you found the quote, paraphrase, or statistic. For example:

In a recent interview, Art Director Andrea Costa of Time Magazine *advised recent graduates to get more exposure to grammar, sentence structure, and mechanics.*

or

Steven Heller points out in Becoming a Graphic Designer *that "design techniques can be taught, but talent comes from another place."*

In informal talks and writing, this information is probably enough. A listener or reader could find Heller's quote on the basis of the information offered or contact you to find out if, when, and where Costa's interview was published. (It is, in fact, excerpted in this book.)

For more formal presentations, bibliographic entries are in order. Give the author or speaker, the title of the book or article, the place of publication, the publisher, and the date published.

There are numerous Web links for information and help on writing bibliographies. The most trustworthy ones end in *edu* (for educational sites). A recent search we did yielded:

- *www.liu.edu/cwis/cwp/library/workshop/citation.htm*
- *www.wisc.edu/writing/Handbook/DocMLAWorksCited.html*
- *http://writing.colostate.edu/demos/chicago_reference/pop3a2.cfm*

You'll find three different formats: MLA (Modern Language Association), APA (American Psychological Association), and Chicago Manual-style, which is preferred by many industries. We recommend following the Chicago style because of its wide usage.

Conclusion

As professional writers and teachers, we recommend ending any business communication—whether it's a presentation, letter, or proposal—on a positive note. Therefore, we offer two final pieces of advice we hope you'll find useful. The first comes from a well-known leader in the design field.

Spotlight On
MICHAEL BIERUT/PENTAGRAM: BE READY FOR ANYTHING

More than twenty years ago, I served on a committee that had been formed to explore the possibilities of setting up a New York chapter of the AIGA. Almost all of the other committee members were older, well-known—and in some cases, legendary—designers. I was there to be a worker bee.

For the committee's first meeting, I had made a list of all the designers I would love to see speak, and I volunteered to share it with the group. A few names in, one of the well-known designers in the group cut me off with a bored wave. "Oh God, not more show and tell portfolio crap." To my surprise, the others began nodding in agreement. "Yeah, instead of wallowing in graphic design stuff, we should have something like . . . a Betty Boop film festival." A Betty Boop film festival? I wanted to hear a lecture from Josef Muller-Brockmann, not watch cartoons. I assumed my senior committee members were pretentious and jaded, considering themselves—bizarrely— too sophisticated to admit they cared about the one thing I cared about most: design. I was confused and crestfallen.

Over the years, I came to realize that my best work has always involved subjects that interested me, or—even better—subjects about which I've become interested, and even passionate about, through the very process of doing design work. I believe I'm still passionate about graphic design. But the great thing about graphic design is that it is almost always about something else. Corporate law. Professional football. Art. Politics. Betty Boop. And if I can't get excited about whatever that something else is, I really have trouble doing good work as a designer. To me, the conclusion is inescapable: The more things you're interested in, the better your work will be.

Not everything is design. But design is about everything. So do yourself a favor: Be ready for anything.

Design Observer excerpt
March 18, 2006

LESSONS FOR WORK (AND LIFE)

From our perspective, we want to share some lessons we've learned (and occasionally forgotten) over the course of our own professional lives. May they guide you along the way, regardless of where your design career takes you.

1. *Sharpen Your Curiosity*—If you fail to keep learning, you fail. Period. Stay at the top of your game by reading, attending conferences, connecting with your peers, asking questions and seeking answers, and shoring up your soft spots. Enrich yourself through museum exhibits, lectures, shows, and concerts. Throughout your professional life be guided by the wisdom of Alvin Toffler, the futurist who wrote, "The illiterate of the twenty-first century will not be those who cannot read and write, but those who cannot learn, unlearn, and relearn."

2. *Believe that "Good Enough" is Never Enough*—Whatever you do, do it well. You know that about designing, but it also goes for writing, presenting yourself and your work, listening to your clients and associates, and all of your professional interactions. Regardless of which communication skills come naturally, and which ones don't, strive to do your best. Refuse to settle for "good enough."

3. *Nourish Yourself*—Play. Play hard. Then rest. Recharge your batteries. Venture outside your comfort zone. Create something outrageous. Develop new hobbies. Travel. Learn from your mistakes. Celebrate your near-misses along with your triumphs. Do what makes you happy. If and when that changes, find something new that gives you pleasure.

4. *Give Back*—Volunteer. Mentor. Lend a helping hand now and then to a young designer just starting out. Do *pro bono* work. Give a workshop at an inner-city or rural school that lacks design programs.

5. *Be Willing to Reinvent Yourself*—Who you are today very well may not be who you are in the days and years to come. Your decision to expand or alter your career goals and/or your business is dependent upon many factors. Some are beyond your control, like technological advances or the vagaries of the economy; other factors are of a more personal nature, including desire, age, energy, lifestyle, family, and health. Every designer we interviewed shared his or her own stories about facing challenges, regrouping, and, ultimately, re-visioning themselves. We hope the advice and tools we've provided in this book will help guide you through your own transitions, however many of them there may be.

Graphic Designers ON STAYING LIMBER

"Multi-media among young people is very flashy these days. People want to be entertained while they're being informed. In five years, video will grow as popular as Web sites are today. Video will do to communication what e-mail did. Who knows where it'll end? Demand drives learning new things."

—*Michael Beall*

• • •

"Keep current on the Internet—Liquid Library, MacWorld, any tricks and tips about Photoshop." —*Michelle Groblewski*

• • •

"Read vociferously. Study the relationship between psychology and graphic arts. Study language. Read propaganda books so you'll learn the principles."

—*Dave Caputo*

• • •

"Always keep in mind that things change . . . a change in the climate or a change in decision-makers and you could be out, no matter how good you are." —*Cathy Teal*

• • •

"Part of art involves being lazy. There's no time in Western culture for down-time. Go out and have fun, learn from your own experiences, and then bring that knowledge into your design." —*Mirko Ilić*

• • •

"Keep playing. I know from personal experience, that you stay fresh with ideas when you keep on 'playing.' Draw, sculpt, paint, collage, anything that you enjoy doing that keeps your creative juices flowing. It will help you with technique—not everything has to be drawn on a computer—composition, imagery, etc." —*Christy White*

• • •

"When I was the president of the AIGA, people kept asking me 'How can we figure out how to get more respect from our clients?' The only way is by working on the highest level of thinking; it's not just about the quality of design." —*Michael Bierut*

About the Authors

Photo credit: Yefim Kaplan

Photo credit: Barbara Chehoski

Barbara Janoff has taught business communications for more than twenty years. She is currently an associate professor of English at The Fashion Institute of Technology, State University of New York. As the college's Writing Coordinator, she developed specialized business-writing courses for graphic designers, photographers, and interior designers. Prior to joining the full-time faculty of the English and Speech Department, she served as Interim Dean of FIT's Continuing Education Division, where she was responsible for the marketing and coordination of its programs.

A consultant on communication issues, job search strategies, and corporate training, she also gives presentations and workshops at academic conferences nationwide. Janoff is a published poet and holds a doctorate in comparative literature from Columbia University. She lives in New York City and Copake Falls, New York.

Ruth Cash-Smith has taught business communications for colleges in the United States, Singapore, Malaysia, and Hong Kong. A former mediator within the Maine court system, she also worked as a federal grants evaluator, a career counselor, and a private job search coach. She has developed and delivered dozens of workshops on group dynamics, leadership, and conflict resolution. Her essays have aired on national public radio, and her articles have appeared in over seventy publications. Recipient of the 2006 Apex Award for Professional Communications, she has written several handbooks for a variety of nonprofit organizations.

Cash-Smith earned a master's degree in interpersonal and intercultural communication from Fairfield University and now works as a business counselor for the Women's Business Center at Coastal Enterprises, Inc. She lives in Downeast Maine.

Contributors

We extend special thanks to these talented graphic designers who contributed in so many ways to the creation of this book:

Steve Adolf
Zimmerman, an Omnicom
 company
Fort Lauderdale, FL

Shamus Alley
The Drawing Space
New York, NY

Larry Asher
School of Visual Concepts
Seattle, WA

Michael Beall
True North
Eau Claire, MI

Michael Bierut
Pentagram
New York, NY

James Bradley
Chase Design Group
Los Angeles, CA

Mark A. Cain
Advertising Art Studio
Milwaukee, WI

Dave Caputo
Positronic Design
Holyoke, MA

Buddy Chase
Studio 3
Ellsworth, ME

Margo Chase
Chase Design Group
Los Angeles, CA

Andrea Costa
Time Magazine
New York, NY

Denise Denson
Avantpage
Davis, CA

Jeff Fisher
Jeff Fisher LogoMotives
Portland, OR

Cameron S. Foote
Creative Business
Boston, MA

Michelle Groblewski
Supermodels Unlimited
Northampton, MA

Deb Handel
Newcomb Marketing Solutions
Michigan City, IN

Mirko Ilić
Mirko Ilić Corporation
New York, NY

J. D. Jordan
Cloudjammer Studio
Roswell, GA

Eric Karjaluoto
smashLAB
Vancouver, B.C.

Steffanie Lorig
Art with Heart
Seattle, WA

Marty Lyons
Studio 3
Ellsworth, ME

Lee Silber
Creative Lee Speaking
San Diego, CA

Sally McElwain
Alexander Designs
New York, NY

Cathy Teal
FireBrand Design
Palm Springs, CA

Philip Opp
Animation Annex
Arvada, CO

Bob Wages
Wages Design
Atlanta, GA

Don Regole
Regole Design
Tucson, AZ

Christy White
Alpha Marketing Inc.
Raleigh, NC

Selected Bibliography

BOOKS

Abraham, Jay. *Getting Everything You Can Out of All You've Got: 21 Ways You Can Out-Think, Out-Perform, and Out-Earn the Competition.* New York: Truman Talley/St Martin's, 2000.

Alred, Gerald J., Charles T. Brusaw, and Walter E. Oliu. *The Business Writer's Companion* (3rd ed.). Boston: Bedford/St Martin's, 2002.

Bowen, Linda C. *The Graphic Designer's Guide to Creative Marketing: Finding and Keeping Your Best Clients.* New York: John Wiley & Sons, 1999.

Covey, Stephen R. *The 7 Habits of Highly Effective People.* New York: Simon & Schuster, 1990.

Cox, Mary, Alice Pope, and Lauren Mosko, eds. *2006 Artist's & Graphic Designer's Market.* Cincinnati: F + W Publications, 2005.

Crawford, Tad and Eva Doman Bruck. *Business and Legal Forms for Graphic Designers.* New York: Allworth Press, 1995.

Crawford, Tad, ed. *Professional Practices in Graphic Design.* New York: Allworth Press copublished with AIGA, 1998.

Fisher, Jeff. *The Savvy Designer's Guide to Success: Ideas and Tactics for a Killer Career.* Cincinnati: HOW Design Books, 2005.

Fleishman, Michael, *Starting Your Career As a Freelance Illustrator or Graphic Designer* (2nd ed.). New York: Allworth Press, 2001.

Foote, Cameron S. *The Business Side of Creativity: A Complete Guide to Running a Small Graphic Design or Communications Business* (Updated ed.) New York: W. W. Norton, 2002.

———. *The Creative Business Guide to Running a Graphic Design Business.* New York: W. W. Norton, 2001.

Glaser, Milton. *Art is Work.* Woodstock, New York: Overlook, 2000.

Gordon, Barbara. *Opportunities in Commercial Art and Graphic Design Careers* (Revised ed.). New York: VGM Career Books/McGraw Hill, 2004.

Hacker, Diana. *A Pocket Style Manual* (4th ed.). Boston: Bedford/St Martin's, 2004.

Heller, Steven and Teresa Fernandes. *Becoming a Graphic Designer: A Guide to Careers in Design* (3rd ed.). New Jersey: John Wiley & Sons, 2006.

Isaacs, Florence. *Business Notes: Writing Personal Notes That Build Professional Relationships.* New York: Clarkson N. Potter, 1998.

Jefferson, Michael. *Breaking into Graphic Design: Tips from the Pros on Finding the Right Position for You.* New York: Allworth Press, 2005.

Kishel, Gregory F. and Patricia Kishel. *Growing Your Own Business.* New York: Perigee/Berkley, 1994.

Kolin, Philip C. *Successful Writing at Work* (8th ed.). Boston: Houghton Mifflin, 2007.

Lawler, Jennifer. *Small-Business Ownership for Creative People.* New York: Aletheia, 2000.

Lehman, Carol M., William C. Himstreet, and Wayne M. Baty. *Business Communications* (11th ed.). Cincinnati: South-Western College, 1996.

Norman, Jan. *What No One Ever Tells You About Marketing Your Own Business.* Chicago: Dearborn/Kaplan, 2004.

Phillips, Peter L. *Creating the Perfect Design Brief: How to Manage Design for Strategic Advantage.* New York: Allworth Press, 2004.

Piscopo, Maria. *The Graphic Designer's and Illustrator's Guide to Marketing and Promotion.* New York: Allworth Press, 2004.

_____. *Marketing & Promoting Your Work.* Cincinnati: North Light, 1995.

Powers, Jacqueline K. *The 21st Century Entrepreneur: How To Start a Freelance Consulting Business.* New York: Avon, 1999.

Quilliam, Susan. *Body Language.* New York: Firefly. 2004.

Reynolds, Sana and Deborah Valentine. *Guide to Cross-Cultural Communication.* New Jersey: Pearson Education, 2004.

Sapp, Jim. *Starting Your First Business: Gain Independence and Love Your Work.* Roseville, California: Publishers Design Group, 2004.

Schenkler, Irv and Tony Herrling. *Guide to Media Relations.* New Jersey: Pearson Education, 2004.

Shapiro, Ellen. *The Graphic Designer's Guide to Clients: How to Make Clients Happy and Do Great Work.* New York: Allworth Press, 2003.

Sides, Charles H. *How to Write & Present Technical Information* (3rd ed.). Phoenix: Oryx, 1999.

Silber, Lee. *Self-Promotion for the Creative Person: Get the Word Out about Who You Are and What You Do.* New York: Three Rivers Press, 2001.

Sparkman, Don. *Selling Graphic Design* (2nd ed.). New York: Allworth Press, 1999.

Spiegel, Robert. *The Complete Guide to Home Business.* New York: AMACOM, 1999.

Thill, John V. and Courtland L. Bovée. *Excellence in Business Communication* (7th ed.). New York: Prentice Hall, 2006.

Webb, Philip and Sandra Webb *The Small Business Handbook: The Entrepreneur's Definitive Guide to Starting and Growing a Business* (2nd ed.). New York: Prentice Hall, 2001.

White, Alex. *The Elements of Graphic Design.* New York: Allworth Press, 2002.

Zelanski, Paul. *Design Principles and Problems.* New York: Holt, Rinehart and Winston, 1984.

PERIODICALS

Advertising Age. Chicago: Crain Communications.
Adweek. New York: BPI Communications.
Creative Business newsletter. Boston: Creative Business, Inc.
Communication Arts. Menlo Park, California: Coyne & Blanchard, Inc.
Entrepreneur. Irvine, California: American City Business Journals, Inc.
How. Cincinnati: F&W Publications.
SmallBiz. New York: Business Week Group.

Index

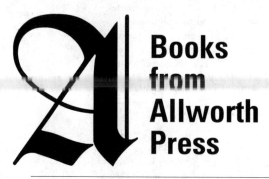

Books from Allworth Press

Allworth Press is an imprint of Allworth Communications, Inc. Selected titles are listed below.

Creating the Perfect Design Brief: How to Manage Design for Strategic Advantage
by Peter L. Phillips (paperback, 6 × 9, 224 pages, $19.95)

Inside the Business of Graphic Design: 60 Leaders Share Their Secrets of Success
by Catharine Fishel (paperback, 6 × 9, 288 pages, $19.95)

The Graphic Designer's Guide to Clients: How to Make Clients Happy and Do Great Work
by Ellen Shapiro (paperback, 6 × 9, 256 pages, $19.95)

How to Grow as a Graphic Designer
by Catharine Fishel (paperback, 6 × 9, 256 pages, $19.95)

The Graphic Design Business Book
by Tad Crawford (paperback, 6 × 9, 256 pages, $24.95)

The Real Business of Web Design
by John Waters (paperback, 6 × 9, 256 pages, $19.95)

Business and Legal Forms for Graphic Designers, Third Edition
by Tad Crawford and Eva Doman Bruck (paperback, 8½ × 11, 208 pages, includes CD-ROM, $29.95)

AIGA Professional Business Practices in Graphic Design
edited by Tad Crawford (paperback, 6¾ × 10, 320 pages, $24.95)

The Graphic Designer's Guide to Pricing, Estimating, and Budgeting, Revised Edition
by Theo Stephan Williams (paperback, 6¾ × 9⅞, 208 pages, $19.95)

Selling Graphic and Web Design, Third Edition
by Donald Sparkman (paperback, 6 × 9, 224 pages, $24.95)

Design Management: Using Design to Build Brand Value and Corporate Innovation
by Brigitte Borja de Mozota (paperback, 6 × 9, 256 pages, $24.95)

Please write to request our free catalog. To order by credit card, call 1-800-491-2808 or send a check or money order to Allworth Press, 10 East 23rd Street, Suite 510, New York, NY 10010. Include $6 for shipping and handling for the first book ordered and $1 for each additional book. Eleven dollars plus $1 for each additional book if ordering from Canada. New York State residents must add sales tax.

To see our complete catalog on the World Wide Web, or to order online, you can find us at **www.allworth.com**.